The Disney
BOOK

A Celebration of the World of Disney

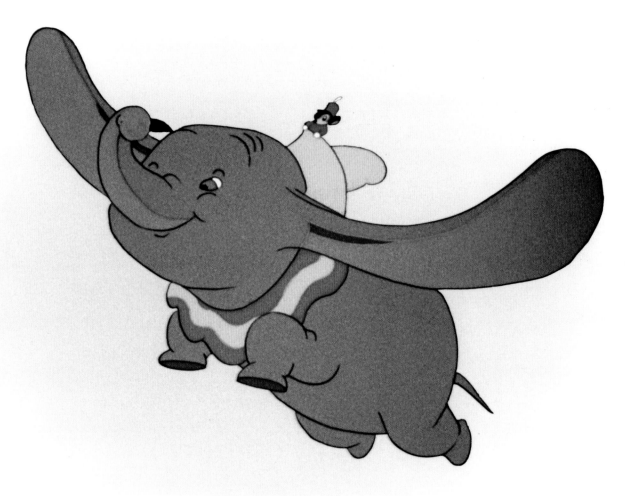

The Disney BOOK

A Celebration of the World of Disney

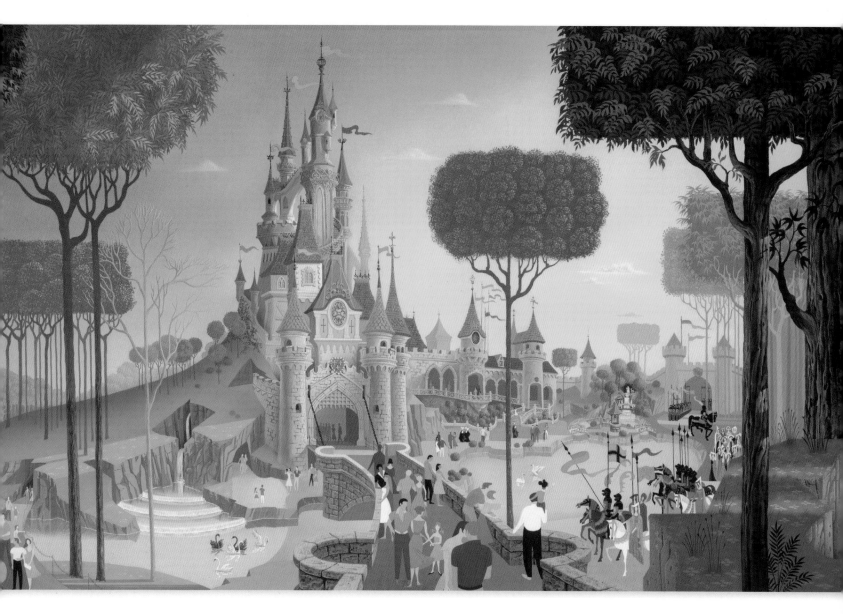

Written by Jim Fanning

See p. 57

Contents

See p. 27

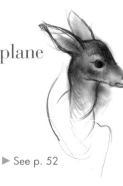
See p. 44

See p. 52

See p. 80

See p. 84

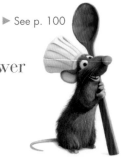
See p. 100

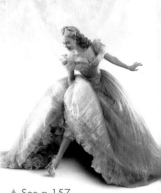

See p. 141

See p. 195

Introduction

Disney means enchantment, fun, and adventure— but beyond that, a touching of the heart, an aspirational stirring of the soul, a feeling of belonging. Behind all the emotion and artistry is a special type of imagination, a creativity born of artists and animators, actors and directors, Imagineers and Cast Members. It is an artistry evident not only in a completed film or a theme park but also in the paintings, drawings, and other artworks produced by the Disney artisans. All of this and more makes up *The Disney Book*.

From the start, Walt wanted the name Disney to represent quality, a novel entertainment that was uniquely engaging. And for more than 90 years, Walt and those who carry on his creative heritage have made that name symbolize a magic that transcends mere entertainment.

This book covers many of the highlights of this singular history. Since its own history is unusually important to the never-ending evolution of Disney, that history is every bit as fascinating as the productions, programs and parks themselves. And as that history has long held a remarkable fascination for Disney fans of every age and ilk, we are very happy to bring together this tome of Disney treasures for you.

Most images in *The Disney Book* were selected from the jam-packed vaults of The Walt Disney Company. With more than 9,000 boxes of documents and merchandise items as well as several thousand historic props and costume pieces—from the earliest Mickey Mouse Club to the latest *Pirates of the Caribbean* film—the Walt Disney Archives documents Disney history as it happens. The Walt Disney Archives Photo Library houses more than four million images. The various types of negatives and color transparencies preserved in the Archives cover all aspects of Disney history, from its beginnings to the present. From concept art to the final film frames, the Disney Animation Research Library houses more than 65 million pieces of original artwork that helped create the beloved Disney films, both classic and contemporary. And from Walt Disney Imagineering, the Slide Library provided select photos of Imagineers and their creations while the Art Library offered a rich tapestry of theme-park masterpieces.

As you can see from the treasures in this book, this wonderful world, as Disney is often described, is actually a vast universe. From Mickey Mouse to Baymax, from *Cinderella* to *Frozen*, and the global theme park kingdom on which the sun never sets, Disney is an ever-expanding, always enchanting subject. This book gives you a glimpse into the magic that made the Mouse—and all that he represents.

By Jim Fanning

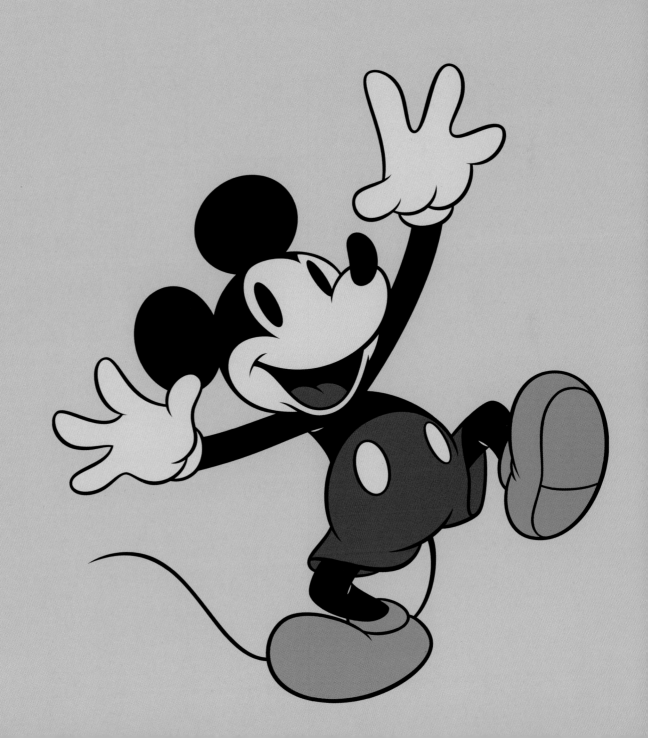

1920s and 1930s

When Walt Disney founded his studio in 1923, black-and-white silent films were state-of-the-art and animated shorts were mere fillers. By the end of the 1930s, Disney led the way in sound and color and transformed the lowly cartoon into an art form. Along the way, Walt and his artists developed a special style of storytelling, a way of creating unforgettable characters, and principles of entertainment that the company Walt founded still follows today.

1924

Alice Comedies: ●
Alice's Spooky Adventure

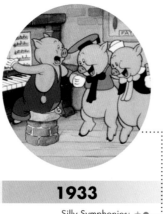

1925

Alice Comedies: ●
Alice in the Jungle

1926

Alice Comedies: ●
Alice's Spanish Guitar

1927

Oswald the Lucky Rabbit: ●
Trolley Troubles

1932

Silly Symphonies: ★ ●
Flowers and Trees

1933

Silly Symphonies: ★ ●
Three Little Pigs

1934

Silly Symphonies: ●
The Wise Little Hen

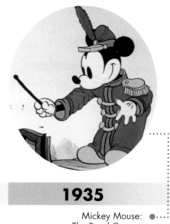

1935

Mickey Mouse: ●
The Band Concert

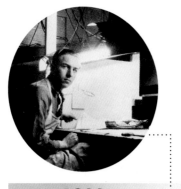

1920

Walt working at a newspaper ❦ ⋯
in Kansas City

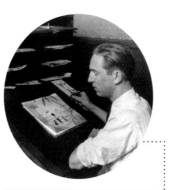

1921

Newman Theater's ● ⋯
first Laugh-O-gram

1922

Jack and the Beanstalk ● ⋯
Laugh-O-gram

1923

Disney Brothers ❦
Cartoon Studio formed

Alice Comedies: ● ●
Alice's Wonderland

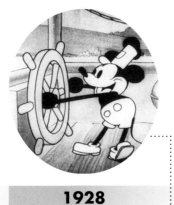

1928

Steamboat Willie ● ⋯

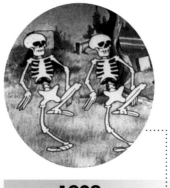

1929

Silly Symphonies: ● ⋯
The Skeleton Dance

1930

Mickey Mouse: *The Fire Fighters* ● ⋯

1931

Silly Symphonies: ● ⋯
The Ugly Duckling

1936

Mickey Mouse: ● ⋯
Thru the Mirror

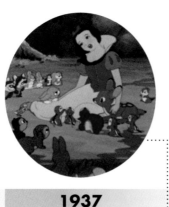

1937

Snow White and the ★ ●
Seven Dwarfs

1938

Silly Symphonies: ● ⋯
Merbabies

1939

The Autograph Hound ● ⋯

1940s and 1950s

Weathering the storm of World War II by contributing to military training films and morale-boosting cinematic explorations, Walt educated and inspired those defending freedom throughout the world. He was also continually developing new filmmaking techniques. In the 1950s, after embracing the technology of television, Walt created an entirely new form of entertainment—the theme park—in the form of a Magic Kingdom known as Disneyland Park.

1944

First Aiders ⬤

1945

The Three Caballeros ⬤ ⬤

1946

Make Mine Music ⬤
Song of the South ★ ⬤ ⬤

1947

Fun and Fancy Free ⬤ ⬤

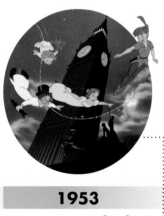

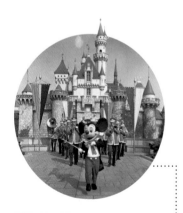

1952

The Story of Robin Hood ⬤
and His Merrie Men

1953

Peter Pan ⬤
The Sword and the Rose ⬤
The Living Desert ★ ⬤

1954

Rob Roy, the Highland Rogue ⬤
The Vanishing Prairie ★ ⬤
20,000 Leagues Under the Sea ★ ⬤

1955

Disneyland opens 🐾
Davy Crockett,
King of the Wild Frontier ⬤
Lady and the Tramp ⬤
The African Lion ⬤
The Littlest Outlaw ⬤

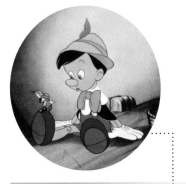

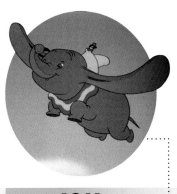

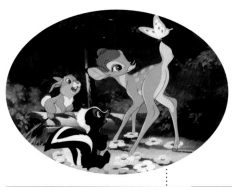

1940

Pinocchio ★ ●····

Fantasia ● ●

1941

The Reluctant Dragon ● ●

Dumbo ★ ●····

1942

Bambi ●····

1943

Saludos Amigos ● ●

Victory Through Air Power ● ●

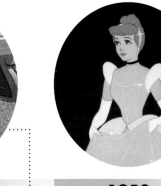

1948

Melody Time ● ●····

Seal Island ●

1949

The Adventures of Ichabod and Mr. Toad ●····

So Dear to My Heart ● ●

1950

Cinderella ●····

Treasure Island ●

1951

Alice in Wonderland ●····

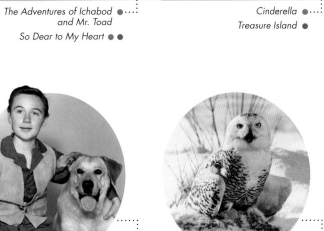

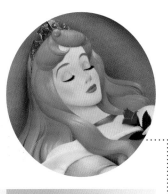

1956

The Great Locomotive Chase ●····

Davy Crockett and the River Pirates ●

Secrets of Life ●

Westward Ho the Wagons! ●

1957

Johnny Tremain ●

Perri ●

Old Yeller ●····

1958

The Light in the Forest ●

White Wilderness ★ ●····

Tonka ●

1959

Sleeping Beauty ●····

The Shaggy Dog ●

Darby O'Gill and the Little People ●

Third Man on the Mountain ●

1960s and 1970s

Walt innovated again with a global live audience at the 1964-65 New York World's Fair, new theme park adventures and plans, and a blockbuster musical about a magical nanny. After his death, the loss was eased by the gain of a new Magic Kingdom in Florida. This set the stage for a constantly evolving expression of the Imagineering art form. Disney kept Walt's imaginative spirit alive with a series of animated features, each more popular than the one before.

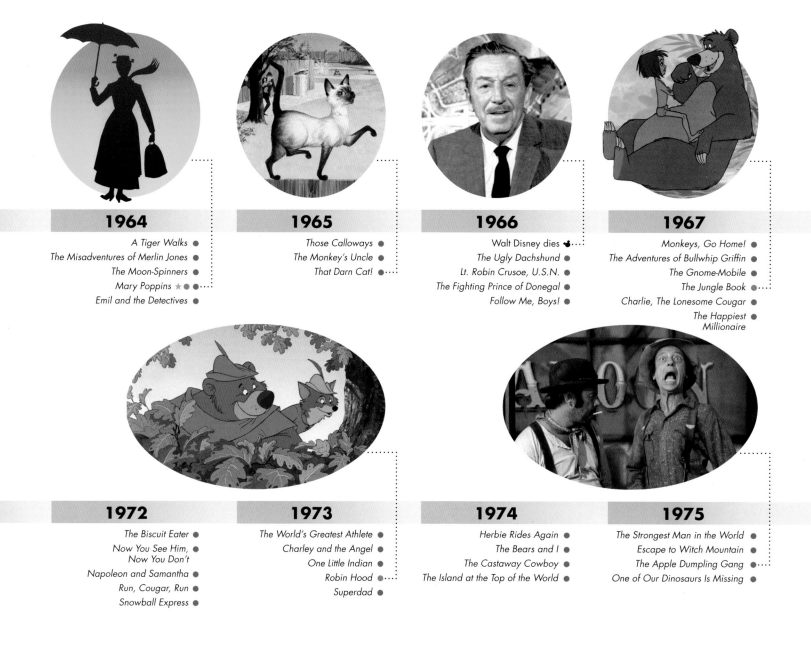

1964
A Tiger Walks ●
The Misadventures of Merlin Jones ●
The Moon-Spinners ●
Mary Poppins ★ ● ●
Emil and the Detectives ●

1965
Those Calloways ●
The Monkey's Uncle ●
That Darn Cat! ●

1966
Walt Disney dies 🐭
The Ugly Dachshund ●
Lt. Robin Crusoe, U.S.N. ●
The Fighting Prince of Donegal ●
Follow Me, Boys! ●

1967
Monkeys, Go Home! ●
The Adventures of Bullwhip Griffin ●
The Gnome-Mobile ●
The Jungle Book ●
Charlie, The Lonesome Cougar ●
The Happiest Millionaire ●

1972
The Biscuit Eater ●
Now You See Him, Now You Don't ●
Napoleon and Samantha ●
Run, Cougar, Run ●
Snowball Express ●

1973
The World's Greatest Athlete ●
Charley and the Angel ●
One Little Indian ●
Robin Hood ●
Superdad ●

1974
Herbie Rides Again ●
The Bears and I ●
The Castaway Cowboy ●
The Island at the Top of the World ●

1975
The Strongest Man in the World ●
Escape to Witch Mountain ●
The Apple Dumpling Gang ●
One of Our Dinosaurs Is Missing ●

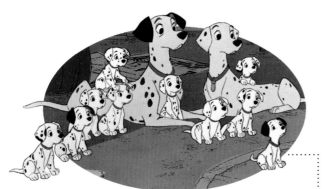

1960

Jungle Cat ●
Toby Tyler, ●
or Ten Weeks
with a Circus
Kidnapped ●
The Horse With ★ ●
the Flying Tail

Swiss Family ●
Robinson
Pollyanna ●
The Sign ●
of Zorro
Ten Who Dared ●

1961

One Hundred and One Dalmatians ● ┄
The Absent-Minded Professor ●
The Parent Trap ● ●
Nikki, Wild Dog of the North ●
Greyfriars Bobby ●
Babes in Toyland ● ●

1962

Moon Pilot ●
Bon Voyage ●
Big Red ●
Almost Angels ●
The Legend of Lobo ●
In Search of the Castaways ●

1963

Son of Flubber ●
Miracle of the White Stallions ●
Savage Sam ●
Summer Magic ●
The Sword in the Stone ● ┄
The Three Lives of Thomasina ●

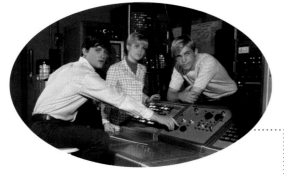

1968

Blackbeard's Ghost ●
The One and Only, Genuine, ●
Original Family Band
The Horse in the Gray Flannel Suit ●
Never a Dull Moment ●

1969

The Love Bug ●
Smith! ●
Rascal ●
The Computer Wore Tennis Shoes ● ┄

1970

King of the Grizzlies ●
The Boatniks ●
The Aristocats ● ┄

1971

Walt Disney World opens ✦ ┄
The Wild Country ●
The Barefoot Executive ●
Scandalous John ●
The Million Dollar Duck ●
Bedknobs and Broomsticks ● ● ★

1976

Ride a Wild Pony ●
No Deposit, No Return ●
Treasure of Matecumbe ●
Gus ●
The Shaggy D.A. ● ┄

1977

Freaky Friday ●
The Littlest Horse Thieves ●
The Many Adventures ●
of Winnie the Pooh
The Rescuers ●
Herbie Goes to Monte Carlo ●
Pete's Dragon ● ● ┄

1978

Return from Witch Mountain ●
The Cat From Outer Space ● ┄
Hot Lead and Cold Feet ●
Candleshoe ●

1979

The North Avenue Irregulars ●
The Apple Dumpling ●
Gang Rides Again
Unidentified Flying Oddball ●
The Black Hole ● ┄

1980s and 1990s

With Tokyo Disneyland, the first Disney theme park outside the U.S., Disney widened its kingdom across the globe. Dynamic new leadership revitalized traditions and challenged creative and business growth, resulting in such expansions as the acquisition of the ABC television network, as well as a re-flowering of the art form Walt created, the animated feature. There was also the revolutionary introduction of and evolution of computer-animated films.

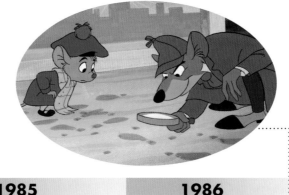

1984
Touchstone Pictures 🐭 was established

1985
Return to Oz ⬤
The Black Cauldron ⬤
The Journey of Natty Gann ⬤
One Magic Christmas ⬤

1986
The Great Mouse Detective ⬤
Flight of the Navigator ⬤

1987
Benji the Hunted ⬤

1992
Euro Disney Resort 🐭
(now Disneyland Paris)
opens near Paris, France
Newsies ⬤
Honey, I Blew Up the Kid ⬤
The Mighty Ducks ⬤
Aladdin ★⬤
The Muppet Christmas Carol ⬤

1993
Disney acquires Miramax 🐭
Homeward Bound: ⬤
The Incredible Journey
A Far Off Place ⬤
The Adventures of Huck Finn ⬤
Hocus Pocus ⬤
Cool Runnings ⬤
The Three Musketeers ⬤
The Nightmare Before Christmas ⬤

1994
Disney Interactive is founded 🐭
Iron Will ⬤ The Lion King ★⬤
D2: The Mighty ⬤ Squanto: ⬤
Ducks A Warrior's Tale
White Fang 2: ⬤ The Santa ⬤
Myth of the Clause
White Wolf Rudyard ⬤
Angels in the ⬤ Kipling's
Outfield The Jungle
Blank Check ⬤ Book

1995
Heavyweights ⬤ Pocahontas ★⬤
Man of the ⬤ A Kid in King ⬤
House Arthur's Court
Tall Tale ⬤ The Big Green ⬤
A Goofy Movie ⬤ Tom and Huck ⬤
Operation Frank and Ollie ⬤
Dumbo Drop Toy Story ⬤

1980

Midnight Madness ●
Herbie Goes Bananas ●
The Last Flight of Noah's Ark ●

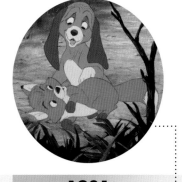

1981

The Watcher in the Woods ●
The Devil and Max Devlin ●
Amy ●
The Fox and the Hound ●
Condorman ●

1982

EPCOT Center opens ●
Night Crossing ●
Tron ● ● ●
Tex ●

1983

Tokyo Disney Resort and Tokyo
Disneyland open in Urayasu, Japan
The Disney Channel launches
Trenchcoat ● *Something* ●
Never ● *Wicked This*
Cry Wolf *Way Comes*

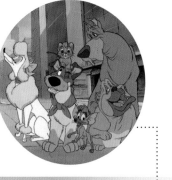

1988

Return to Snowy River ●
Oliver & Company ●
Who Framed Roger Rabbit ★ ● ●

1989

Honey, I Shrunk the Kids ●
Cheetah ●
The Little Mermaid ★ ●

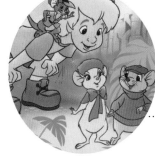

1990

DuckTales: the Movie, ●
Treasure of the Lost Lamp
The Rescuers Down Under ●

1991

White Fang ●
Shipwrecked ●
Wild Hearts Can't Be Broken ●
The Rocketeer ●
Beauty and the Beast ★ ●

1996

Muppet Treasure Island ●
Homeward Bound II: ●
Lost in San Francisco
James and the Giant Peach ● ●
The Hunchback of Notre Dame ●
First Kid ●
D3: The Mighty Ducks ●
101 Dalmatians ●

1997

That Darn Cat ●
Jungle 2 Jungle ●
Hercules ●
George of the Jungle ●
RocketMan ●
Flubber ●
Mr. Magoo ●
Air Bud ●

1998

Meet the Deedles ●
Mulan ●
The Parent Trap ●
I'll Be Home for Christmas ●
A Bug's Life ●
Mighty Joe Young ●

1999

My Favorite Martian ●
Doug's 1st Movie ●
Endurance ●
Tarzan ★ ●
Inspector Gadget ●
The Hand Behind the Mouse: ●
The Ub Iwerks Story
The Straight Story ●
Toy Story 2 ●

2000s and 2010s

While continuing to innovate with technologies such as Disney Digital 3D, the company reached into its own legacy to create new entertainment, including live-action princesses. It also reached out with an official fan club dubbed D23, and added the universes of Marvel and Lucasfilm. With many ambitious projects, including Shanghai Disneyland Park in China, the company built by Walt Disney marches on ... to infinity and beyond!

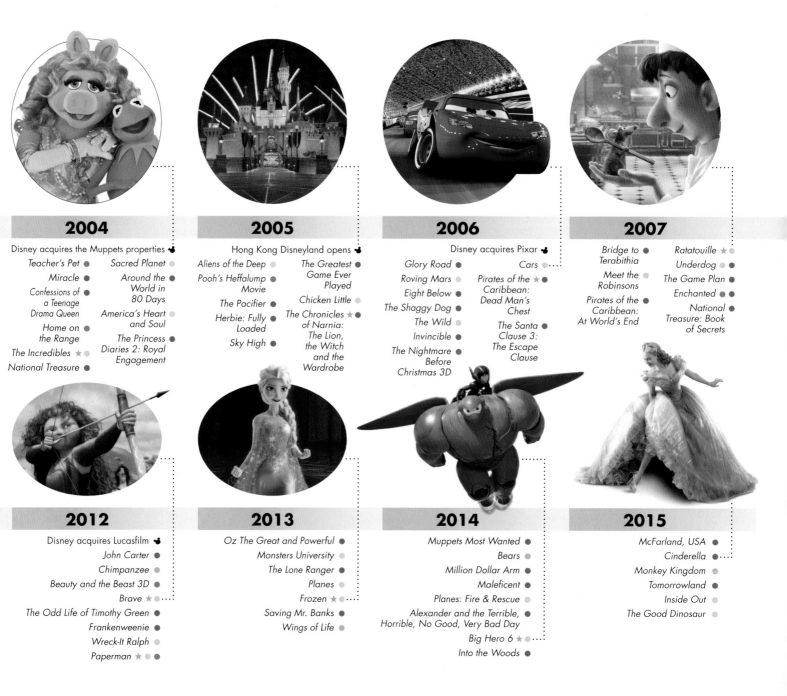

2004

Disney acquires the Muppets properties

- Teacher's Pet
- Miracle
- Confessions of a Teenage Drama Queen
- Home on the Range
- The Incredibles ★
- National Treasure
- Sacred Planet
- Around the World in 80 Days
- America's Heart and Soul
- The Princess Diaries 2: Royal Engagement

2005

Hong Kong Disneyland opens

- Aliens of the Deep
- Pooh's Heffalump Movie
- The Pacifier
- Herbie: Fully Loaded
- Sky High
- The Greatest Game Ever Played
- Chicken Little
- The Chronicles of Narnia: The Lion, the Witch and the Wardrobe ★

2006

Disney acquires Pixar

- Glory Road
- Roving Mars
- Eight Below
- The Shaggy Dog
- The Wild
- Invincible
- The Nightmare Before Christmas 3D
- Cars
- Pirates of the Caribbean: Dead Man's Chest ★
- The Santa Clause 3: The Escape Clause

2007

- Bridge to Terabithia
- Meet the Robinsons
- Pirates of the Caribbean: At World's End
- Ratatouille ★
- Underdog
- The Game Plan
- Enchanted
- National Treasure: Book of Secrets

2012

Disney acquires Lucasfilm

- John Carter
- Chimpanzee
- Beauty and the Beast 3D
- Brave ★
- The Odd Life of Timothy Green
- Frankenweenie
- Wreck-It Ralph
- Paperman ★

2013

- Oz The Great and Powerful
- Monsters University
- The Lone Ranger
- Planes
- Frozen ★
- Saving Mr. Banks
- Wings of Life

2014

- Muppets Most Wanted
- Bears
- Million Dollar Arm
- Maleficent
- Planes: Fire & Rescue
- Alexander and the Terrible, Horrible, No Good, Very Bad Day
- Big Hero 6 ★
- Into the Woods

2015

- McFarland, USA
- Cinderella
- Monkey Kingdom
- Tomorrowland
- Inside Out
- The Good Dinosaur

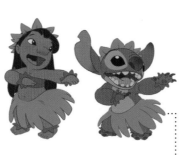

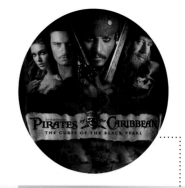

2000

Fantasia/2000 ● ◍
The Tigger Movie ●
Dinosaur ● ◍
Remember the Titans ●
Whispers: An Elephant's Tale ●
102 Dalmatians ●
The Emperor's New Groove ●
Disney's The Kid ●

2001

Recess: School's Out ● ⋯
Atlantis: The Lost Empire ●
The Princess Diaries ●
Max Keeble's Big Move ●
Monsters, Inc. ★ ◍

2002

Snow Dogs ●
Return to Never Land ●
The Rookie ●
Lilo & Stitch ● ⋯
The Country Bears ●
Tuck Everlasting ●
The Santa Clause 2 ●
Treasure Planet ●

2003

The Jungle Book 2 ●
Piglet's Big Movie ●
Ghosts of the Abyss ●
Holes ●
The Lizzie McGuire Movie ●
Finding Nemo ★ ◍
Freaky Friday ●

Pirates of the Caribbean: The Curse of the Black Pearl ●
Brother Bear ●
The Haunted Mansion ●
The Young Black Stallion ●

Copyright © 2015 Disney Enterprises, Inc.
Based on the "Winnie the Pooh" works, by A.A. Milne and E.H. Shepard

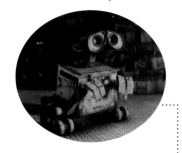

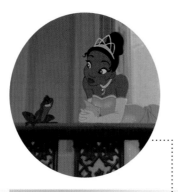

2008

Hannah Montana & Miley Cyrus: Best of Both Worlds Concert ●
College Road Trip ●
The Chronicles of Narnia: Prince Caspian ●
WALL•E ★ ◍
Beverly Hills Chihuahua ●
Morning Light ●
High School Musical 3: Senior Year ●
The Crimson Wing: Mystery of the Flamingos (first released in France) ◍
Bolt ◍
Bedtime Stories ●
Tinker Bell ◍

2009

Disney acquires Marvel ◔
D23 formed ◔
Jonas Brothers: The 3D Concert Experience ●
Race to Witch Mountain ●
Hannah Montana: The Movie ●
Earth ◍
The Boys: The Sherman Brothers' Story ◍
Up ★ ◍
G-Force ◍ ●
Walt & El Grupo ◍
Disney's A Christmas Carol ●
Old Dogs ●
The Princess and the Frog ● ⋯
Tinker Bell and the Lost Treasure ◍

2010

Alice in Wonderland ★ ◍ ●
Waking Sleeping Beauty ◍
Oceans ◍
Prince of Persia: The Sands of Time ●
Toy Story 3 ★ ◍
The Sorcerer's Apprentice ●
Secretariat ●
Tangled ◍ ⋯
Tron: Legacy ● ◍

2011

Mars Needs Moms ◍
African Cats: Kingdom of Courage ◍
Prom ●
Pirates of the Caribbean: On Stranger Tides ●
Cars 2 ◍
Winnie the Pooh ◍ ⋯
The Muppets ★ ●

"Cartoon animation offers a medium of storytelling and visual entertainment which can bring pleasure and information to people of all ages everywhere in the world." WALT DISNEY

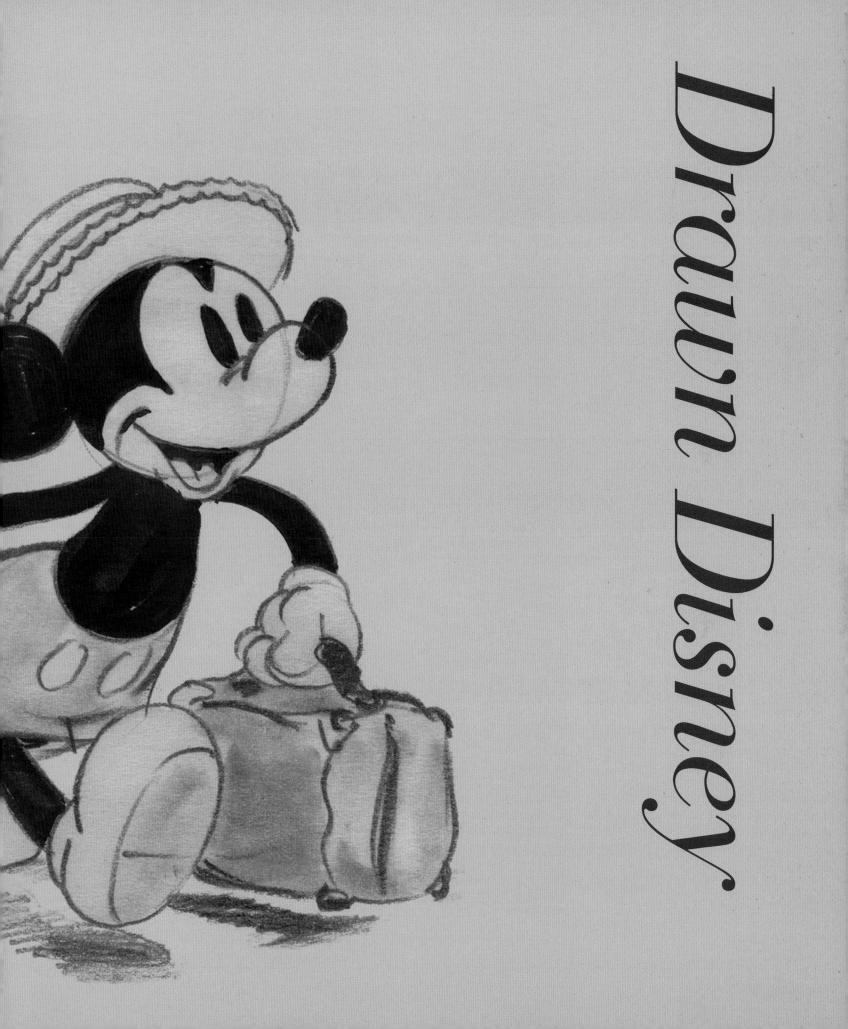

Drawn Disney

Meet Walt

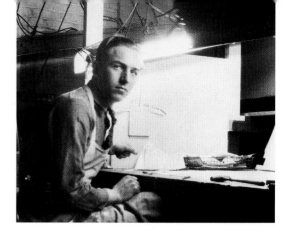

Like Thomas Edison and Charlie Chaplin, Walt had humble beginnings—and grew up to become a genius. Born on December 5, 1901 in Chicago, Illinois, young Walt loved to draw cartoons, dress up in costumes, and entertain. He also made simple drawings that appeared to move as he flipped the pages—his first animation. Walt's captivation with entertainment and showmanship would combine with his love of drawing to form the foundation of his life's work. A restless innovator, Walt Disney would go on to receive hundreds of honors and citations from around the world.

FREELANCE ADVERTISING
Young Walt Disney working at his desk at Kansas City Film Ad, circa 1920.

HIGH SCHOOL CARTOONIST
The young artist made use of his talents in high school, where he drew cartoons for the McKinley High School campus magazine, *The Voice*, in Chicago, Illinois, 1918.

AN EARLY SKETCH
Another example of the young artist's work, Walt drew this lady in his sister Ruth's school book titled "My Golden School Days."

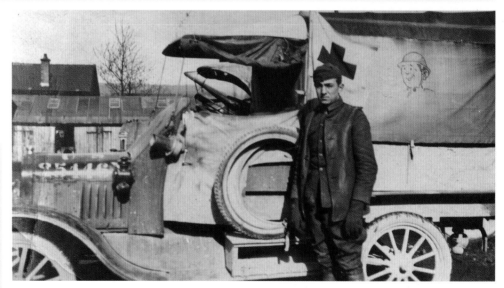

RESIDENT ARTIST
Walt served as a driver in the Red Cross Ambulance Corps in France in the immediate aftermath of World War I, for ten months. He was known as the resident artist and decorated his truck with his comical hand-drawn illustrations.

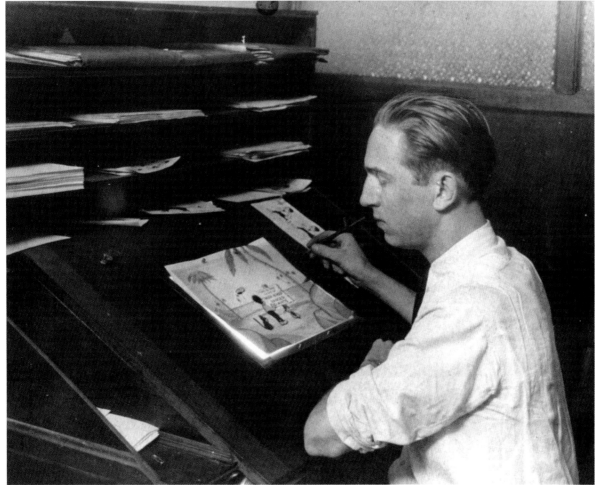

STUDIO SHORTS
Walt in Kansas City in 1922, working on one of the first Laugh-O-grams, *Jack and the Beanstalk*. Walt's goal for his first studio, Laugh-O-gram Films, Inc., was to move beyond "filler" shorts and produce animated films for movie theaters nationwide. What followed was a series of seven modernized cartoon adaptations of famous fairy tales, but sadly the studio went bankrupt.

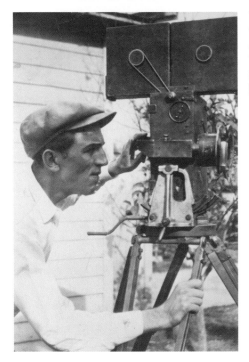

THE DREAM BEGINS
Walt with his first motion picture camera. This photo was taken in Los Angeles shortly after his arrival in 1923.

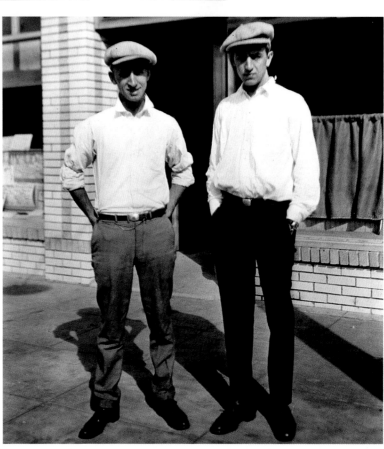

FAMILY AFFAIR
Walt and his brother Roy photographed at Disney Brothers Cartoon Studio on Kingswell Avenue in Los Angeles, 1923. Roy soon thought that one individual should personify the company. From then the studio bore the name Walt Disney.

The Early Years

From Walt's first live-action shorts to a lucky animated rabbit named Oswald, the future looked bright for the Disney brothers.

▲ Alice, played here by Virginia Davis, in Cartoonland, from the pilot *Alice's Wonderland* for the Alice Comedies (1923)

▼ Roy O. Disney (second from left) and Walt (fourth from left) pose with early employees, circa 1926: (l-r) Rollin "Ham" Hamilton, Roy, Hugh Harman, Walt, Margie Gay (second young actress to portray Alice), Rudy Ising, Ub Iwerks, Walker Harman.

By the end of 1923, Walt and Roy, his brother and business partner, had their first official studio—a tiny office, rented for $10 a month at the back of a storefront real estate office at 4651 Kingswell Avenue. They also rented a small space for outdoor shooting and bought a $200 camera. It was, as Walt would often point out, the first animation studio in California. Walt used *Alice's Wonderland*—a pilot film the young cartoonist had produced in Kansas City—to establish a distribution deal for the Alice Comedies, a series of silent animated shorts that put a live-action girl in an animated world.

FIRST PROJECT

Walt animated on several of the first Alice Comedies himself, and directed the live-action scenes. The first of the new Alice Comedies, *Alice's Day at Sea*, was delivered on December 26, 1923. With the Alice Comedies appearing in theaters, Walt invited his colleague from Kansas City, animator Ub Iwerks, to join the new Disney Studio. As he would for the rest of his career, Walt sought talents that were superior to his own, knowing such skills would improve the quality of his films.

ONE LUCKY RABBIT

With Ub Iwerks on board, Walt gave up drawing in June 1924. By late 1926, Universal Pictures asked Disney's distributor Charles Mintz for a new cartoon series starring a rabbit. He turned to Walt, who submitted sketches for a character named Oswald the Lucky Rabbit. The new cartoon

◀ Publicity shot of Walt directing Alice (Margie Gay) for *Alice's Spanish Guitar* (1926) from the Alice Comedies. The series comprised 56 silent films made by Walt between 1924 and 1927.

character seemed to be lucky for Walt—he was popular, even sparking the first Disney merchandise. Oswald's creator felt secure in asking for more money in order to continue to improve both the story and the animation with each new film short. Later, after meeting with Charles Mintz in New York City, the young producer was stunned when Mintz informed him that he had hired all of Walt's animators away, with the exception of Ub Iwerks. Even more stunning was the news that Walt did not own the copyright for Oswald; Universal Studios did. Rather than accept any deals to continue with Oswald under these circumstances, Walt left the character and distributor behind. He was determined to create a new character that would be a greater success than Oswald the Lucky Rabbit.

"My brother Walt and I first went into business together [in 1923]. And he was really, in my opinion, truly a genius—creative, with great determination, singleness of purpose, and drive." ROY O. DISNEY

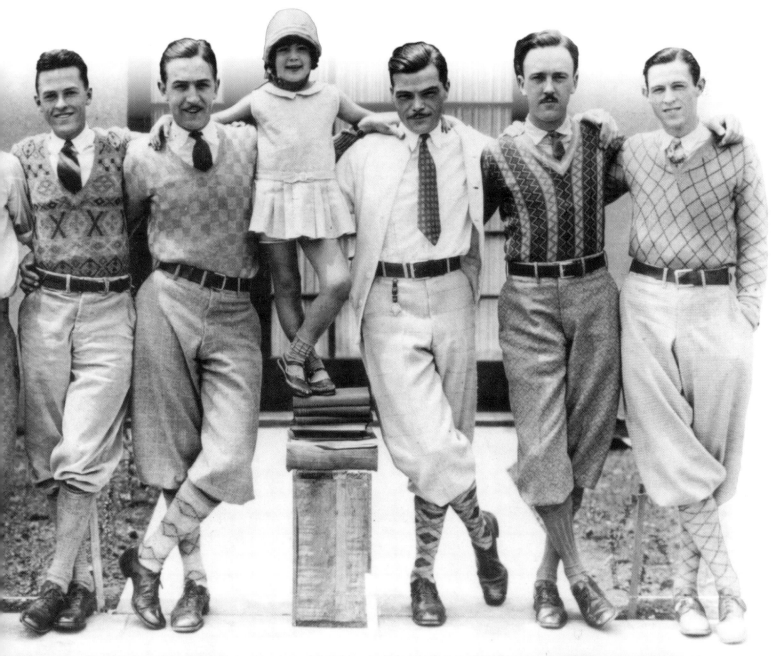

The Mouse who Started it all

Created by Walt Disney and Ub Iwerks, Mickey Mouse defines the Disney brand. As Walt Disney said, "I only hope we don't lose sight of one thing—it all started with a mouse."

▼ The designer of Mickey Mouse, Ub Iwerks. Disney's first animator, Iwerks single-handedly animated the first produced Mickey Mouse cartoon, *Plane Crazy* (1928).

This mini superstar with the outsized ears has caused quite a stir in sight and sounds ever since he was first unveiled in 1928. Walt created his new character on the train ride back to California after finding out he didn't own the copyright for Oswald the Lucky Rabbit. He dreamed up a lively little mouse with big round ears and wanted to name him Mortimer, but Walt's wife Lillian thought the name was too pompous. She suggested Mickey instead.

INSPIRED BY A RABBIT

Walt conferred with his top animator Ub Iwerks, who is credited with Mickey's iconic design. They immediately began work on the first produced Mickey Mouse cartoon, *Plane Crazy*

(1928), in which Mickey emulated the aviation hero Charles "Lucky Lindy" Lindbergh. No distributor would take a chance on this unproven character created by an independent producer. With Mickey Mouse-like resolve— his animators always said Mickey's personality

◄ The most reprinted image in Disney history: Mickey Mouse cheerfully steering a boat in his debut cartoon, *Steamboat Willie*

"When people laugh at Mickey Mouse, it's because he's so human ..."

◄ Story sketch for the "Mickey and the Beanstalk" segment of *Fun and Fancy Free* (1947), Mickey's second feature film appearance

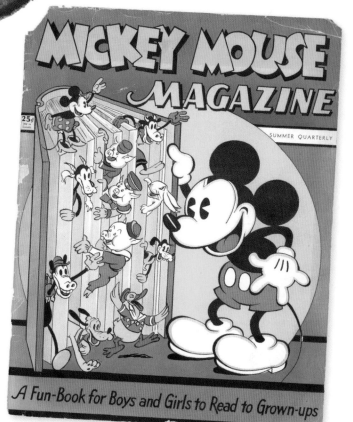

▲ Mickey's popularity extended to newspaper comic strips, comic books, and his own newsstand magazine, *Mickey Mouse Magazine*. It began the summer of 1935 and in October 1935, it became a monthly periodical.

reflected Walt's own—Walt forged into production on another silent Mickey, *The Gallopin' Gaucho*. Meanwhile, the "talkies" era had begun and Walt dropped everything to begin a third Mickey cartoon, *Steamboat Willie* (1928), with music and sound effects, synchronized to Mickey's antics aboard a riverboat. Walt screened *Steamboat Willie* for the New York exhibitors without attracting much interest. However, the manager of the Colony Theatre in New York agreed to screen the film. *Steamboat Willie* was an overwhelming success and Mickey was an overnight sensation.

DISNEY PERSONIFIED

The public clamored for more Mickey cartoons and each film starring the lovable Mouse was a smash hit. Technically and artistically, Mickey Mouse cartoons were far superior to other contemporary cartoons, and competing studios not only struggled to keep up, they also established animation units where none had existed—all to emulate the Mouse. Mickey's cartoons were billed in lights on movie theatre marquees, often above the feature film's title and live-action stars. "What—no Mickey Mouse?" became a national catchphrase signifying

disappointment, as was experienced with a theater program with no Mickey cartoon on the bill. To this day, Mickey Mouse is an internationally beloved star. Besides being the personification of everything Disney, Mickey steadfastly shines as one of the most enduring and endearing characters of our culture and times.

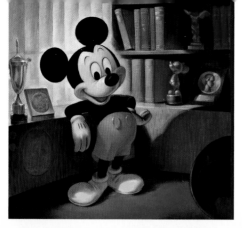

At Walt's request, Disney artist John Hench painted this portrait of Mickey for the Mouse's 25th anniversary in 1953. Hench also painted Mickey's portrait for his 50th, 60th, 70th, and 75th birthdays.

Mickey Mania

Mickey's beaming face is recognized around the globe, and his endearing personality has captured the imagination of generations spanning two centuries.

▶ Reflecting Mickey's sunny personality, this famed "sunburst" title opened most of the Mouse's animated shorts from 1935 onwards.

On November 13, 1978, Mickey became the first animated character to be honored with a star on the Hollywood Walk of Fame

"Mickey was simply a little personality assigned to the purposes of laughter." WALT DISNEY

Mickey's head is made from three circles making him easy to animate and a perfect logo.

Mickey has been the merry master of all media, from cartoons and comics to video games and apps, for eight decades and counting. It's not surprising that Walt Disney was awarded an honorary Academy Award® for the creation of Mickey in 1932, a testament to both Disney's creativity and Mickey's overwhelming popularity. What's behind the Mouse mania that has endured for almost 90 years? For such a modest little fellow, Mickey has a powerful design. Many artists, designers, and commentators have noted the character has one of the most innately attractive graphic designs ever, and the simplified three-circle symbol of Mickey's head-and-ears is an internationally recognized icon.

GLOBAL MEDIA STAR

In addition to the 121 Mickey Mouse theatrically released cartoons, Mickey has also appeared in feature films, like *Fantasia* (1940), which had its world premiere in the same New York theater as *Steamboat Willie* (1928) 12 years earlier. Since Walt Disney was the first Hollywood heavy-hitter to enter the burgeoning medium of television, Mickey was naturally one of TV's earliest stars. Inspired by the Mickey Mouse Clubs of the 1930s— the club met every Saturday for an afternoon of cartoons and games in local theaters—Walt created the *Mickey Mouse Club* television series in 1955. Mickey's evergreen popularity made the show an instant hit. In 1956 viewership was at more than 14 million, with more than one-third of that audience made up of adults. Mickey's timeless cartoons were showcased in the daily Mouse cartoon, with more people seeing them in one day than during their original theatrical releases. But Mickey's talents don't end there. He is also a recording star, with a hit platinum-selling album, *Mickey Mouse Disco*, released in 1979.

MODERN MICKEY

Today, in addition to the computer- animated *Mickey Mouse Clubhouse*, Mickey is spotlighted in the Emmy® Award-winning *Mickey Mouse* series, featuring Mouse cartoons released online, on Disney Channel, and additional formats. These all-new shorts have a slapstick feel of classic Mickey Mouse, combined with contemporary direction and pacing. In 2014, Mickey Mouse received his first Oscar® nomination in nearly 20 years with the groundbreaking hand-drawn CG-animated short, *Get a Horse!* directed by Lauren MacMullan. Whatever the platform on which the happy Mouse pops up, Mickey always remains his audience-pleasing self.

Mickey Mouse Memorabilia

By 1929, Mickey Mouse was a bona fide box-office star, and his public wanted much more Mouse. While it may have seemed only logical to let everyone have their favorite Mouse in their very own house, the Mickey merchandise boom actually started with a chance encounter in a New York hotel lobby. A man asked Walt Disney for permission to produce a Mickey school pencil tablet and the mania for Mouse memorabilia was born. Since that day, Mickey's ear-to-ear smile has appeared on an infinite number of primo products, including umbrellas, soap, and wallpaper.

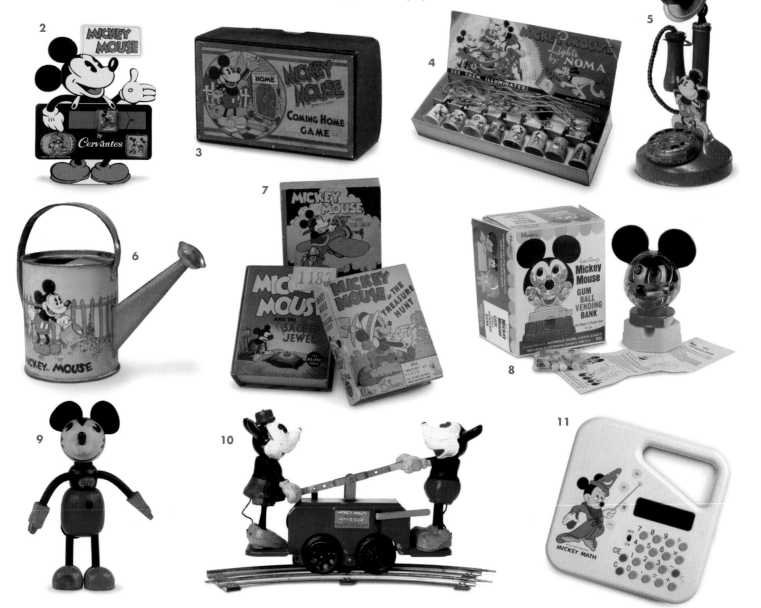

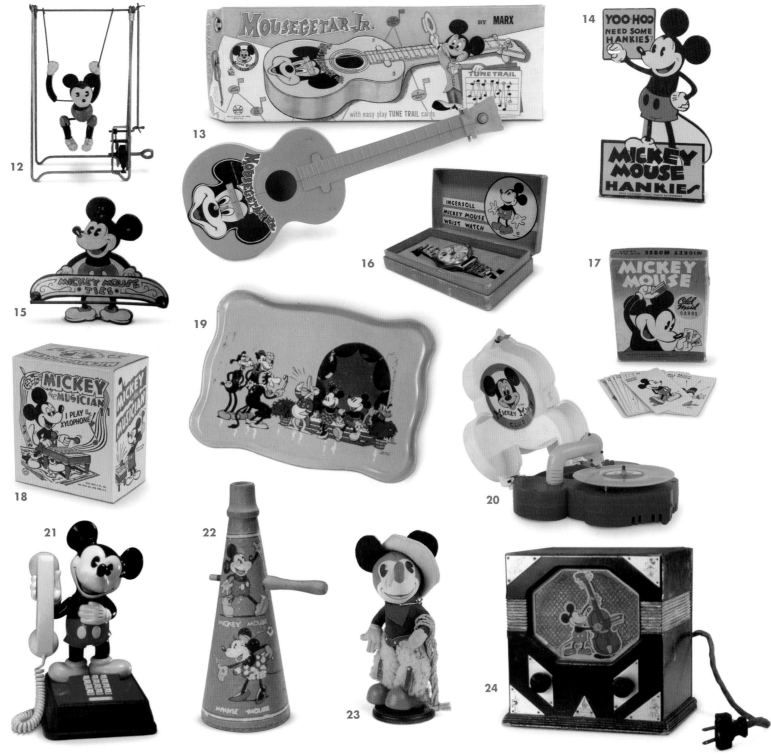

1 Folding chair, Crawford Furniture Mfg. Co. (1934) 2 Belt buckle display, Cervantes, Limited Edition (1976)
3 Coming Home game, Marks Brothers (1930s) 4 Christmas lights, Noma Electric Corp. (1930s) 5 Candlestick phone, N. N. Hill Brass Co. (1930s)
6 Tin watering can, Ohio Art Co. (1930s) 7 Big Little Books, Whitman Publishing Co. (1930s) 8 Gum Ball Vending Bank, Hasbro (1970s)
9 Fun-E-Flex Mickey, Nifty/Flex-E-Flex Toys for George Borgfeldt Corp. (1930s) 10 Handcar, Lionel Corporation (1930s)
11 Mickey Math Calculator, Omron for Alco. (1975) 12 Trapeze, George Borgfeldt Corp. (1930s) 13 Mousegetar Jr., Marx (1960s)
14 Hankies display standee, Hermann Handkerchief Co., Inc. (1930s) 15 Tie bar, D.H. Neumann Co. (1930s) 16 Watch, Ingersoll-Waterbury Co. (1930s)
17 Old Maid card game, Whitman Publishing Co. (1930s) 18 Mickey the Musician, Louis Marx & Co. Inc. (1960s)
19 Tea tray, Ohio Art Co. (1930s) 20 Mickey Mouse Club phonograph (c.1950s) 21 Telephone, American Telecommunications Corp. (1977)
22 Party horns, Marks Brothers Co. of Boston (1930s) 23 Cowboy Mickey Mouse doll, Knickerbocker Toy Co. (1936)
24 Art Deco radio, Emerson Radio and Phonograph Corp. (1934)

▲ Walt Disney's Silly Symphony superstars—Fiddler, Practical, and Fifer Pig—from one of the most popular cartoons ever produced

Silly Symphonies

An orchestration of glittering color, winsome characters, and unforgettable music, the Silly Symphonies raised the art of animation to new and harmonious heights.

"We used [the Silly Symphonies] to test and perfect the color and animation techniques we employed later in full-length feature pictures ..." WALT DISNEY

Scene I
First pig building straw house.

MOVE DOWN TO ABOUT 3/2

use larger FIELD

Scene II
Second pig building house of sticks

SHORTER STICKS?

Scene III
Third pig building house of brick

WOLF PROOF CEMENT WOLF PROOF PAINT WOLF PROOF HOMES

3

T he Silly Symphonies were born of Walt Disney's unending drive to improve and innovate. Mickey Mouse was an overnight sensation, but the ever-imaginative producer was not content to simply ride the coattails of Mickey's popularity. He immediately began thinking of a new series of cartoons that would give him the artistic freedom to create any number of animated personalities, without being tied down to one continuing character.

NEW POSSIBILITIES

Walt's first musical director Carl Stalling, later famed for his compositions for the *Looney Tunes* cartoons, suggested a new series of shorts where music would be the main ingredient. Originally, the shorts were to feature inanimate objects coming to life to the rhythm of the soundtrack melodies, but they soon evolved into something more. The first Silly Symphony—a series title that Walt himself dreamed up—was *The Skeleton Dance* (1929), a one-of-a-kind animated musical unlike anything seen or heard on the screen before. These early mini-musical extravaganzas, such as *Autumn* (1930) and *Mother Goose Melodies* (1931), were well received, but the series really struck the right note with the addition of color. The production of *Flowers and Trees* (1932) coincided with the perfection of the

◀ The three little pigs are a study in contrasts—and contrasting homes of straw, sticks, and bricks—in these story sketches.

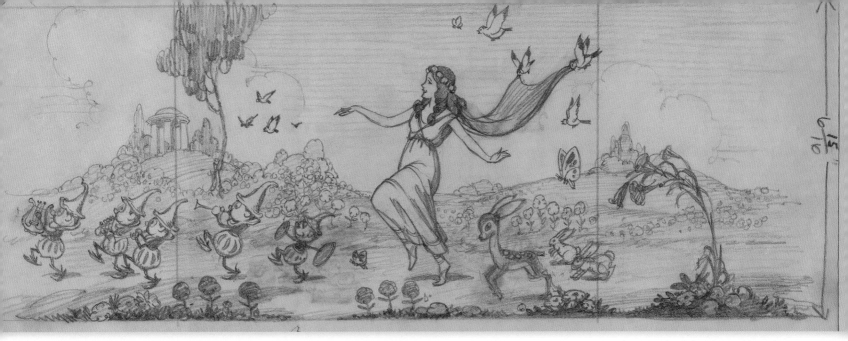

full-color Technicolor® process. Many in Hollywood were uninterested, but Walt was thrilled with the possibilities. At great cost, the completed work on *Flowers and Trees* was scrapped and the film was redone in breathtaking color, winning Walt Disney his first Academy Award®.

AWARD TRIUMPHS

The Silly Symphonies reached a new level of excellence when *Three Little Pigs* (1933) became a phenomenon. Boasting a hit song, "Who's Afraid of the Big Bad Wolf?" and three distinct personalities, whom Walt considered to be a quantum leap in character animation, the short started a mania

matched only by Mickey. Other hits followed, featuring ever more sophisticated music, as in *The Grasshopper and the Ants* (1934), and vibrant new personalities such as the cute little cats who frolicked in *Three Orphan Kittens* (1935), the put-upon pachyderm in *Elmer Elephant* (1936), and the diminutive brave in *Little Hiawatha* (1937). The series dominated the Academy Awards®, winning the Best Animated Short Film Oscar® every year, until the Silly Symphonies were phased out in 1939. Many innovations were introduced and perfected in these special animated shorts, making possible Walt's future animated triumphs.

▲ This story sketch for *The Goddess of Spring* (1934), a precursor for *Snow White*, shows Disney's early attempts at depicting the human form.

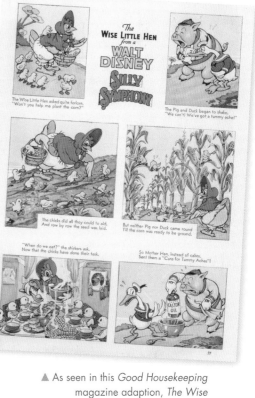

▲ As seen in this *Good Housekeeping* magazine adaption, *The Wise Little* Hen (1934) hatched a new star—Donald Duck.

◀ One of the most elaborate of the Silly Symphonies, *The Old Mill* (1937) was a cinematic tone poem and the first animated film to utilize Disney's revolutionary multiplane camera.

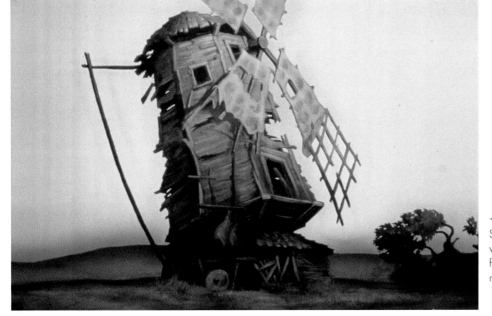

▲ Donald's leading lady is Daisy Duck, seen in this story sketch for the Noah's Ark "Pomp and Circumstance" segment of *Fantasia/2000* (2000)

Mickey's Friends

A popular Mouse like Mickey is never going to be short of friends. Among his delightful pals are a leading lady, a thoughtful mutt, and a clumsy dog.

Mickey Mouse wasn't the only star who made an auspicious debut in *Steamboat Willie* (1928). His cute leading lady Minnie Mouse also made her motion picture bow in the short. Befitting her performance in the first animated film with fully synchronized sound, Minnie is quite a music maker, especially when performing side-by-side with her eternal sweetheart.

A MOUSE'S BEST FRIEND
Mickey's canine costar had an unusual start to his career. The character who would go on to be known as Pluto makes his first appearance in *The Chain Gang* (1930). In *The Picnic* (1930) he was a pet named Rover and belonged to Minnie, not Mickey. Finally, in his third film, *The Moose Hunt* (1931), he became Mickey's pet once and for all, and the pooch was most likely named Pluto the Pup in honor of the then-newly discovered planet. It was master animator Norm Ferguson who made Pluto the thinking man's mutt, and animated the pantomime pooch's thought processes and inner life. Mickey's faithful pal starred in 48 of his own cartoons, but also appeared alongside Mickey and Donald Duck.

FAMOUS FOWL
Donald Duck also had an unusual debut. He was hatched June 9, 1934 with the release of the Silly Symphony, *The Wise Little Hen*. Walt Disney created the Duck character around the distinctive voice performed by Clarence "Ducky" Nash. Donald was such a hit he

◀ Mickey, Donald, and Goofy teamed up as a trio in cartoons like *Moose Hunters* (1937).

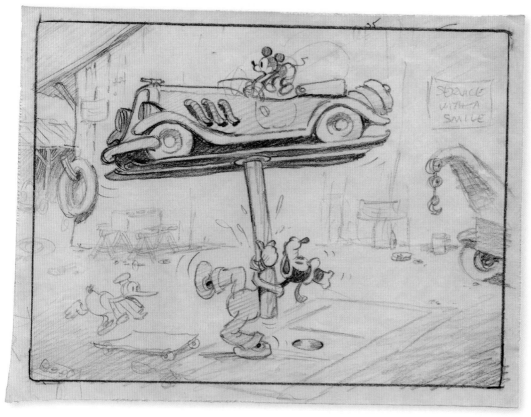

◄ Story sketch from *Mickey's Service Station* (1935), the first cartoon to feature Mickey, Donald, and Goofy working together as a comedy team

▼ Right from the start, Minnie Mouse played, performed, and romanced with her sweetheart and leading man, Mickey

"Mickey is ... an impresario, sharing the spotlight with many new personalities. Some of them ... have gone on to become stars in their own right."

WALT DISNEY

costarred with Mickey in his very next film, *Orphan's Benefit* (1934). Universally acclaimed, the foul-tempered fowl has movie fans in 76 countries, readers who follow his daily comic strip in 100 foreign newspapers, friends who read his comic books published in 47 nations, and television families who watch him in 29 countries.

CLUMSY DOG

Like Donald Duck, the lanky, lovable Goofy started with a voice, or in this case, a laugh. Disney story artist Pinto Colvig came up with a novelty laugh that inspired Walt Disney to create a hayseed hound in *Mickey's Revue* (1932). In addition to aiding and abetting—and occasionally even actually helping—Mickey in his comic-book and comic-strip

adventures, Goofy also starred in 49 screen cartoons of his own, but the Goof also joined Mickey and Donald to form one of the screen's funniest teams.

▼ Mickey's loyal pet Pluto often took a starring role in the Mouse's films, such as *Society Dog Show* (1939).

A Very Rare Toy

Donald Duck was all the rage (apt considering the Duck's explosive temper) from the moment he first waddled onto the silver screen in 1934. By 1935, as a testament to Donald's overnight stardom, Donald Duck soap, ties, handkerchiefs, and other memorabilia filled shop shelves. At first, Donald had a long thin neck and an extended, narrow beak. This early style continued for only a year or two, making the dolls, toys, and other "long-billed" memorabilia manufactured from 1934 to 1936 eagerly sought after collector's items. The ducky products from this period often featured one of the quarrelsome quackster's eyes closed in a wink, indicating Donald's mischievous nature.

ORIGINAL MODEL SHEET
This original model sheet from 1934 was created by character designer Ferdinand Horvath for Donald's first appearance in *The Wise Little Hen* (1934). The style was maintained through 1936 until the character was re-designed with the cuter appearance we know today.

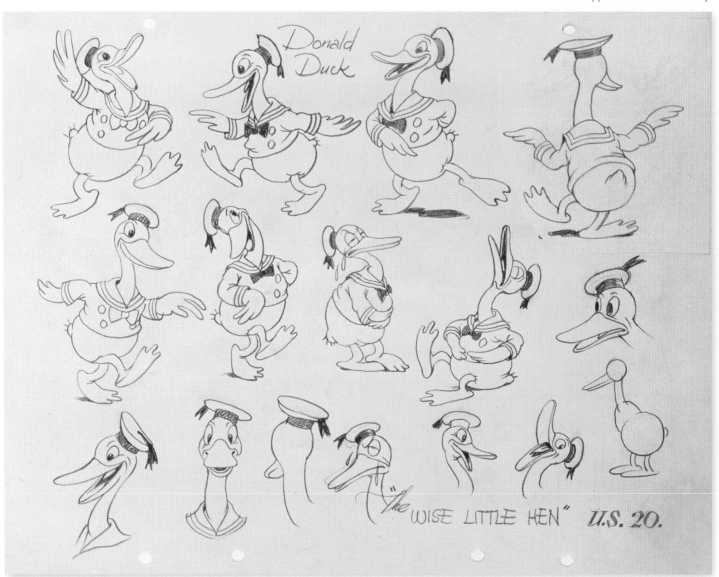

LONG-BILLED DONALD
This wood composition toy is one of many "long-billed" Duck toys made from 1934 through 1936. It was made in Japan for distribution in the United States.

The signature long bill indicates that this is memorabilia from Donald's earliest era.

The long neck is another indication of this sought-after era of Donald merchandise.

The Disney artists gave Donald a sailor suit because they saw him as a rascally little boy—and because Walt pointed out that ducks like water!

Paint captures the red tie and blue blouse of Donald's trademark sailor suit.

Though not visible here, Donald's fingers were originally intended to be feathers, but soon evolved into actual digits.

During this early period, Donald's famous webbed feet were fuller and more pronounced. They were later redesigned to be flatter.

A Cartoon Family

With the huge success of Mickey and his pals, Disney animators were inspired to extend his family and friends.

▲ Mickey's nephews, Morty and Ferdie, frequently appeared in the comics, as in this cover for *Mickey Mouse* #95 (1964), drawn by Paul Murry.

Every star needs supporting players—and the popularity of not only Mickey, but also of Donald Duck and Goofy, inspired Walt and his artists to create a gang of new characters. Before Donald and Goofy, Mickey had two pals that evolved out of the barnyard origins of some of his earliest screen successes. Gossipy Clarabelle Cow first appeared in *The Plowboy* (1929), and quickly evolved to become the confidante of Mickey and especially Minnie. Clarabelle was often paired with Horace Horsecollar,

▼ Donald's frequent companions in adventure: his outrageously wealthy uncle, Scrooge McDuck, and his quick-thinking nephews, Huey, Dewey, and Louie

who started out as an actual barnyard equine, but soon became Mickey's reliable buddy with horse sense. Clarabelle and Horace are on hand when Mickey's friends get together in cartoons such as *Mickey's Birthday Party* (1942), but it is in comics that these small-town friends make most of their neighborly appearances.

MICKEY'S NEPHEWS
Like Clarabelle and Horace, Mickey's nephews, Morty (Mortimer) and Ferdie (Ferdinand) Fieldmouse, had a limited screen career compared to their appearances in comics.

Their only screen appearance was in *Mickey's Steamroller* (1934), but they first featured in the *Mickey Mouse* comic strip on September 18, 1932.

TALES ABOUT A DUCK
Since Mickey had two nephews, Donald had to go one better. Huey, Dewey, and Louie debuted in the *Silly Symphony* Sunday comic feature (which starred Donald at that time) on October 17, 1937. Soon after the dauntless ducklings appeared in their first screen cartoon, *Donald's Nephews* (1938) and have been a part of the quarrelsome quacker's life ever since. Together with Donald's nephews, Scrooge McDuck starred in the *DuckTales* TV series in 1988.

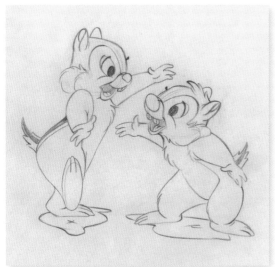

▲ Chip and Dale in a clean-up animation drawing by Bill Justice for *All in a Nutshell* (1949)

"One of the greatest satisfactions in our work here at the studio is the warm relationship that exists within our cartoon family." WALT DISNEY

The "richest duck in the world" was first introduced as a foil for Donald in a 1947 comic book story, "Christmas on Bear Mountain." A perfect sparring partner for Donald, the miserly mallard was also a veritable gold mine of comedy and excitement. In many comic-book escapades, Uncle Scrooge, Donald, and the nephews form an intrepid band of globetrotting adventurers. Though they first appeared with Mickey and Pluto in 1943, Chip and Dale became the perfect irritants for Donald Duck. The chipmunks appeared in 24 theatrical cartoons and starred in their own TV series *Chip 'n' Dale's Rescue Rangers*, that premiered in 1989.

▲ Two of Mickey's earliest and most comical cohorts, Clarabelle Cow and Horace Horsecollar, in a story sketch for *The Beach Party* (1931)

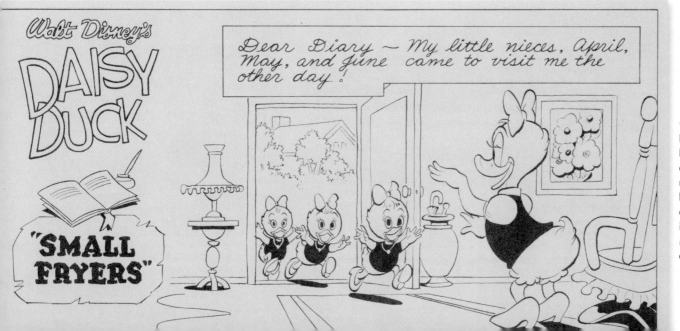

◀ Counterparts to Huey, Dewey, and Louie, April, May, and June are the nieces of Daisy Duck, seen here in a story from a 1961 issue of *Daisy Duck's Diary* comic book, drawn by Carl Barks.

The Fairest One of All

With the success of Mickey Mouse and the *Silly Symphonies*, Walt set out to create an entirely new form of cinema—the feature-length animated film.

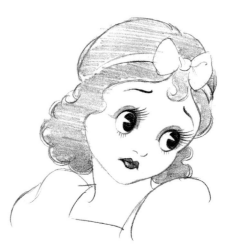

▲ Early concept art explored different designs for Disney's first princess.

As successful as Walt's animated shorts were, they didn't artistically satisfy him for long. In deciding to produce an animated feature, he envisioned not just a long "cartoon," but also an entertainment experience that would surpass what even the finest live-action motion picture could achieve. With the romance of Snow White and the Prince, the menace of the evil Queen, and the sympathetic, comical Dwarfs, *Snow White and the Seven Dwarfs* (1937) was, Walt believed, the perfect story. The human characters presented the animators with their greatest challenge. As Disney artist Woolie Reitherman later pointed out, no one at Disney had ever animated a realistic girl, but Walt was determined to create a believable fairy tale princess.

He pioneered a landmark method for training and preparing his animators by sending them to art classes to study human form and movement. He also hired artists schooled in traditional painting and sculpture. The artists continually sought ways to bring the princess to life: a subtle but effective touch is the rosy glow on Snow White's cheeks, which was real rouge applied by the ink-and-paint artists.

DRAWING DWARFS

Walt set out to establish his Dwarfs as seven distinct, vivid characters. The filmmakers spent hours discussing everything about the Dwarfs—how they would move and act, and even how they would move their hands. The animators managed to convey personality and attitude just through the shape of the body and posture. Dopey was the biggest challenge for the animators. At first the character didn't have a suitable voice or even a name. Finally, animator Fred Moore drew the seventh Dwarf with the simple, childlike appeal Walt wanted. Walt himself chose the endearing name "Dopey" and made the decision that he wouldn't speak at all.

MOVIE MAGIC

Walt and his staff just met their deadline of Christmas 1937 and two prints of the completed *Snow White and the Seven Dwarfs* were delivered to the theater mere hours before the premiere. After four years

▲ In the original Brothers Grimm fairy tale, the Dwarfs were anonymous figures, but Walt gave each of his Dwarfs a name that would explain his personality: (l-r) Sneezy, Dopey, Bashful, Happy, Sleepy, Grumpy, and the leader, Doc.

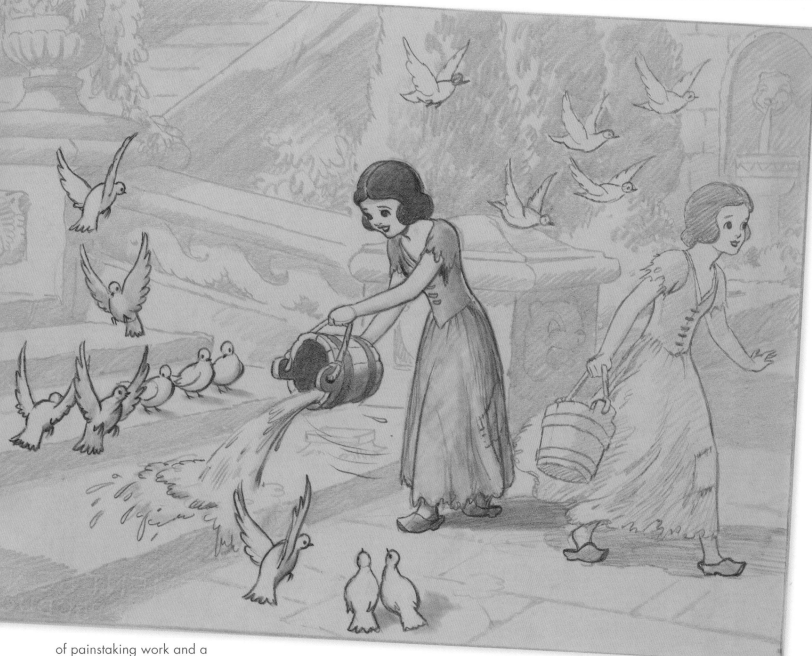

of painstaking work and a then record-shattering $1.5 million budget, Disney's masterpiece was unveiled on December 21, 1937. Critics raved and audiences flocked to see *Snow White*, making it the top box-office hit up until that time. Generally regarded as one of the most popular motion pictures ever produced, *Snow White* was a dream come true for Walt Disney and audiences everywhere.

▲ Through story sketches such as this one, Walt and his artists strove to create a character audiences would care about.

"Of all the characters in the fairy tales I loved Snow White the best, and when I planned my first full-length feature, she inevitably was the heroine." WALT DISNEY

The enchanting final scenes of *Snow White and the Seven Dwarfs* include all the necessary elements for "happy ever after": a handsome prince, true love's kiss, a magnificent castle, and the triumph of good over evil. Walt Disney had been convinced that the magic and romance of *Snow White and the Seven Dwarfs* made it the perfect story, and he was not wrong. Each of these elements would continue to appear in many successsful Disney movies for decades to come.

A Sumptuous Epic

▲ Watercolor pre-production painting by Gustaf Tenggren featuring early designs of the kindly Geppetto and the magical Blue Fairy

▼ Watercolor pre-production painting of the Italian village setting by Gustaf Tenggren

Pinocchio weaves the tale of a little wooden boy who comes to life in a wondrously wrought world. At the time of its release, it was the most elaborate animated movie ever made.

With *Pinocchio* (1940), Walt Disney and his artists set out to surpass the success of *Snow White and the Seven Dwarfs* and in so doing they created what many consider to be the ultimate in the art of animation. The quaint storybook setting inspired much intricate detail in this film's lavish production design, from the ornate clocks and toys in Geppetto's workshop right down to the cobblestones in the crooked streets of Pinocchio's village. Cost was no object as Walt poured a sizable portion of the profits from *Snow White* into this new movie. The visionary filmmaker sought an unprecedented level of animated extravagance as Albert Hurter, Gustaf Tenggren, and other celebrated masters of fantasy created the intricate visual style for *Pinocchio*, with an

emphasis on old world atmosphere. Sculptors crafted three-dimensional models of the characters and many of the props, including the Pleasure Island stagecoach, Stromboli's birdcage, and the ribcage of Monstro the whale.

A REAL BOY AND HIS CONSCIENCE

Such was Walt's tireless quest for perfection that he discarded six months of animation and story work because he felt the burgeoning project lacked emotion and warmth. The main problem was Pinocchio himself. Reflecting the character as portrayed in the original book by Carlo Collodi, Disney's first version of the wooden puppet was a sticklike and unsympathetic delinquent with hands like paddles and a cocky personality. In February 1939, animator Milt Kahl designed a cute and rounded character—more an innocent little boy than a marionette. Once the lovable child was drawn it was a simple matter to add the wooden joints and nails that made him a puppet. Walt knew that a guileless main character—literally "born yesterday," thanks to the Blue Fairy's magic—needed a guide, and so the master storyteller took a talking cricket (squashed in the original book by the ill-tempered puppet) and made him Pinocchio's conscience. Walt's directive to animator Ward Kimball was to design a cute cricket named

▲ Final frame showing the little wooden boy and his cricket conscience

Jiminy. After 14 or so different versions, the artist finally eliminated all insect appendages and came up with a tiny, bald, man-like character, wearing a tailcoat suggesting folded wings and with two hairs evocative of antennae. Today, with its endearing characters and sumptuous settings, the movie is still considered by many to be the pinnacle of Disney animation.

"... technically and artistically [Pinocchio] was superior. It indicated that we had grown considerably as craftsmen ..." WALT DISNEY

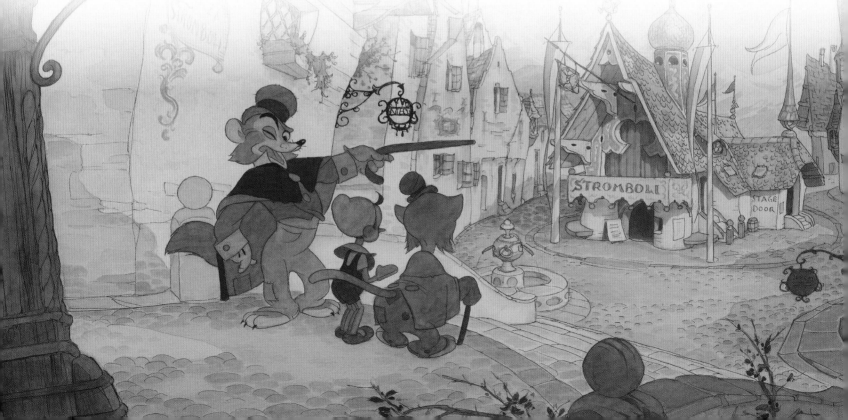

PUBLICITY PUPPET
Created to be a real working puppet, this Pinocchio marionette could be articulated by Disney artists in publicity photos using some of the techniques taught them by model maker Bob Jones, who was also a puppeteer.

Disney's Ink and Paint artists applied authentic colors to the Pinocchio puppet's face.

Skilled puppeteer Bob Jones helped determine exactly where to place the strings, ensuring that the marionette could be moved in a myriad of actions.

A screen-accurate costume was tailored for the publicity puppet.

As real as a marionette in any puppet show, Pinocchio had wooden joints in his arms and legs that allowed him to wave, walk, and dance.

A Marionette Discovered

In creating *Pinocchio*, Walt wanted his artists to capture the movement of an actual wooden puppet. Character Model Department artists Wah Ming Chang, Charles Cristadoro, and Bob Jones crafted a 3D model of the marionette movie star. Jones was a skilled puppeteer and trained the directing animator Frank Thomas to properly manipulate a marionette.

Jones also created a fully functional Pinocchio puppet to help publicize the new film. In 2003, the marionette was discovered in near-perfect condition in a homemade plywood cabinet—covered over the years by telephone cables—built into the basement at Walt Disney Studios in Burbank. Today the priceless figure has a new home in Disney's Animation Research Library.

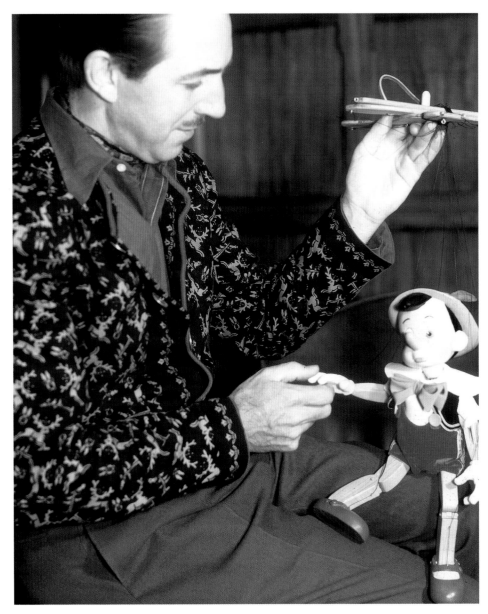

WALT AND PINOCCHIO
Just prior to the premiere of *Pinocchio* in 1940, Walt Disney put the working marionette crafted by model maker Bob Jones through its paces for the publicity cameras. For many years, this photograph was the only evidence that the puppet had existed.

▲ Mickey Mouse scampers up to the podium to congratulate conductor Leopold Stokowski.

A Symphony in Sight and Sound

Classic animation and classical music combine to form *Fantasia*, a spellbinding motion picture of timeless artistry.

A sight-and-sound celebration of music and artistry, *Fantasia* (1940) began in late 1937 with a chance meeting at a Beverly Hills restaurant between Walt and famed conductor Leopold Stokowski. When Walt mentioned that he was considering Dukas' "The Sorcerer's Apprentice" as a deluxe short to star Mickey Mouse, Stokowski offered to conduct the music. The collaboration between these two creative giants struck the right chord and the ambitious short soon evolved into

an entire feature consisting of classical pieces as interpreted by the Disney artists. The project was known as the "Concert Feature" until Stokowski, keeping in mind Walt's vision of great music and visual fantasy, suggested the title "Fantasia," literally meaning "an unconventional music piece."

INNOVATIVE ANIMATION

Walt and his artists met regularly with Stokowski and listened to the world's most acclaimed classical music, eventually selecting seven additional pieces. From innovative abstraction in "Toccata and Fugue in D Minor" to the hilarious corps de ballet of hippos and elephants in Ponchielli's "The Dance of the Hours," *Fantasia* overflows with unsurpassed artistry. In "The Nutcracker Suite" by Tchaikovsky, the comical mushrooms from the Chinese Dance steal the show from twirling flowers and dancing thistles. "Pastoral Symphony" is an interpretation of life in mythical ancient Greece. It features centaurs frolicking in the shadow of Mount Olympus and unicorns, perfect subjects for Disney animation's unique ability to bring anything to life. Walt made a bold choice selecting

▶ *Fantasia* debuted in 1940 at the Broadway Theatre, a mere twelve years after *Steamboat Willie* premiered there in 1928.

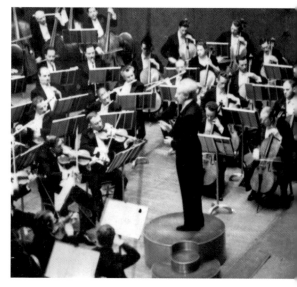

▲ Stokowski conducts the Philadelphia Orchestra playing the *Fantasia* score at Philadelphia's acoustically excellent Academy of Music.

Stravinsky's "Rite of Spring." For the innovative impresario, the avant-garde composition inspired visions of nothing less than the formation of the earth and the coming of dinosaurs. The Disney animation effects artists animated both the real and the fantastical—bubbling lava, delicate sprites, and intricate snowflakes. In the climatic combination of Moussorgsky's "Night on Bald Mountain" and Schubert's "Ave Maria," there are creeping shadows and ghostly specters, as well as glowing candles in a mist-filled forest.

INTO THE FUTURE

This magnificent animated feature was honored with a special Academy Award® for its sound, which recognized *Fantasia* as a work that widened the scope of the motion picture as an art form. Walt had intended to turn *Fantasia* into an ongoing event, re-releasing it every year with new segments. His vision was finally realized in late 1999 with *Fantasia/2000*, a spectacular follow-up spearheaded by Walt's nephew, Roy E. Disney.

▲ *Fantasia* used new techniques, including special paints and mechanical devices, to create worlds like the undersea realm in "The Nutcracker Suite."

"In a profession that has been an unending voyage of discovery in the realms of color, sound, and motion, Fantasia represents our most exciting adventure." WALT DISNEY

▶ The Disney artists studied prima ballerinas to create "The Dance of the Hours" concept art, including this study of dancing hippos and elephants.

Little Elephant, Big Heart

One of Walt's most beloved animated features, *Dumbo* is the heartwarming tale of the world's one and only flying elephant.

O ne day in 1940, Walt Disney stopped Ward Kimball in the Studio parking lot to tell him the story of an outcast baby elephant with oversized ears— and the animator immediately knew that the simple story had great cartoon heart, held together with the great fantasy of a flying elephant. To create the colorful circus backdrop, Walt turned to big-top aficionados Bill Peet (story artist) and Herb Ryman (pre-production artist) who had both painted circus scenes. All the *Dumbo* (1941) artists went on a field trip to the celebrated Cole Bros. Circus where they studied the colorful performers and fabulous animals.

▲ The circus provides a vibrant setting for *Dumbo*.

▶ Dumbo takes flight with Timothy along for the ride.

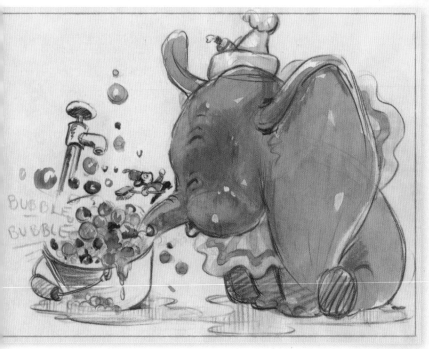

▲ Story sketch of Dumbo and his sidekick Timothy from 1941

BUBBLE BUBBLE

CREATING CUTENESS
Animator John Lounsbery was the first to draw the eponymous big-eared elephant with caricatured human baby-like features. Many were surprised when Walt assigned Bill Tytla as the baby pachyderm's directing animator, as Bill was best known for animating powerful characters such as the demonic Chernabog in *Fantasia*. Bill shut himself in his office for two weeks and emerged with the charming little character, whose sincere expressions and mannerisms the animator had observed in his own uninhibited two-year-old son.

A CHATTY SIDEKICK
To guide the oppressed Dumbo through his trials and tribulations, the Disney artists came up with the delightful conceit of a mouse—traditionally seen as an elephant's enemy—as Dumbo's best pal. The chatty rodent—a circus

show mouse called Timothy—talked enough for both himself and his voiceless friend. The Disney artists had trouble finding the perfect voice for Timothy until Walt advised them to simply look for a voice that made them laugh. The filmmakers cast Hollywood character actor Ed Brophy, well-known for playing comical crooks, who also served as the real-life model for tough but tenderhearted Timothy.

A TRUE TRIUMPH

One of the film's highlights is the brilliantly conceived and innovative "Pink Elephants on Parade" sequence. Years ahead of its time in color, form, and surreal imagery, this musical number imaginatively employed the unbounded

◀ Pastels and black construction paper "Pink Elephants on Parade" story sketch from 1941

"Dumbo was a fun picture to make and the result is a fun picture to watch." WALT DISNEY

nature of the art of animation in visualizing Dumbo's bizarre hallucinations—for example, an elephant entirely made from heads and one made from nothing but trunks. Produced in the remarkably short time of only a year and a half, *Dumbo* reflected the confidence Walt and his entire staff felt in this delightful project. The master storyteller felt the joy radiating from the film was a reflection of the happiness he and his artists experienced in creating it.

▼The colorful Casey Jr. circus train transporting Dumbo and company

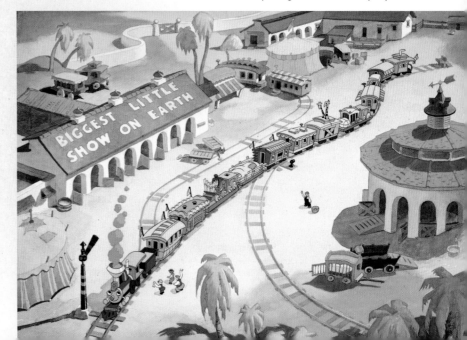

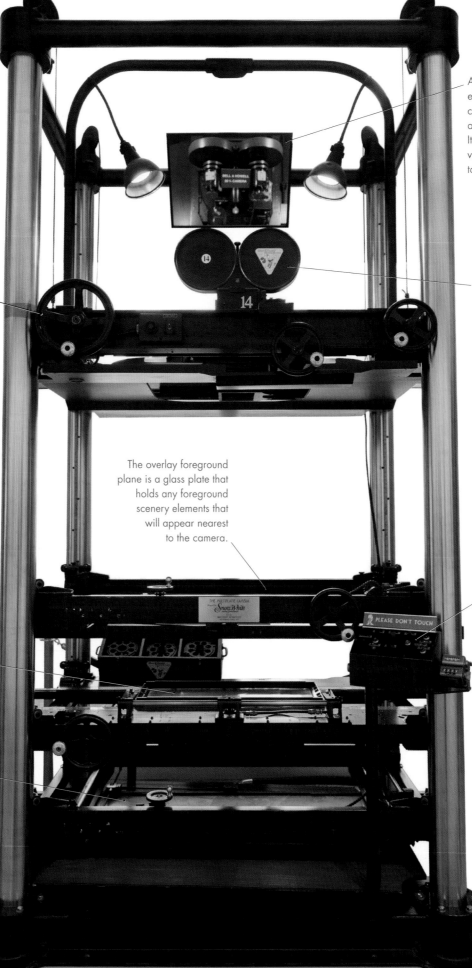

MULTIPLANE CAMERA
Disney's magical multiplane camera has a place of honor in the lobby of the Frank G. Wells Building, right next to the Walt Disney Archives. Though no longer used, this iconic artifact was one of the most important tools of the art of animation.

The camera motor drive raises or lowers the camera carriage. The wheels can be used for manual adjustments.

The overlay foreground plane is a glass plate that holds any foreground scenery elements that will appear nearest to the camera.

This contact plane or animation level is where character animation would be placed.

The lower background plane holds the final painting that serves as a backdrop for all the other planes.

A mirror tops this elaborate animation camera crane to assist the technicians. It enabled the operator to view the (film) magazine take-up wheels.

The camera, moved up and down by the camera carriage, points down through the multiple levels of animation backgrounds.

The control box operates the camera shutter, the movements of the various planes, and the lights that illuminate the art so it may be photographed.

The Marvelous Multiplane

Fantastical Disney environments such as *Bambi*'s idyllic forest or *Pinocchio*'s quaint village took on a new level of reality thanks to the wizardry of the multiplane camera. Under the guidance of Disney technical expert Bill Garity, a department of 18 skilled engineers invented this 14-ft (4.3-m) high crane that allowed background, middle distance, and foreground objects (painted in oil on large planes of glass or, for the bottom level, masonite) to be placed at different levels under the camera lens. It was developed for *Snow White and the Seven Dwarfs* but wasn't ready in time to be used exclusively. The multiplane camera was first used in the Academy Award®-winning Silly Symphony, *The Old Mill* (1937). The "marvelous multiplane" earned its creators a special Academy Award® in the Scientific and Technical category.

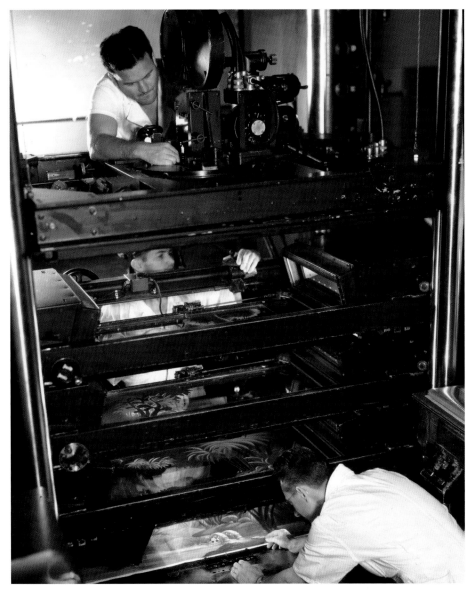

LOADING THE LAYERS
Disney Studio camera operators at work with the multiplane camera crane, 1940s. The multiplane camera required five to six technicians to operate. Each of the multiplane scenes took from two to three weeks to plan, involving many different elements from perspective to lighting.

Animal Artistry

The dramatic story and gentle animal characters of *Bambi* challenged Walt Disney and his artists to take the art of animation to breathtaking new heights of wonder and beauty.

▲ Concept art by Tyrus Wong from 1942

▼ Animal artist Rico Lebrun guides *Bambi* artists as they sketch a live deer

Adapted from Felix Salten's novel, *Bambi: A Life in the Woods*, Walt Disney's sublime animated feature tells the story of a young deer's coming of age with his friends, Thumper the rabbit and Flower the skunk. When *Bambi* (1942) development began in 1936, Walt started to prepare a team of hand-selected artists who would ultimately spend six years working on the film. The ever-imaginative impresario brought in expert animal draftsman Rico Lebrun to train the *Bambi* artists in animal anatomy and locomotion. A pair of four-month-old fawns was brought to live at the Studio for the animators to study. Additional creatures, including birds, squirrels, chipmunks, and rabbits, also served as live models.

VISUAL POETRY

To create a realistic yet stylized forest environment for *Bambi*, Walt enlisted the talents of conceptual artist Tyrus Wong. Wong created hundreds of subtle and evocative inspirational sketches that suggested moods and themes. Walt recognized that Wong's poetic style had a great influence throughout the film especially within staging, backgrounds, and color imagery. He brought a visually poetic sensibility to the film's art direction with his impressionistic paintings and styling sketches, suggesting the mood and

"There was a need for subtlety in our animation and the need for a more lifelike type of animation."

WALT DISNEY

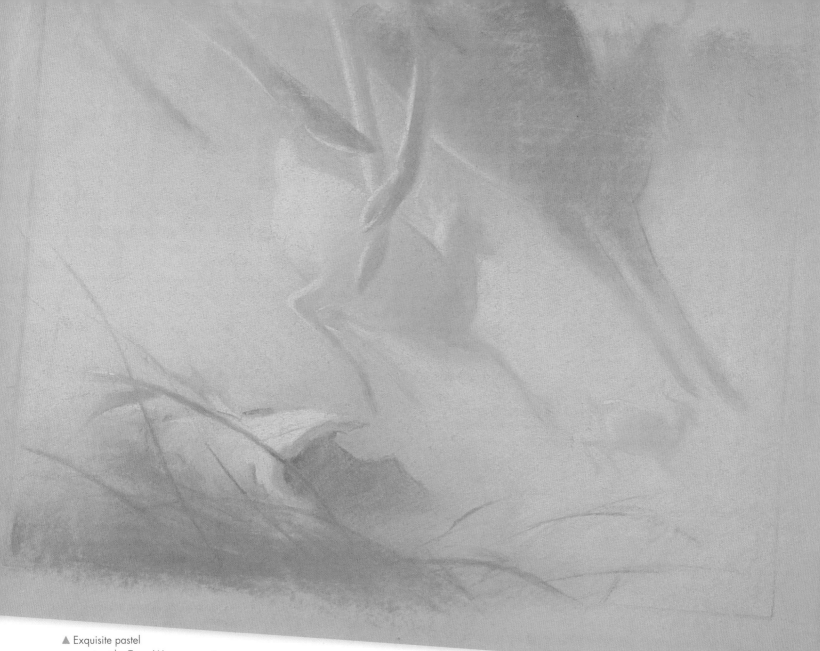

▲ Exquisite pastel concept art by Tyrus Wong suggests the look and tone of the movie.

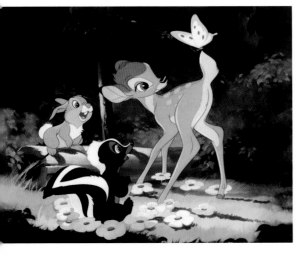

▲ Final frame from the movie with Bambi, Flower, and Thumper in the forest

color of the setting rather than elaborate detail. Wong's goal was to create the atmosphere of the forest.

HEARTWARMING CHARACTERS

Two of *Bambi's* most beloved stars were not in the original book. Flower the skunk was introduced into the movie by Walt during an early story conference. Thumper was originally to be only one of the children of a central character named Mr. Hare. However, Thumper's role as Bambi's best friend kept expanding and the storyline was adapted to fit the appeal of this emerging character. The young rabbit's personality really took off when four-year-old Peter Behn was cast as the character's voice. The young voice actor's unaffected acting helped to turn the enthusiastic rabbit into a scene-stealing star. Thumper soon not only displaced Mr. Hare, but also became the young deer's guide to the natural wonders of the forest, taking over the role from Bambi's mother. Walt Disney felt the personalities in *Bambi* were, as he put it, "pure gold." According to two of the film's supervising animators, Frank Thomas and Ollie Johnston, *Bambi* was Walt's favorite of all his films.

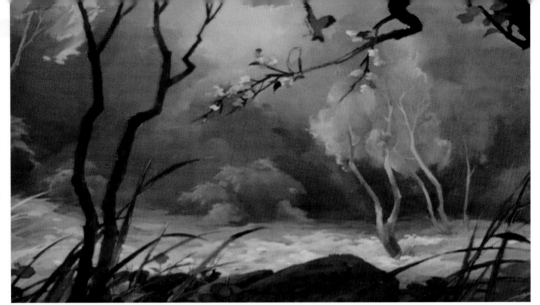

THE FINISHED SCENE
From the completed film:
Note the birds landing
on the branch. The birds
and the slender tree on
the left are not part of
the painting below as
they were painted on
separate pieces of glass
as foreground planes.

BAMBI ARTWORK ON GLASS
The control, restraint, and subtle artistry
of this masterful painting are all the more
remarkable considering it is painted on glass.

In keeping with the atmospheric art direction of *Bambi*—
inspired by Tyrus Wong's impressionistic pastels—
details are suggested rather than rendered in detail.

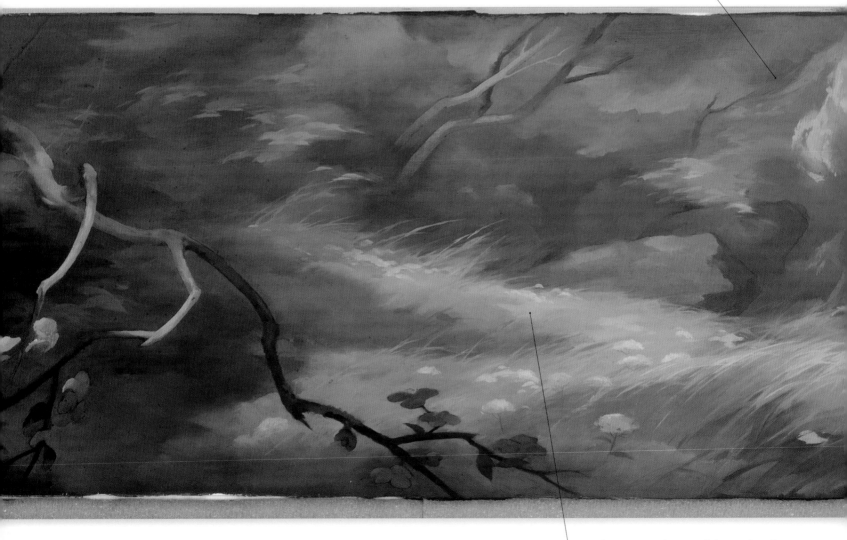

More than just an indication of sky, patches of
light are used in background paintings to direct
the viewer's eye to the animated action.

A True Treasure

The multiplane camera was an important tool in expanding Walt Disney's cinematic storytelling vocabulary. Very few of the fragile multiplane backgrounds survive, so this one, showing the majestic forest in *Bambi* (1942), is one of the most precious treasures in Disney's Animation Research Library. There are multiplane shots throughout *Bambi*, but perhaps one of the most effective is a lengthy pan during the "Let's Sing a Gay Little Spring Song" number. It follows two blue jays as they fly through a springtime clearing to land on a blossoming branch.

While being photographed, the various multiplane levels move one-hundredth of an inch at a time. This pan stopped on this tree branch, the destination of the in-flight birds.

The backs of the glass planes were painted black to prevent light from the lower levels of the setup showing through the upper painting and spoiling the illusion.

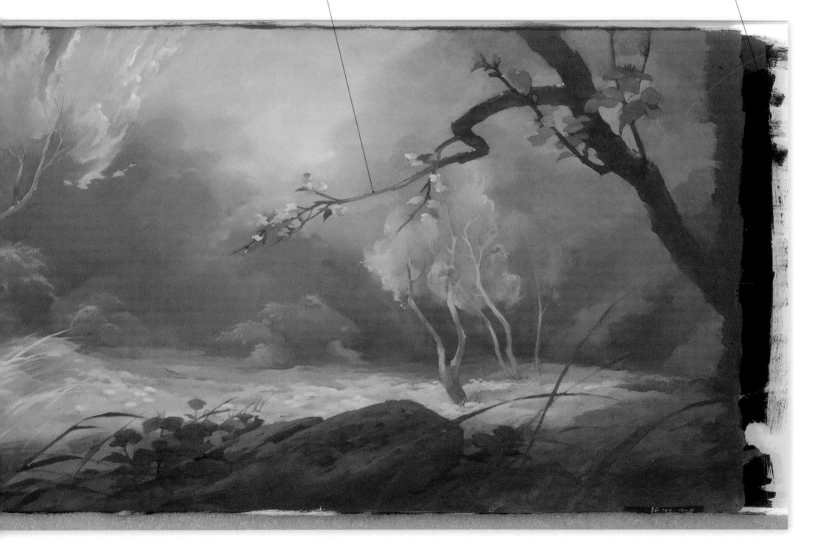

A Rags to Riches Princess

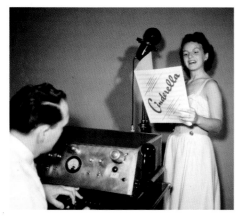

▲ Ilene Woods, the voice of Cinderella, rehearses before a recording session.

Cinderella (1950) proves that hope and kindness triumph over evil.

From the moment Cinderella awakens in her attic room and sings to her adoring animal friends, the lonely scullery maid wins hearts with her grace and kindness. Cinderella is soft-spoken and gentle, but there's more to her than first meets the eye. Despite the humiliating treatment she receives from her jealous stepsisters and evil stepmother, Cinderella is anything but weak-willed and dares to stand up to her stepmother, insisting that she, too, should attend the royal ball.

▶ Clean-up drawing of Cinderella in her ball gown from a scene by Marc Davis

"Even though Cinderella had her sad moments, she still stood strong all the way through." MARC DAVIS

▼ Ethereal concept painting conveys the fairy-tale magic of *Cinderella*

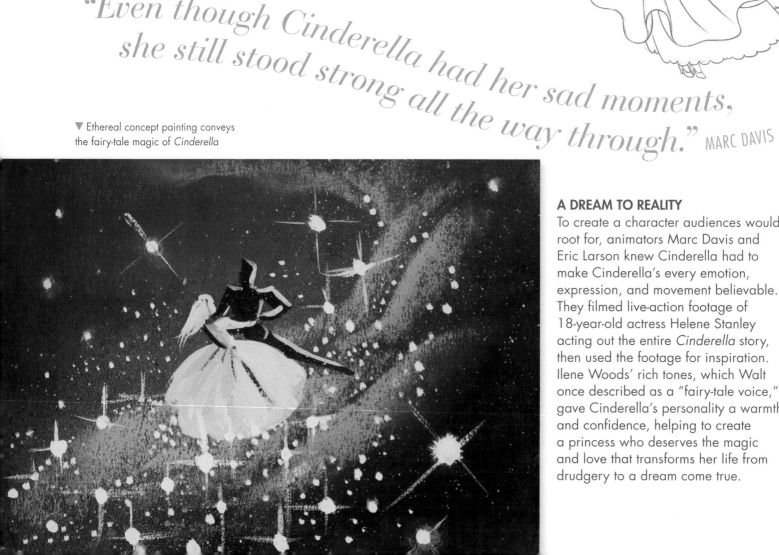

A DREAM TO REALITY

To create a character audiences would root for, animators Marc Davis and Eric Larson knew Cinderella had to make Cinderella's every emotion, expression, and movement believable. They filmed live-action footage of 18-year-old actress Helene Stanley acting out the entire *Cinderella* story, then used the footage for inspiration. Ilene Woods' rich tones, which Walt once described as a "fairy-tale voice," gave Cinderella's personality a warmth and confidence, helping to create a princess who deserves the magic and love that transforms her life from drudgery to a dream come true.

The Secret Princess

In *Sleeping Beauty* (1959), Disney animation brings the secret princess, with her subtle style and grace, to life.

▲ Aurora's beautiful singing voice captures the attention of Prince Phillip and the pair instantly fall in love, as seen in this cel setup.

"From the time I started making motion pictures I dreamed of bringing Sleeping Beauty to life through ... animation."

WALT DISNEY

Cursed at birth by the wicked fairy Maleficent, Princess Aurora is renamed Briar Rose and hidden in the woods by the three good fairies until her 16th birthday. Character designer Tom Oreb based Aurora's style on that of artist Eyvind Earle's medieval-inspired backgrounds, using strong vertical lines for both her peasant clothes and her pink gown, and he created stylized swirls for her hair. The willowy beauty of movie star Audrey Hepburn also provided inspiration for Aurora's elegant poise. Tall, slender, and lithe, the princess moves with a refined grace, thanks to the talents of animator Marc Davis.

SWEET SINGING VOICE
Aurora is given the "gift of song" at birth, so her dulcet voice was an integral part of her personality. Encouraged by Walt Disney to "paint with her voice," singer Mary Costa helped bring the secret princess's personality to life. Her graceful movements, elegant design, and nuanced emotions, make audiences feel as if they, too, have met Aurora "once upon a dream."

▼ Actress Helene Stanley portrayed Aurora in live-action reference footage for the animators (left to right: Marc Davis, John Lounsbery and Milt Kahl).

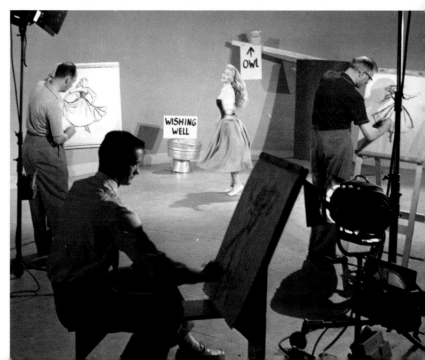

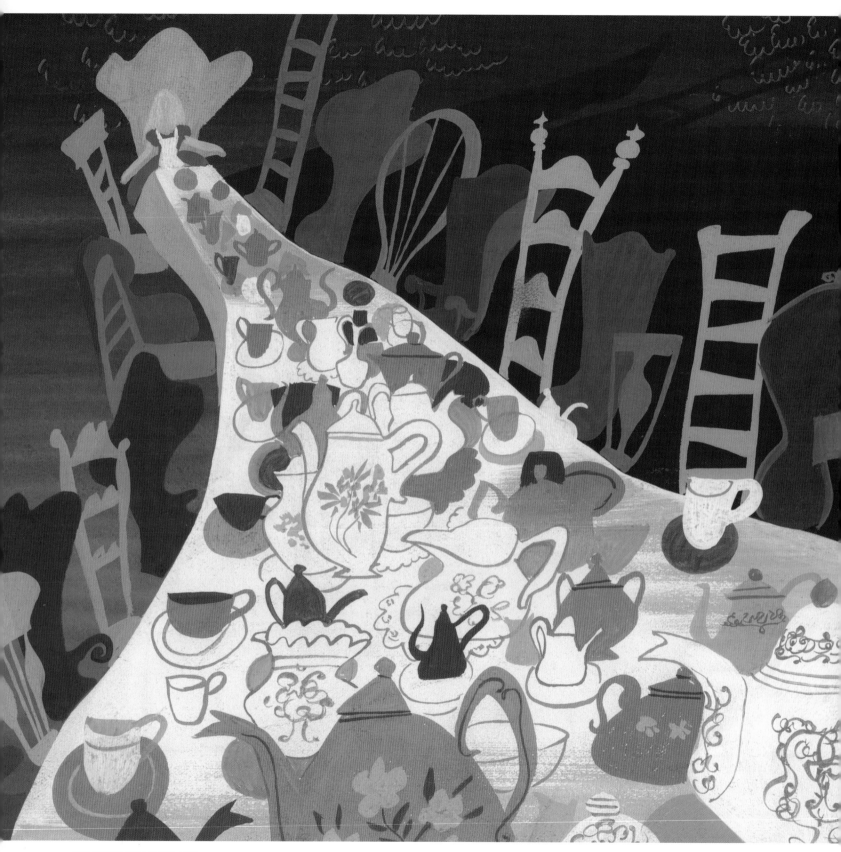

TEA PARTY CONCEPT ART
Mary Blair's phantasmagorical concept painting—portraying
Alice lost at the head of a table set with a bewildering
assortment of tea things—helped make the Mad Hatter's
Tea Party one of the wildest sequences in Disney animation.

Welcome to Wonderland

From the 1930s right through today, the imaginative wellspring of Disney animation has been fed by the inspirational work of concept artists. These inventive illustrators stimulated ideas, characters, and even entire sequences with their colorful sketches and paintings. The pre-production artwork of influential stylist and designer Mary Blair appealed to Walt Disney and inspirited the story artists on such films as *Cinderella* (1950) and *Peter Pan* (1953). Her exuberant take on the wacky world of *Alice In Wonderland* was a particularly strong influence on Walt's 1951 adaptation of Lewis Carroll's literary classic. Blair's many artworks—full of contrasting colors and geographic gymnastics—helped form this happily eccentric animated dreamscape.

THE FINISHED SCENE
Walt Disney was adamant that Mary Blair's unique visions be faithfully translated to the screen. The surreal setting of *Alice in Wonderland* was an ideal environment for the artist's idiosyncratic designs, as seen in this beautiful final film frame.

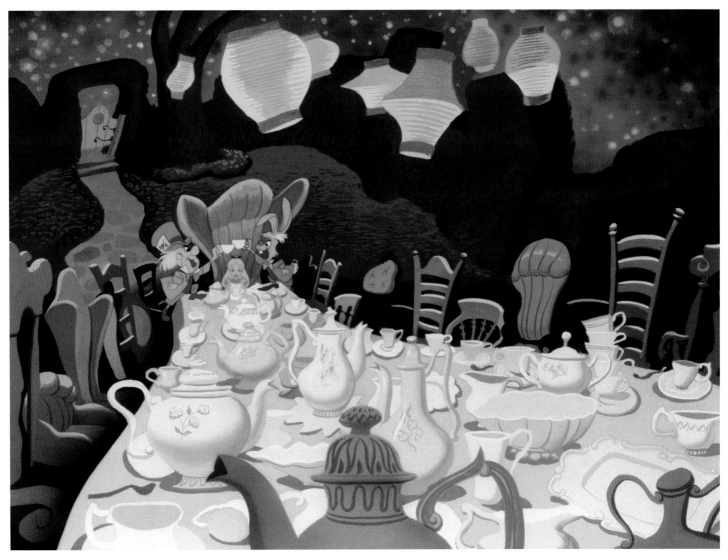

Burbank Studio Tour

Buoyed by the financial success of *Snow White and the Seven Dwarfs* (1937), in 1938 Walt decided to build the ultimate animation studio. When the Studio opened in 1940 in Burbank, California, its original purpose was to produce animated films. However, it eventually expanded to include the production of live-action pictures, too. Today the 44-acre (18-ha) Studio serves as the headquarters for the entire worldwide Disney team, and remains one of Walt's greatest creative and technical achievements.

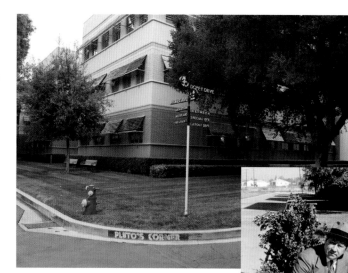

PLUTO'S CORNER
The famous intersection of Mickey Avenue and Dopey Drive features the iconic sign originally created as a prop for *The Reluctant Dragon* (1941), later used for promotion.

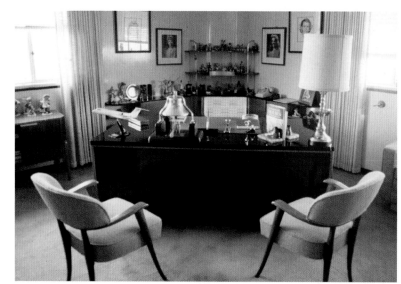

THE MASTER STORYTELLER'S OFFICE
Walt's office in the 3H wing of the Animation Building displayed his collection of miniatures, along with a Grumman Gulfstream II model, a plane Walt had ordered before he passed away.

LOOKING BACK
The Walt Disney Studios served as a movie set for *Saving Mr. Banks* (2013). Here, P. L. Travers (Emma Thompson) arrives outside Stage A, welcomed by Disney artist-writer Don DaGradi (Bradley Whitford) and the songwriting Sherman Brothers (B. J. Novak and Jason Schwartzman).

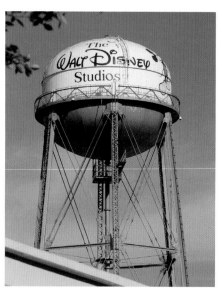

TOWERING TALL
The historic water tower soars 135 ft (41 m) high. Roy O. Disney considered the unique six-legged structure to be more aesthetically appealing than the standard four-legged towers.

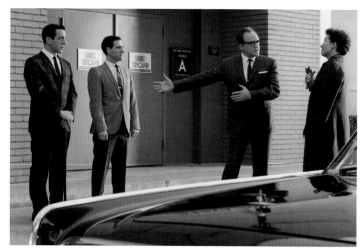

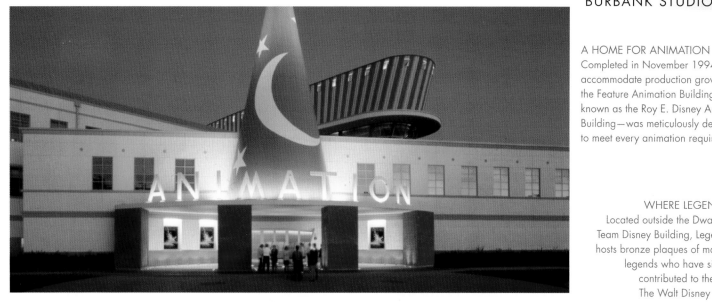

A HOME FOR ANIMATION
Completed in November 1994 to accommodate production growth, the Feature Animation Building—now known as the Roy E. Disney Animation Building—was meticulously designed to meet every animation requirement.

WHERE LEGENDS MEET
Located outside the Dwarf-adorned Team Disney Building, Legends Plaza hosts bronze plaques of many Disney legends who have significantly contributed to the legacy of The Walt Disney Company.

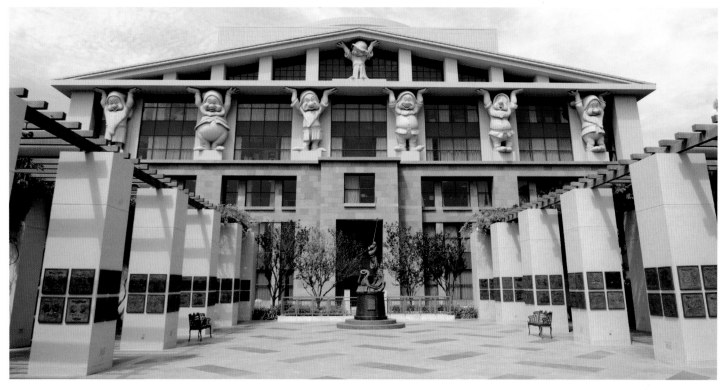

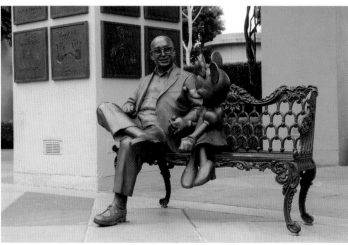

TWO OF A KIND
Sculpted by legendary Imagineer Blaine Gibson, the "Partners" statue of Walt and his old pal Mickey Mouse stands at the east end of Legends Plaza.

SHARING THE MAGIC
Roy O. Disney and Minnie Mouse lounge at the north edge of Legends Plaza in this statue based on a photo taken of Roy shortly before the opening of Walt Disney World® Resort in 1971.

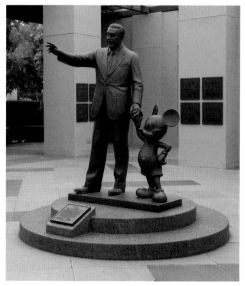

Early sketches helped story artists get a feel for the film's characters and setting.

An animator's model of Albert Einstein, who has an encounter with the genius infant in the "Baby Weems" sequence of *The Reluctant Dragon* (1941).

Adjustable lamps could be moved in virtually any direction.

Models, such as this one of Sir Giles, were created to give the animators an idea of how characters should look.

The desk houses many of the animator's necessities with ample storage for their unique supplies.

The animation paper sits on a rotating disk that can be spun in either direction.

A thin metal plate, or peg bar, holds the animator's paper in place to stop it from sliding.

The exposure sheet is a printed table that breaks down the film's action and serves as a timing guide for the animator.

ANIMATION IN ACTION

A recreation of an animator's office from 1940 is on display in the Walt Disney Archives in the Frank G. Wells Building at The Walt Disney Studios in Burbank, California. Work from *The Reluctant Dragon* (1941) is displayed on the animator's desk but the Disney archivists sometimes change the film that is depicted on the desk.

Early Animator's Desk

To create the ideal artistic workstation, Walt worked with furniture and industrial designer Kem Weber to make special desks and furniture for the Disney animators. Housed in the Animation Building that served as the cornerstone of the Burbank Studio, the animator's desk is where the Disney characters came to life. The impressive Art Moderne design of the desks provided an aesthetically pleasing environment for the artists, and the placement of the drafting area and drawers offered the ultimate in functionality. The first floor of the Animation Building was home to several of Walt's top animators—known as the Nine Old Men—who utilized these desks to create some of the most iconic animated films of all time.

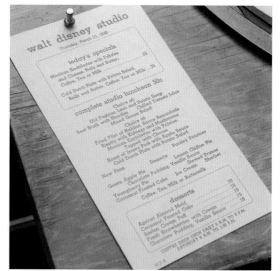

LET'S EAT
A Disney Studio commissary menu from March 21, 1940 provides staff with the day's lunch options. Walt's Chili was often on the menu and remains so today.

ALL THE ESSENTIALS
Original animator's tools, including pushpins, erasers, and a Blackwing pencil were specially designed by Walt to assist the animator.

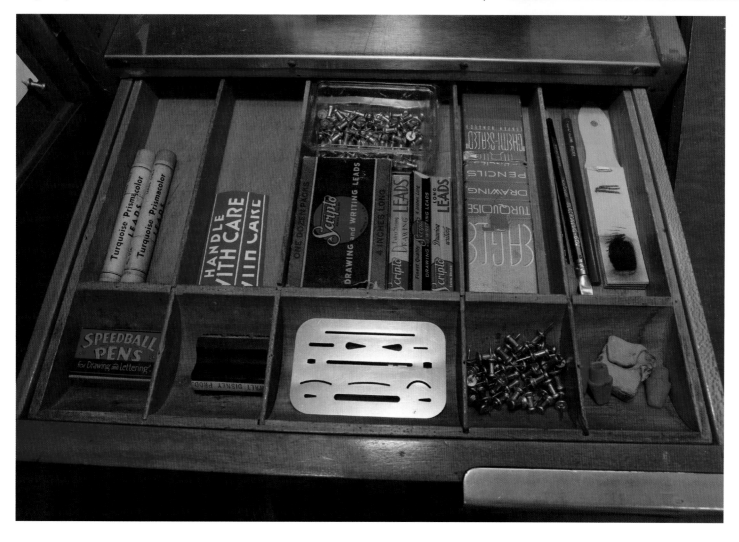

Tools of the Trade

Walt Disney did not invent animation as some people believe—he perfected it. In taking hand-drawn animation from a mere program-filler to an art form, Walt and his staff developed existing techniques and invented others, such as the storyboard. In order to better manufacture his unique product, Walt merged artistry with something of an assembly-line mentality—a step-by-step approach perfect for the animation studio that was affectionately known as "the Mouse factory."

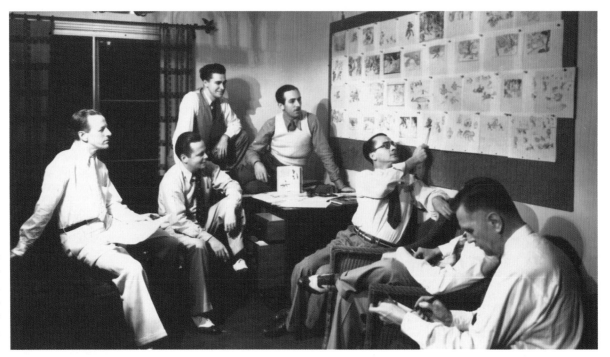

1. STORY CONFERENCE
Story conferences, such as this one seen in 1934, were held to present storyboards and review the story. This process allowed the directors and story artists to refine the action of the short or feature.

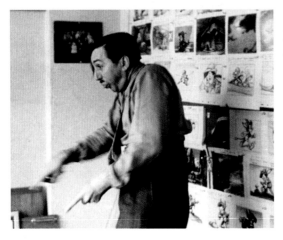

2. PRESENTING IDEAS
At a *Pinocchio* conference, Walt acts out the story. The Disney artists were always impressed with Walt's performances, saying he was as comedic as Chaplin.

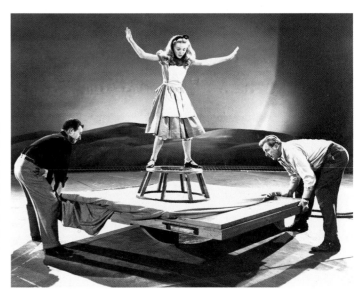

3. LIVE MODELS
After the storyboards were approved, live-action reference footage was sometimes shot to assist the animators. Here, Kathryn Beaumont performs for *Alice in Wonderland.*

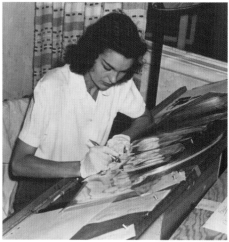

4. ANIMATION DRAWING

Supervising animators define the characters, from their final design to their onscreen performances. Here, Eric Larson "draws" inspiration from some spotted canine models. Creating the illusion of movement that gives life to a character, animators focused on key poses in a movement or action. Afterwards, a team of "In-betweeners" completed the necessary number of drawings for the 24 frames per second of on-screen running time.

5. INKING CELS

With nimble fingers and steady hands, the inkers traced the animation drawings— in ink, using the thinnest nibs available— onto clear celluloid sheets known as "cels."

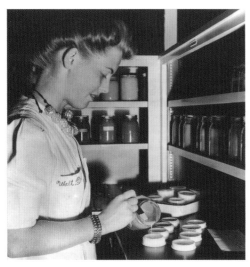

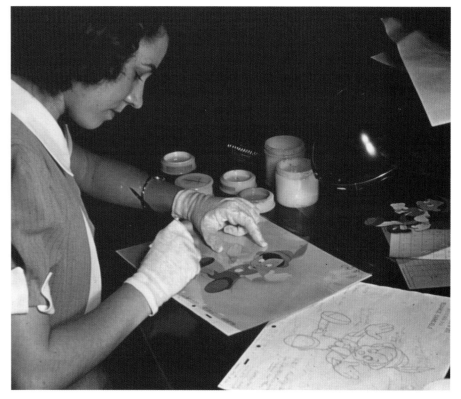

6. CREATING COLORS

At the Disney Paint Lab, custom-made colors were ground with a stone mill and mixed into hundreds of hues. These specially developed pigments made paints that photographed with true colors.

7. PAINTING CELS

Skilled painters swiftly applied the colors to the back of each inked cel. Each cel was then placed on a background under the animation camera to create one frame of film.

The Art of Sound

As seen with Mickey Mouse's debut in *Steamboat Willie* (1928), Walt understood the importance of sound at a time when many in the industry considered "talkies" a passing novelty. There had been sound cartoons before *Steamboat Willie*, but they commonly just played a phonograph record as the cartoon ran. Walt created a way to put a soundtrack on the film itself, allowing for the synchronization of action and audio. The blending of voices, sound effects, and music with the visual realized Walt's vision for an all-encompassing entertainment experience.

VOICE ARTIST
Walt credited Cliff Edwards and his uniquely ebullient voice for helping make Jiminy Cricket a lovable presence in *Pinocchio* (1940) and more than 30 episodes of the *Mickey Mouse Club* television show.

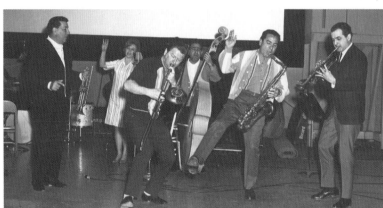

FROM VOICE TO TRUMPET
During production of *The Jungle Book* (1967), singer-songwriter Louis Prima, the voice of King Louie, performs with Sam Butera and The Witnesses who inspired the animators to create King Louie's monkey band.

QUACKTACULAR CLAMOR
Walt's creation of Donald Duck was inspired by voice actor Clarence "Ducky" Nash. Ducky provided the voice of the feisty fowl for more than 50 years.

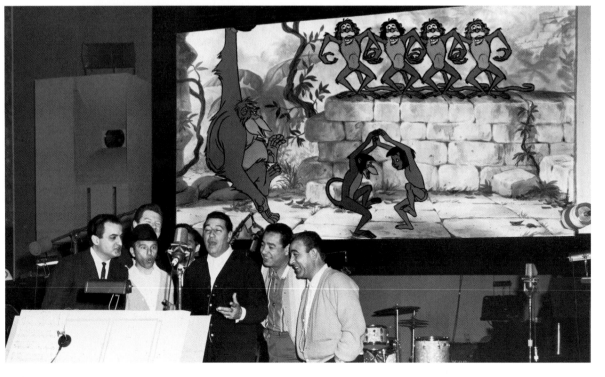

FREE-RANGE MELODIES
Louis Prima's jazz vocals make King Louie the scatting king of the jungle with numbers such as "I Wanna Be Like You."

THE SONGS SPEAK
An orchestra assembles at the Disney Studio to record music for *Bambi* (1942). The film has fewer than 1,000 words of dialogue, allowing the action and music to speak volumes.

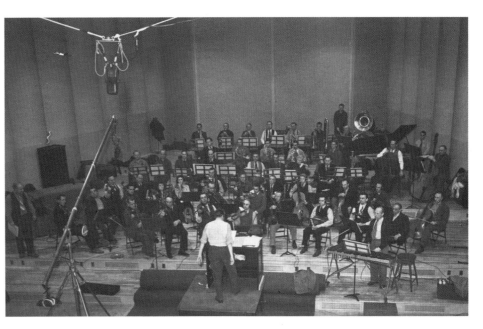

JOIN IN THE CHORUS
A large choir sings the lyrical songs and acclaimed choral effects for *Bambi*.

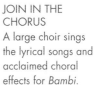

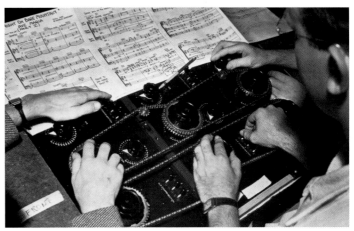

A MELODIST AT WORK
Prolific composer and multi-Oscar® winner Alan Menken applies his sound expertise during a recording session for *Aladdin* (1992).

A NEW SOUND
Re-mixing for *Fantasia* (1940) took place at the new Disney Studios in Burbank, California using a Disney-devised stereo system called Fantasound.

The Master's Final Film Triumph

A swingin' safari of music, fun, and brilliant character animation, *The Jungle Book* was Walt's animated farewell to the world.

Walt had considered Rudyard Kipling's famous collection of stories, with its many colorful animal personalities, as an ideal subject for Disney animation since the mid-1930s. He finally bought the screen rights in 1962. However, the great storyteller felt that Kipling's tales were too somber. He assigned the Sherman Brothers to compose some breezy songs—"The Bare Necessities" had already been written by Terry Gilkyson—to help make the film a playful romp, and the brothers created songs in lively styles as disparate as jazz and barber shop. Baloo, the dignified, lawgiving bear of the original book was transformed into a "jungle bum," and the relationship between the carefree bruin and Mowgli the jungle boy

▲ Pencil story sketch of the confrontation between Shere Khan and Kaa

▶ Jungle bear and jungle boy: Baloo and Mowgli are the center of the film.

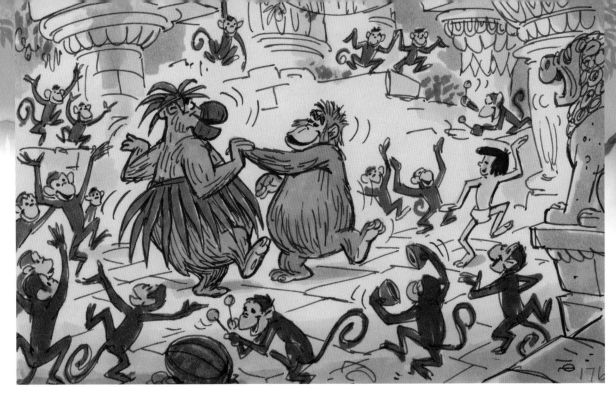

◄ Story sketch of the "I Wanna Be Like You" number

"Many strange legends are told of these jungles of India ... but none so strange as the story of a small boy named Mowgli." BAGHEERA THE PANTHER

became the heart of the film. Walt inspired his team of elite animators by pantomiming Baloo's happy-go-lucky walk for animator Ollie Johnston and wildly flapping his arms up and down as he acted out the antics of the mop-topped vultures for animator Eric Larson.

THE CHARACTERS ARE THE STORY

Walt sought a fresh approach to villainy for Shere Kahn, the film's arrogant antagonist. When character designer Ken Anderson added an air of superiority to his sketch of the powerful tiger, Walt took one look at this interpretation and knew it was exactly the attitude he was seeking for the movie's chief villain. Directing animator Milt Kahl then drew the contemptuous tiger as a caricature of sophisticated actor George Sanders. From greatly expanding the roles of Baloo and Kaa the sinister serpent, right down to ordering changes in the design of King Louie because he felt the orangutan's eyes were too beady, Walt was, as ever, the creative catalyst.

AFTER WALT

In the midst of production, on December 15, 1966, the great showman died, to the great shock of his longtime creative team. Without Walt, Woolie Reitherman—the first to be given a sole animation director's credit by Walt on *The Sword in the Stone* (1963) —set out to guide the film to completion. Thirty years after the triumph of Walt's first animated feature, *Snow White and the Seven Dwarfs*, *The Jungle Book* premiered at Hollywood's world-famous Grauman's Chinese Theatre on October 18, 1967. The freewheeling new animated feature was an enormous international hit, reaffirming animation as perfected by Walt Disney as an art form for the ages.

During his adventures in the jungle, Mowgli meets the smooth-talking orangutan King Louie, who rules over a group of monkeys in the ruins of an ancient temple. Louie tries to persuade the young Man-cub to share with him the secret to making fire, so that he can be more like his human cousins. The King of the Apes was given the voice and personality of famed jazz trumpeter Louis Prima, who also provided the instrumentals for one of *The Jungle Book's* most infamous songs, *I Wanna Be Like You.*

Cache of Classics

Through the years, Disney animation has enveloped audiences in fabulous worlds of adventure, romance, and excitement.

Disney animation brings to life all sorts of fantastic sights from children flying to Never Land and dogs falling in love, to a classic story retold with an all-animal cast. Walt Disney recognized that to make *Peter Pan* (1953), only animation would do justice to the J. M. Barrie play about the boy who never grows up. Extensive live-action reference footage was shot to inspire the animators, with the voice actors performing their roles. The story's fantasy called for the artists to animate the characters flying. To indicate high-spirited Peter Pan's power of flight, veteran Disney artist Milt Kahl animated the character as if he was floating in midair. *Peter Pan* was proof that the Disney artists had become expert at animating human characters.

▲ Development for *Peter Pan* began in the late 1930s, as seen in this early concept art.

▼ Story sketch of the Dalmatian clan by Bill Peet. According to Disney publicity, there is a total of 6,469,952 spots on the Dalmatians in all 113,760 frames of the final film.

"Fantasy, if it's really convincing, can't become dated, for the simple reason that it represents a flight into a dimension that lies beyond the reach of time." WALT DISNEY

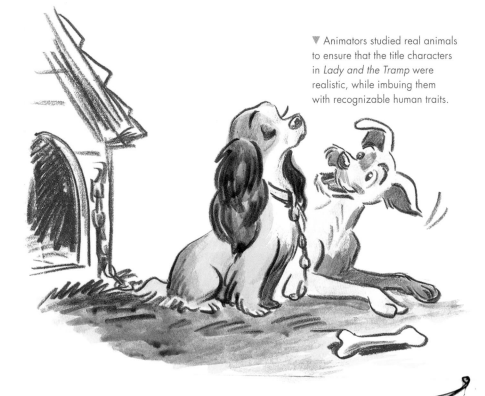

▼ Animators studied real animals to ensure that the title characters in *Lady and the Tramp* were realistic, while imbuing them with recognizable human traits.

ANIMATION FIRSTS

The nostalgic animated feature, *Lady and the Tramp* (1955) centers on the charming romance between a pampered pooch and a streetwise mutt. The film marks a series of Disney firsts—the first Disney animated feature with an everyday American setting and the first animated feature to be photographed in the new widescreen format of CinemaScope®. The artists studied real animals to animate the canine cast, and the model dog for Tramp was actually a female stray found by story artist Ed Penner.

ANIMAL ANTICS

One Hundred and One Dalmatians (1961) is the tale of Pongo and Perdita, the proud Dalmatian parents who rescue 99 puppies from the evil Cruella De Vil. The feature film pioneered the use of the Xerox process, a timesaving technique that eliminated the inking process and transferred the animators' drawings directly to animation cels. Each of the dog's spot patterns were designed like a constellation in order to maintain continuity frame-to-frame. With its sharp angles and thick lines, the art direction incorporated the sketchy Xerox look, giving the film the contemporary style of a sophisticated pen-and-ink drawing.

AN OLD TALE

Robin Hood (1973) is an animated retelling of the famous legend. The well-known figures, such as Friar Tuck and the Sheriff of Nottingham are "performed" by a cast of delightfully caricatured animals. The country and western elements of the soundtrack set the film apart from other traditional Disney animated features as does the tale, which is set in England.

▶ *Robin Hood* concept art by Ken Anderson of the sly fox Robin Hood

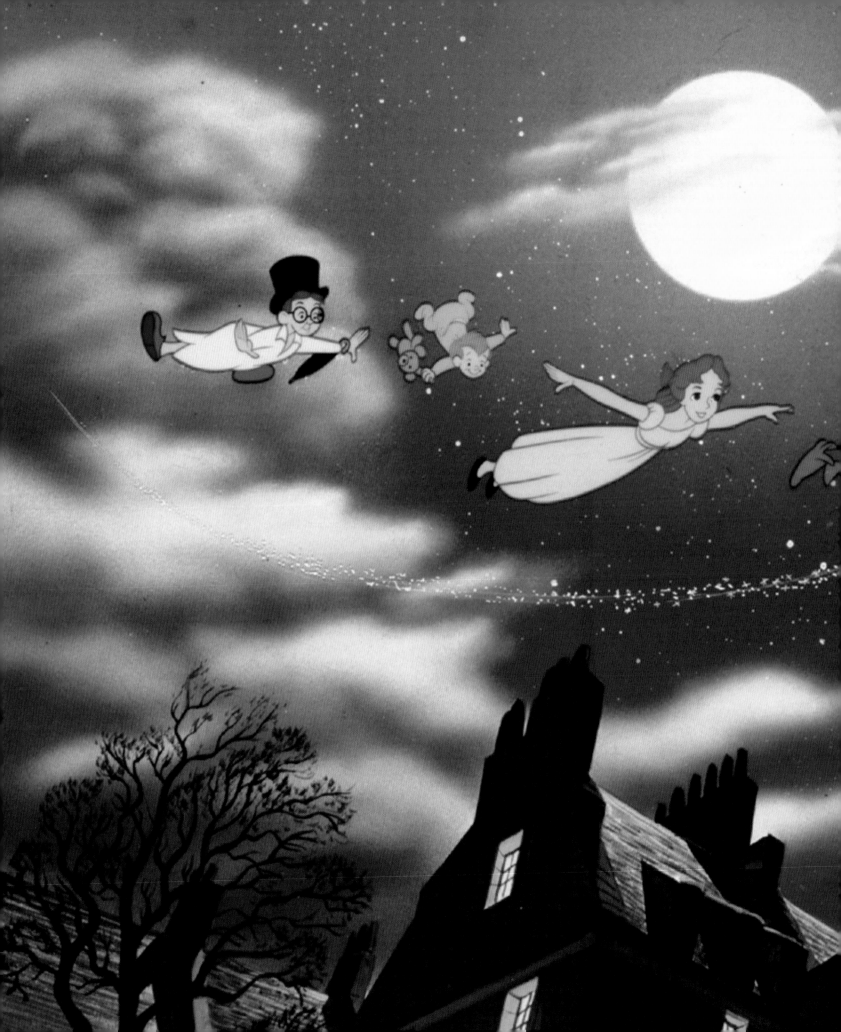

Peter Pan was one of Walt Disney's favorite stories, but when he finally gained the rights to make the movie, he had a hard time deciding exactly how Peter should be portrayed, both in terms of appearance and character. Walt eventually settled on a merry—but mischievous—individual who could fly without wings. Viewers would be enthralled when they watched this fairy-like boy take Wendy, John, and Michael Darling swooping and soaring over the spires of London, heading toward Never Land.

Light-filled color in this concept art by Andy Gaskill influenced the Caribbean-inspired palette for *The Little Mermaid*.

Ariel's youthful spirit shines through in this pencil character sketch by Glen Keane.

A Transforming Princess

The story of a princess who transforms herself for love, *The Little Mermaid* ushered in a renaissance of Disney animation.

The first new Disney princess to appear on screen since Princess Aurora in Walt Disney's *Sleeping Beauty* (1959), Ariel in *The Little Mermaid* (1989) is different from her three gentle predecessors. Not only is she not human, the lively mermaid is a feisty, rebellious teenager who dreams of completely transforming herself and leaving the world she lives in behind.

When she rescues handsome Prince Eric from the sea, Ariel's yearning to be with him becomes the force that drives her to act upon her dreams.

A WORLD APART
Ariel's youthful voice (from voice talent Jodi Benson) and long red hair set her apart from previous princesses. Deciding the color of her hair caused much discussion among the Disney

artists, as there was concern that red hair wouldn't appeal to audiences. To create its flowing movement underwater, animators studied footage of astronaut Sally Ride when she was in space. Now it is impossible to imagine Ariel any other way, and her courage as she risks everything to determine her own life paved the way for a whole new era of self-empowered princesses.

"What makes Ariel real and identifiable is her struggle to be free and her father's struggle to let her grow up." GLEN KEANE (ANIMATOR)

The Princess Who Tamed a Beast

A reader and a dreamer, Belle seeks adventure as the heroine in her own story.

Belle's intelligence, compassion, and sincerity are the driving force in *Beauty and the Beast* (1991)—a timeless tale of love's redemptive power. Belle dreams of adventure outside the provincial town where she lives with her father, and finds it when she selflessly takes his place as the Beast's prisoner.

▲ A tentative attraction grows between the two dancers, portrayed in this pencil concept sketch by Glen Keane.

BRIGHT BEAUTY

Belle's love of reading sets her apart from the other villagers, a fact that the Disney artists visually reinforced in the film's opening scene by making her the only character dressed in blue. Despite her dreaminess, Belle is also practical and down to earth. Her relaxed, natural good looks were inspired by actress and singer Judy Garland, and animators chose actress Paige O'Hara to be the voice of Belle because it reminded them of Judy Garland's rich, warm tones. Belle doesn't seem to notice how beautiful she is—for her, it is the person within that counts. It isn't her beauty that affects and changes the Beast's heart, but her kindness, patience, and sympathy. While Belle is teaching him etiquette and how to read, she is also teaching him how to love.

◄ Evoking the stained glass art at the film's beginning, this concept art by Brian McEntee, Mac George, and Vance Gerry completes the story.

"The lessons of the Beauty and the Beast story are truly timeless: you can't judge a book by its cover, and beauty is only skin deep."

LINDA WOOLVERTON (SCREENWRITER)

Some of the most beloved characters from *Beauty and the Beast* are the magical servants, including Mrs. Potts, Lumiere, and Cogsworth. The animators faced a challenge in creating motion and personality for household objects, so they focused on an impression of movement and a wide variety of facial expressions. As a result, they were able to make everyday objects truly come to life! The castle servants are essential to guiding the audience through the story, and they add warmth and humor to an otherwise dark tale.

The World's Favorite Fairy

From a mere twinkling light to a full-fledged personality, Tinker Bell has captured the hearts of generations of fans.

◄ Tink's mischievous spirit shines in a clean-up drawing by animator Marc Davis.

From her beginning as a twinkling light in J. M. Barrie's stage play to her unforgettable performance as the sassy sprite in Walt Disney's *Peter Pan* (1953), and her role as a feisty but loyal friend in *Disney Fairies*, Tinker Bell is one of Disney's most iconic and beloved characters. Her coquettish looks and fiery personality were created by master animator Marc Davis. With only the silvery sound of tinkling bells as a voice, Davis relied solely on Tink's movements to bring the pretty pixie's personality to life. She flits, flirts, fumes, crosses her arms, stamps her feet, and blushes furiously when angry. Tink proved such a favorite with audiences that she soon came to represent the magic of Disney. She sprinkles her pixie dust in the opening of weekly Disney TV shows, appears at the beginning of Disney DVD releases, and flutters above Disneyland® Park during the fireworks shows.

► The Pixie Dust Tree, the magical heart of Pixie Hollow, spreads its sheltering branches in this Disney Publishing illustration.

"Tinker Bell is one of the greatest characters ever created by Walt Disney." JOHN LASSETER

◄ Tink and her *Disney Fairies* friends. Clockwise from Tinker Bell: Periwinkle, Rosetta, Iridessa, Silvermist, Fawn, and Vidia.

TINK GETS A VOICE

In the early 2000s, plans began to expand Tink's world, and she was given a voice for the first time in *Tinker Bell* (2008), provided by voice actress Mae Whitman. But being able to speak wasn't the only change for Tinker Bell. She was also given a distinctive home, Pixie Hollow in Never Land, and a troupe of fairy friends who each have unique talents, from creating things with light and water to taking care of animals and plants. Tinker Bell, as her name suggests, is a master tinker—a whiz at inventing ingenious gadgets. She is the irrepressible heart of the group in each of the seven feature films released on DVD to date. In *The Secret of the Wings* (2012), we discover that she has a sister, and in *Tinker Bell and the Legend of the NeverBeast* (2015) Tink and her friends worry about a new furry addition to Pixie Hollow. Impulsive, impatient, and determined, Tinker Bell remains the charming fairy beloved by so many for so long. She may be only 6 in (15 cm) tall, but her big emotions are ones everyone can relate to.

A Whole New World

▲ Clean-up animation drawing from a scene animated by Mark Henn conveys the excitement and romance of Aladdin and Jasmine's exhilarating magic carpet ride.

Like a gleaming treasure uncovered in the Cave of Wonders, *Aladdin* glows with a jewel-like color palette and a signature style uniquely its own.

Weaving an exotic tapestry of romance, adventure, and enchantment, *Aladdin* (1992) is an animated adaptation of the Arabian Nights tale of a lad and his magic lamp. In the fabled city of Agrabah, a young "diamond in the rough" teams up with an outrageous shape-shifting Genie to win the heart of beautiful Princess Jasmine while trying to outsmart the evil vizier Jafar.

COLORS ARE KEY

In a production where color and shape defined personalities, the design team set out to create a unity of character and environment and used a vivid color palette with a level of saturation reminiscent of Disney's early animated classics. The artists went to great lengths to create the film's signature style. Artistic supervisor for the layout department and native Iranian Rasoul

▶ According to background director, Kathy Altieri, the colors and design of the backgrounds affect the audience's emotions. This background painting of the Sultan's palace at sunset has a red hue, which indicates a bad turn of events for Aladdin and Jasmine.

01 01.1 002 02.1 04.1 005 008 08.1 009

Azadani returned to his hometown of Istahan to photograph more than 1800 shots to assist the artists in authentically recreating the Middle Eastern world of the 15th century. Production designer Richard Vander Wende turned to ancient Persian miniatures, incorporating many of their design elements, such as their vibrant colors, into the film. Background director Kathy Altieri explained that since blue is associated with water, a life-giving force in the desert, the film's heroes are depicted in the cooler range of colors while villains are in the red range. This can be seen in the true-blue Genie and the red-and-black clad Jafar.

SHAPING THE CHARACTERS

Vander Wende had the *Aladdin* artists use the thick and thin 'S' curve seen in Arabian calligraphy. The designs are based on caricatured drawings that emphasize these curves and shapes, where one shape organically leads into another. This fluid caricature style was even worked into the animation itself, particularly with the Genie. Art director Bill Perkins emphasized the shape relationships of the main characters and the interior/exterior locations that would best fit their personalities. Aladdin's wide stance, narrow waist, and broad shoulders are visually distinct from Jafar's sharp-edged T-shape, which in turn

▲ This color script was developed by production designer Richard Vander Wende to map out the emotional impact of colors throughout *Aladdin*, sequence by sequence.

contrasts with the Genie, referred to by Perkins as an anti-gravity machine because of his floating mass which tapers down to nothing. The Sultan's throne room reflects his rounded shape with an egg motif seen in the columns, throne, and oil lamps. When Jafar gains control of the kingdom, the shapes in the Sultan's room transform to echo the pointed silhouette of the scheming sorcerer. *Aladdin* remains one of the most popular Disney animated films. The colorful characters captured people's hearts and so did the songs—the movie won Academy Awards® for Original Music Score and Best Original Song for "A Whole New World."

◄ Genie drawing by Eric Goldberg. The graceful, curvy lines of legendary caricaturist Al Hirschfeld influenced the designs of all the characters especially Aladdin's big blue friend.

" Inspired art direction, layout and background paintings give Aladdin a look unlike any other animated feature." ROY E. DISNEY

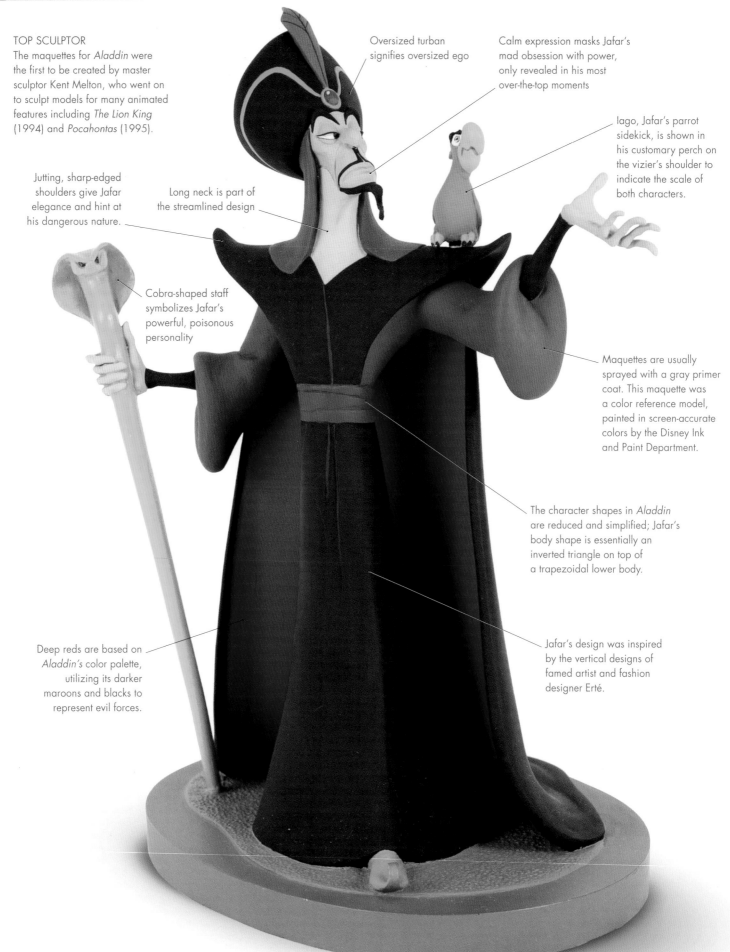

TOP SCULPTOR
The maquettes for *Aladdin* were the first to be created by master sculptor Kent Melton, who went on to sculpt models for many animated features including *The Lion King* (1994) and *Pocahontas* (1995).

Oversized turban signifies oversized ego

Calm expression masks Jafar's mad obsession with power, only revealed in his most over-the-top moments

Iago, Jafar's parrot sidekick, is shown in his customary perch on the vizier's shoulder to indicate the scale of both characters.

Jutting, sharp-edged shoulders give Jafar elegance and hint at his dangerous nature.

Long neck is part of the streamlined design

Cobra-shaped staff symbolizes Jafar's powerful, poisonous personality

Maquettes are usually sprayed with a gray primer coat. This maquette was a color reference model, painted in screen-accurate colors by the Disney Ink and Paint Department.

The character shapes in *Aladdin* are reduced and simplified; Jafar's body shape is essentially an inverted triangle on top of a trapezoidal lower body.

Deep reds are based on *Aladdin*'s color palette, utilizing its darker maroons and blacks to represent evil forces.

Jafar's design was inspired by the vertical designs of famed artist and fashion designer Erté.

Menacing Maquette

Disney animators use sculptures as a visual reference to help them visualize the characters they are drawing from different angles. These 3D models, known as maquettes or animator's models, are meticulously sculpted in a character-defining pose. The characters are usually portrayed full length so the artist can rotate it and view the character from any angle, as required by the scene that is being animated. The maquette of Jafar, the wicked vizier from *Aladdin* (1992), was sculpted by Kent Melton, who began by bending a wire armature (support structure) from aluminum wire as a base for the clay. Once approved, the sculpture was molded and cast in resin.

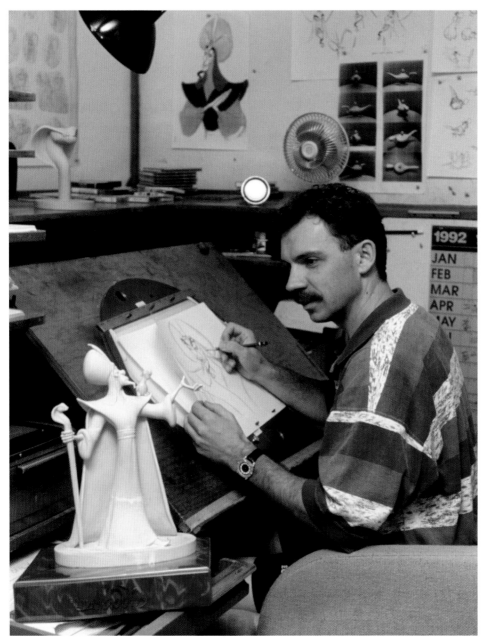

USING A MAQUETTE
Supervising animator Andreas Deja sought to design a streamlined character with long lines and sharp angles. Here he consults the Jafar maquette as he animates the villain. The model gave three-dimensional form to Deja's final design of the character, and he then used the maquette to bring Jafar to life.

"Jasmine is very different from the rest; a lot more feisty than Belle, and not as naïve as Ariel." MARK HENN

An Independent Princess

▲ Jean Gilmore's concept art depicts a coy Jasmine with Aladdin and Abu.

Jasmine's confidence and freedom-loving spirit make her a unique heroine.

The moment in *Aladdin* (1992) that feisty Jasmine kicks her latest suitor out of the palace and tells her father, the Sultan of Agrabah, that she is determined to marry for love, the bold princess makes it clear that she has her own ideas about how she is going to live her life. Jasmine is not interested in a pampered life of luxury. The world outside the palace walls is colorful and intriguing and nothing is going to stop her from experiencing it.

A WHOLE NEW KIND OF HEROINE
The inspiration for the first Disney princess not to be based on a European fairy-tale came from the thick and thin S-curves used in the film's styling, where curves and shapes are emphasized in caricatured drawings. However, it is Jasmine's outspoken attitude and confidence that presented Disney supervising animator Mark Henn with a whole new world of challenges. Henn looked at a number of live models before he realized his inspiration was right in front of him—in the form of a graduation photo of his younger sister Beth. It was then that Jasmine became a reality. She is a brave young woman with a mind of her own—and the courage to jump over any wall and discover life on her own terms.

◄ Jasmine's alluring beauty seems to come straight from the collection of stories, *One Thousand and One Nights,* which provided inspiration for the film.

A Heroine from History

History comes to life with Pocahontas, the first Disney princess based on a real person.

▲ Story sketch by Glen Keane of Captain John Smith and Pocahontas

Although Pocahontas lived more than 400 years ago, the story of her friendship with English explorer Captain John Smith has made her an American heroine. To make *Pocahontas* (1995) real to audiences, Disney artists had to discover the heart of the protagonist's story. They spent months researching and consulting with Native American leaders, and they began to see Pocahontas as a young, curious, and intrepid woman trying to bridge two different worlds and find her own path between them. The real Pocahontas, whose name means "Little Mischief," was younger than Disney's tribal princess. By making her older, they could add the emotional drama of a romance to highlight her struggle to find her place in the world.

BRAVE AND BEAUTIFUL

Animated by Glen Keane and voiced by Native American Irene Bedard, Pocahontas exudes confidence and athleticism. One of the strongest Disney princesses, both physically and spiritually, she is a complex character—brave, daring, and compassionate, with a deep spiritual connection to nature. In Pocahontas, Disney created a heroine whose heart is truly painted with all the colors of the wind.

◀ An ink and watercolor sketch by Joe Grant for the "Colors of the Wind" film sequence

"The more we learned about Pocahontas, the more she captured our imaginations." GLEN KEANE

Animals Rule

In the great tradition of animated Disney animal tales, *The Lion King* explores universal truths about honoring heritage and living responsibly and became a worldwide phenomenon.

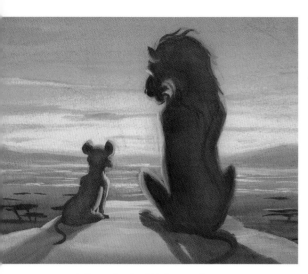

▲ Story sketch of Mufasa and Simba surveying the Pride Lands

*T*he Lion King (1994) boldly tells the epic tale of a lion cub named Simba and his journey of self-discovery as he follows in the paw prints of his father, the great king Mufasa. An enormous international hit that also inspired a popular stage version, this musical animal allegory celebrates the "circle of life."

EPIC INSPIRATION
The earliest version of the Serengeti-set story, originally entitled *King of the Jungle*, came about in 1989 when the idea of creating an animated feature about lions was first considered. The story was inspired in part by allegories and spiritual stories, such as the accounts of Joseph and Moses of the Old Testament. With its themes of responsibility and maturation, the filmmakers felt there was a certain religious epic quality to this coming of age tale.

▼ Color study for the opening "Circle of Life" sequence depicts the color palette for the movie

"The Lion King is essentially a love story between a father and a son." DON HAHN (PRODUCER)

▶ Story sketch by Burny Mattinson of Simba and his wastrel pals Timon and Pumbaa

GOING ON SAFARI

Real animals, including a lion cub, two young adult lions, and a fully-grown male and female were brought to the Disney Studios for the animators to study. In November 1991, six of the filmmakers embarked on a two-week artistic safari to Kenya in North Africa. Armed with cameras and sketchbooks, these intrepid artists journeyed across the African savannah by Land Rover™, experiencing lions and hyenas up close. The artists' safari guides tied a rope to their vehicle and drove slowly as lion cubs chased after the rope, playing with it like house cats. Story director Brenda Chapman recalled that she had imagined lion country as dusty

and dry. Instead the team found an expansive world teeming with life, sound, and color. The artists photographed scenery to help them capture the real African environment in their art, including an entire rainstorm moving across the plains. This African

field trip even gave the movie the little nonsense song—"Asante sana. Squash banana"—chanted by Rafiki the baboon shaman on screen, but originally sung by one of the party's guides.

MUSICAL MASTERPIECE

With a powerful Academy Award®-winning score by Hans Zimmer, the film features songs written by Sir Elton John and Tim Rice. "Can You Feel the Love Tonight" won the Oscar® for Best Original Song in 1994. "Circle of Life" and "Hakuna Matata" were also nominated in the same Academy Award® category. The most successful film of 1994, *The Lion King* was the highest-grossing animated feature ever produced up until that time, and the Broadway show that it inspired has become the top-earning production in box office history.

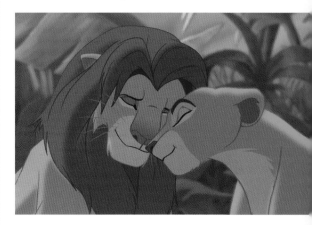

▲ A fully-grown Simba and Nala from the "Can You Feel the Love Tonight" sequence

The Lion King's opening scene is one of the most memorable in the history of Disney cinema, both visually and musically. The sequence was originally supposed to include dialogue, but when directors Roger Allers and Rob Minkoff heard the final version of "Circle of Life," they decided that words were no longer needed. The combination of this powerful song, beautiful animation, and the introduction of an important young lion cub, draws viewers into the story before the opening credits of the movie are even shown.

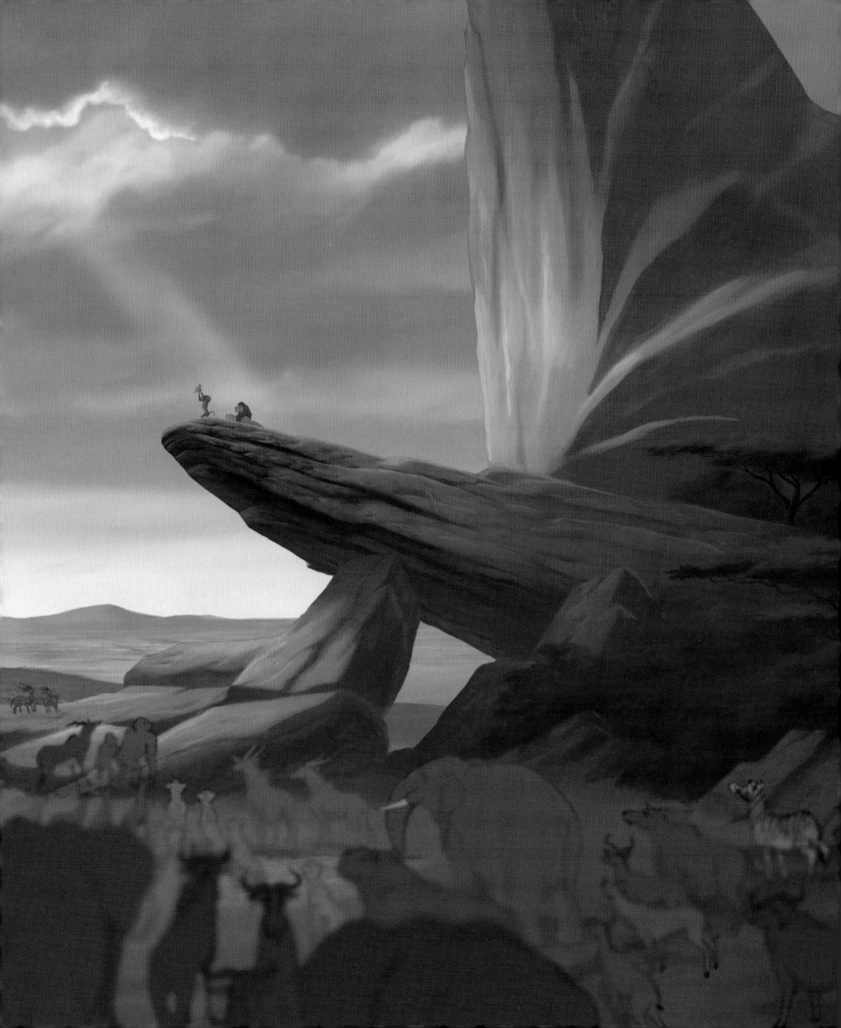

Silly Old Bear

Disney animation brings to life the endearing characters and whimsical wisdom of A. A. Milne's original *Winnie the Pooh* books about the bear of very little brain.

▲ Story sketch of Winnie the Pooh with his honey pot

Who's the most lovable bear around? It shouldn't take too much think-think-thinking to come up with the answer: Winnie the Pooh. First introduced to Disney fans in *Winnie the Pooh and the Honey Tree* (1966), the huggable, honey-loving teddy bear and his captivating friends were created by British author A. A. Milne in 1924, inspired by the stuffed toys of his young son, Christopher Robin. As early as 1937, Walt wanted

to animate Milne's witty stories. When he acquired the screen rights in 1961, the great showman sought to retain the delicate whimsy of the literary work. Story artist Bill Justice recalled Walt's specific direction to maintain the charm of the writing and the characters. Woolie Reitherman, director of the first two Pooh featurettes, noted that keeping the intrinsic innocence and sweetness of Pooh Bear and his Hundred Acre Wood friends was a challenge, especially since so much animation emphasized slapstick and action, elements mostly absent from Pooh's gentle world. Walt also wanted his artists to stay true to the spirit and integrity of the pen-and-ink drawings

of E. H. Shepard in adapting the visuals to Disney animation. In drawing these quaint characters, Disney designers gave Pooh a thumb so he could pick up objects (mostly honey pots) and Piglet cheeks to make his face more expressive, but they maintained the whimsical appeal and basic design of the originals.

A FILM AND TV STAR

At first, Walt envisioned *Winnie the Pooh* as a feature, but as the story developed he decided to produce shorter featurettes to be followed by a feature film. *Winnie the Pooh and the Blustery Day* (1968), which introduced both Piglet and Tigger, was developed at the same time as *Winnie the Pooh and the Honey Tree*. When it was released, it won an Academy Award® as Best Cartoon Short Subject. These first featurettes were combined with the Oscar®-nominated *Winnie the Pooh*

▼ Concept art based on the E. H. Shepard drawings. Tigger ended up looking very different from this in the finished films and series.

◄ Animation
drawing of Tigger
by Milt Kahl

► The Pooh featurettes
opened with a Hundred
Acre Wood map based
on the endpapers drawn
by E. H. Shepard.

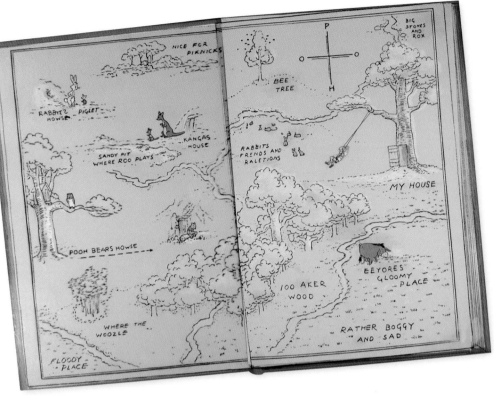

and Tigger Too (1974) to become the feature-length *The Many Adventures of Winnie the Pooh* (1977). The cuddly bear became a TV star in 1988 with *The Many Adventures of Winnie the Pooh*, which won two Daytime Emmy® Awards for Best Animated Program and was followed by other series and specials. *The Tigger Movie* (2000) led to more features, including the all-new *Winnie the Pooh* (2011).

"The beauty is in the tenderness and warmth of the characters." WOOLIE REITHERMAN (ANIMATION DIRECTOR)

▼ Production background painting
of the Hundred Acre Wood

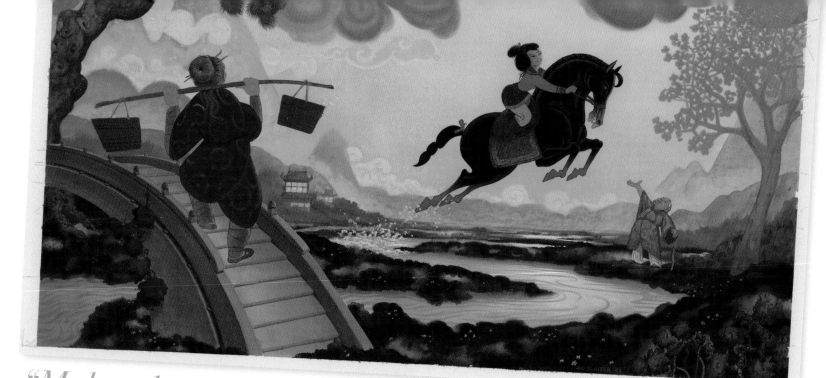

> *"Mulan doesn't accept that she's powerless. That's what makes her great."* PAM COATES (PRODUCER)

▲ The beauty of the Chinese landscape and Mulan's bold spirit are evoked in concept art by Ric Sluiter.

A Warrior and a Princess

Inspired by a Chinese legend, Mulan's story makes her a unique Disney heroine.

▲ Delicate pen and marker story sketch by Chris Sanders and Joe Mateo conveys Mulan's awe and respect for her father, Fa Zhou.

Disney's first animated feature set in China, *Mulan* (1998) features a unique Disney Princess. Although the rebellious young woman does meet her true love, Captain Shang, she does so in an unconventional way—while posing as a male warrior and training for combat under his command. Supervising animator Mark Henn found this brave heroine a challenge as he was animating not only Mulan, but also her soldier persona Ping—two very distinct personalities. Henn was also tasked with the fact that Mulan has more costume changes than any Disney Princess before her. With the help of character and costume designer Chen-Yi Chang, they created a character whose design is rooted in traditional Asian artwork, bringing to life the figure found in Chinese folklore who is regarded as the Asian Joan of Arc.

FINDING HER PLACE

Whatever her guise, Mulan's driving force is her desire to bring honor to her family, while ultimately remaining true to herself. Mulan eventually discovers courage within, but it's not until she drops her disguise as a man and acts like her true self that she really triumphs.

Recipe for a Perfect Princess

Disney artists hopped at the chance to create *The Princess and the Frog* in traditional hand-drawn animation.

► Concept art by Kevin Gollaher of Tiana in her waitress outfit

T*he Princess and the Frog* (2009) was the first hand-drawn feature film from Walt Disney Animation Studios since 2004, and was a return to the traditional musical—this time with a jazz soundtrack. Practical and realistic, the heroine Tiana doesn't believe in wishing on stars—she is all about working hard to make her dreams come true. Disney's first African-American princess, Tiana's warmth and beauty comes from her humor, optimism, and willingness to do whatever it takes to succeed—no matter how many jobs she has to balance. Unlike other Disney princesses, determined Tiana doesn't wonder where her path in life is leading. She knows exactly where she is headed—until one kiss with a frog sends her in a completely different direction, much to her chagrin.

A PRINCESS IN FROG FORM

Disney artists needed to make Tiana recognizable and endearing as a frog. Animator Mark Henn gave frog Tiana large expressive eyes with lashes to make her appealing. He also developed recognizable features and characteristics that she has in all of her three forms, such as her sweet smile and the way she stands. Tiana is the quickest-thinking frog in the bayou, as well as an empowered princess that audiences identify with and cheer on from the start.

◄ Bill Schwab's concept art of Tiana and Naveen's bayou wedding

"Tiana's a little more vulnerable, so you want to cheer her on."

MARK HENN (SUPERVISING ANIMATOR)

Introducing Pixar

Since the mid-1980s, Pixar Animation Studios has evolved from a high-end computer hardware company to a powerhouse of imaginative and creative filmmaking with an unbroken string of full-length animated hits. Recognized for its collaborative corporate culture—ideas are welcome from anyone in the company—Pixar has successfully turned everything from toys, monsters, and cars into memorable characters. Each character has human emotions that have moved and inspired audiences worldwide.

LUXO JR. (1986)
Pixar Animation Studios' first short, about two desk lamps and a ball, was the first computer animated film to be nominated for an Academy Award® in the category Short Film (Animated).

PIXAR ANIMATION GROUP
The Animation Group; from left to right: Bill Reeves, Eben Ostby, Yael Milo, Deirdre Warin, Flip Phillips, John Lasseter, Andrew Stanton, Ralph Guggenheim, Pete Docter, Don Conway, and Craig Good.

PIXAR UNIVERSITY
Pixar University, Pixar's internal professional development program, gives employees opportunities to explore creative options beyond their usual roles. Here, Ed Catmull takes a sculpture class.

PIXAR H.Q.
As the first noteworthy Pixar character, Luxo Jr. has become the company's iconic image. Here, he takes an honorary place at Pixar Animation Studios in Emeryville, California.

PIXAR'S RENDER FARM
"Renderfarm" is Pixar's playful name for the room that holds the 20,000 computers required to calculate the colors, textures, and lighting of each frame of the movies.

THE SECRET SPACE
Animator Andrew Gordon and Director Pete Docter hang out in the secret room named the Love Lounge. The hidden nook was discovered by Andrew Gordon, as it was next to his office.

PIXAR'S EXECUTIVE TEAM
Ed Catmull, Steve Jobs, Bob Iger, and John Lasseter are photographed after the acquisition of Pixar Animation Studios by The Walt Disney Company in 2006.

Magical New Heights

A collaboration between Pixar Animation Studios and Walt Disney Feature Animation brought new magic to animated storytelling.

▲ A stylus is used to record every point on a sculpted character model, like this one of the baby from the short *Tin Toy* (1988). The coordinates are then fed into computers for animating.

I n the mid to late 1980s, the filmmakers at Pixar Animation Studios experimented with award-winning short films and assembled their teams and technology in preparation for their first feature-length computer-animated film.Simultaneously, the leaders at Walt Disney Feature Animation were looking for ways to diversify their productions beyond traditional two-dimensional, hand-drawn animation. When the two studios collaborated, the result was a movie that is now considered a major milestone in animated filmmaking—*Toy Story* (1995). Four years in the making, the warm and humorous tale of two toys vying for a young boy's affection was the first full-length computer-animated feature film. Giving audiences a toy's-eye view of the world, the film made Pixar a household name and inspired two hugely popular sequels: *Toy Story 2* (1999) and *Toy Story 3* (2010).

◄ Concept character sketches, like this one of Woody and Buzz Lightyear, are the starting point for a character's on-screen appearance.

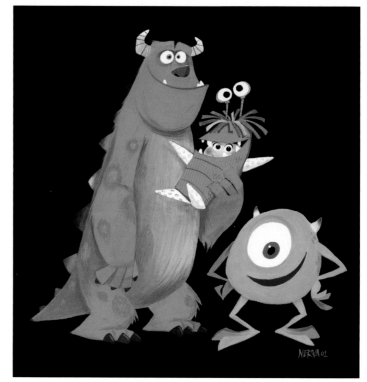

◄ Retired Pixar animator Bud Luckey with his concept sketch of Woody from *Toy Story*

► A vivid character concept sketch by Ricky Nierva emphasizes the shapes of Sulley, Mike, and Boo.

TECHNOLOGICAL ADVANCES

True to the Pixar storytellers' penchant for choosing unusual subjects, their next film, *A Bug's Life* (1998), opened up the world of insects to viewers with a colony of ants, a troupe of down-on-their-luck circus bugs, and some very bad grasshoppers. In making the film, Pixar storytellers pushed the boundaries of computer technology to create natural, organic shapes and characters that squashed and stretched. Setting up new technical challenges seemed to become standard operational procedure at Pixar, as long as the technology served the story. Technological advances used for *Monsters, Inc.* (2001) included a breakthrough depiction of fur and hair to make Sulley, whose world is turned upside down by a human toddler—another believable monster.

▲ Lighting pastels by Ralph Eggleston explore lighting—and by extension color, staging, and character for a sequence in *Finding Nemo*.

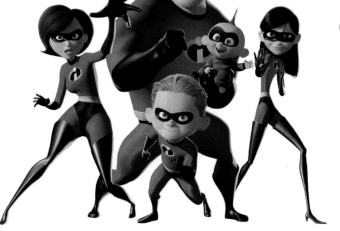

▼ *The Incredibles* was the first time Pixar animated an entire cast of human characters.

"*You have to tell a great story and have characters that will live beyond it.*" JOHN LASSETER

HEARTFELT STORIES

Moving from a world inhabited by monsters to one populated by fish, Pixar storytellers once again took computer-animation technology to new heights to create the underwater world of *Finding Nemo* (2003), at its heart a touching father-son story. Whether they are using technology to animate human characters, like *The Incredibles* (2004) or machinery, as in *Cars* (2006), it is always a tool and never an end in itself. Like an animator's pencil of the past, computer animation serves one purpose—to create believable worlds and tell stories that come straight from the heart.

▲ *Cars* co-director Joe Ranft found the perfect model for Mater in a vacant lot in Galena, Texas.

▶ *Cars* director John Lasseter insisted that the cars all look as "human" as possible.

Characters with Heart

Whether robots, rats, or humans, there's a foundation of real emotional truth to all Pixar's characters.

▲ Remy can walk upright and use his forepaws for cooking, as seen in this colorscript study by Harley Jessup.

Since becoming part of The Walt Disney Company in 2006, Pixar storytellers have continued to create characters that resonate emotionally with moviegoers. The Pixar stories frequently explore one particular overarching theme: a character yearns for a goal, and with the help of friends or family, ventures into the world to seek it and learns to appreciate their loved ones along the way—a universal, timeless theme that touches the hearts of audiences.

◄ Remy dreams of becoming a chef in *Ratatouille* (2007).

LOVABLE CHARACTERS

In *Ratatouille* (2007), Remy, a young rat, has an impossible dream. He wants to become a chef—in a culinary world that obviously does not welcome rats in the kitchen. To make their rodent star appealing, animators studied real rats at length and layered their innate cleverness and natural sense of curiosity into Remy's character. A sense of yearning pervades *WALL•E* (2008), the story of a rusty little trash compactor, who, left alone on Earth for years, meets a sleek seeker robot named EVE and follows her across the galaxy. Despite the fact that WALL•E's speech is limited, the animators were able to evoke different emotions using his eyes, whose design was inspired by binoculars. They kept his movements simple to convey his playfulness and wonder, which help audiences believe that a machine is capable of a deep and noble love.

▲ Story artist Brian Fee works on a *WALL•E* storyboard. Storyboards help filmmakers hone the characters' stories and emotional arcs.

◄ WALL•E's eyes evoke different feelings when tilted at different angles, as shown in this lighting study by John Lee.

REAL-LIFE EXPERIENCES

Pixar filmmakers often draw upon emotional experiences for their work. In *Up* (2009), they captured the emotions of Carl, who wants to have one last adventure, and Russell, the naïve young boy who accidentally accompanies him. While creating both characters, the filmmakers coined the term "simplexity"—a combination of simple design with complex emotions. Carl's facial expressions are considered the most subtle and sophisticated of all Pixar characters to date.

EMOTIONAL TRUTHS

Whether returning to old friends in *Toy Story 3* (2010), *Cars 2* (2011), and *Monsters University* (2013) or exploring the relationship between mother and daughter in *Brave* (2012), Pixar storytellers have always searched for the characters' motivating emotions. In *Inside Out* (2015), they have even depicted human emotions as actual characters, giving them shape, color, and personalities. It was simply the next challenge to be met. After all, to paraphrase John Lasseter's comment about "truth in materials," for Pixar filmmakers, every film is really about "truth in emotion."

◄ Shading Art Director Bryn Imagire and Director Pete Docter discuss rock formations during an *Up* art review.

▼ Concept art from *Up*, such as this painting by Ricky Nierva, helps define both the look and personality of determined Carl Fredricksen

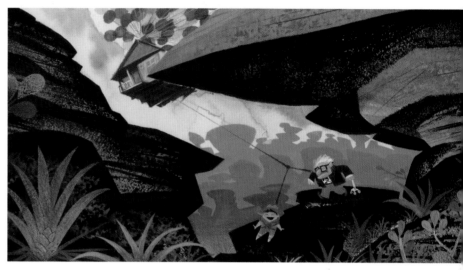

> *"When you have characters with big obstacles to overcome, that's really juicy stuff for animators."* BRAD BIRD (WRITER-DIRECTOR)

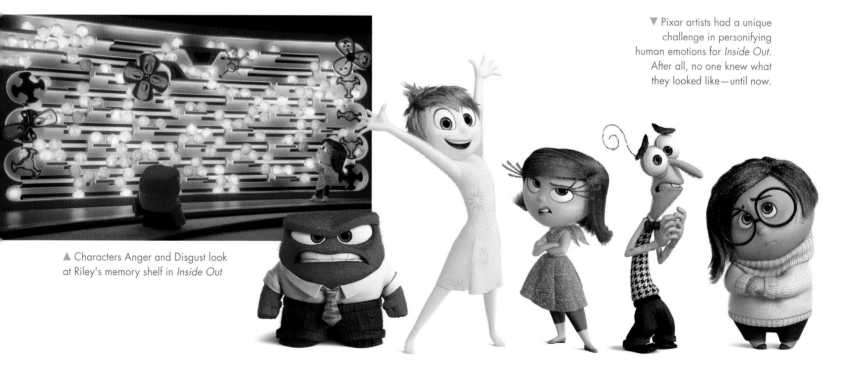

▲ Characters Anger and Disgust look at Riley's memory shelf in *Inside Out*

▼ Pixar artists had a unique challenge in personifying human emotions for *Inside Out*. After all, no one knew what they looked like—until now.

Pixar Easter Eggs

Playful Pixar artists embed visual in-jokes in their films as a treat for themselves and their most attentive audiences. Known as "Easter Eggs," these references are cleverly concealed, or sometimes "hidden in plain sight." They include cameo character appearances, visuals of props, titles of previous works, or places and events from Pixar history. A few of the Easter Eggs, such as the Pizza Planet truck and "A113" are Pixar perennials, and the artists who hide them have hatched an entire cadre of eagle-eyed fans who pride themselves on finding every one.

TOY STORY 2 (1999)
The yellow Pizza Planet truck that first drove onto the silver screen in *Toy Story* (1995) appears again in *Toy Story 2* when the toys drive the it to the airport.

UP (2009)
In homage to Pixar's much-loved first feature, the Pizza Planet truck appears in every subsequent Pixar and Disney•Pixar movie. In *Up*, it makes a cameo appearance in the fantastic sky-high view of the street from Carl Frederickson's soaring residence.

BRAVE (2012)
How do you add a truck to a film that is set in medieval times? Possibly the crafty Witch has seen into the future—and made a carving depicting a vehicle from it.

TOY STORY (1995)
A113 pays homage to the number of a classroom at CalArts (California Institute of the Arts) where John Lasseter and director Brad Bird studied.

FINDING NEMO (2003)
Director Brad Bird was the first to use A113 in a 1987 animated segment, "Family Dog," of the Amazing Stories TV series. The number appears in every Pixar feature, although sometimes audiences have to dive deep to spot it such as in *Finding Nemo* where it appears as the model number on a diver's camera.

UP (2009)
Charged with assault for defending his cherished home from destruction, Carl Fredricksen sits outside a courtroom that just happens to have the number A113.

MONSTERS UNIVERSITY (2013)
The use of A113 comes full circle from its reference to a CalArts classroom where Pixar animators studied hard, to Sulley's first college classroom—where he does not.

▶ The twilight sky glows with light from the floating lanterns in this ethereal concept painting by Jeffrey Turley.

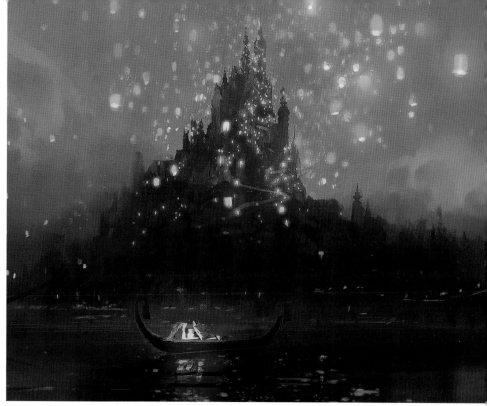

"We wanted Rapunzel to be a role model ... and her girl power to drive the story."

BYRON HOWARD (DIRECTOR)

The Lost Princess in the Tower

The princess with the flowing locks goes on a journey of discovery, with a little help from the Floating Lanterns.

▲ Rough model sheets by Glen Keane show Rapunzel playing with her hair in ways that express her emotions.

L ike Sleeping Beauty, Rapunzel from *Tangled* (2010) has no idea she is a princess. She just wants to leave the tower she is locked in to go see the Floating Lanterns. Disney's first computer-generated princess is a self-sufficient young woman who has learned to entertain herself within the confines of the tower walls. She bakes, reads, cleans, exercises, and paints. She also spends a lot of time maintaining her hair—all 70 ft (21 m) of it. Creating Rapunzel's hair was a challenge for the Disney animators—it took three years and the formation of a new software program to animate, resulting in a magical mane that almost appears to have a personality of its own.

THE GIRL NEXT DOOR
There is much more to Rapunzel than her locks, however. Disney's animators wanted the naturally happy young woman to appear down-to-earth and radiate a girl-next-door appeal, which they achieved with the help of voice artist Mandy Moore. Rapunzel may be naïve, but she is also smart, resourceful, and brave enough to leave the tower. When she does, she finds her parents, true love—and herself. *Tangled* is the fourth highest-grossing movie from Walt Disney Animation Studios to date.

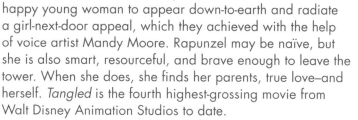

The Untamed Princess

Disney•Pixar's first historical period film, *Brave*, is inspired by Scotland, a land steeped in legend, myth, and magic.

▲ Merida's fierce determination is captured in this pencil concept sketch by Steve Pilcher.

"Merida is an independent spirit, a child of nature. Brave is an ode to girl power." MARK ANDREWS (DIRECTOR)

◀ Steve Pilcher's dramatic image of Merida and Elinor as a bear was the first painting created for the movie.

As wild as the landscape around her, Princess Merida of Castle DunBroch refuses to let anyone—especially her mother, Queen Elinor—decide her destiny. She is determined to hunt it down for herself. The feisty lass is thoroughly bored by her mother's lessons on how to behave like a princess. She would much rather be galloping her horse, Angus, over the Scottish Highlands, or practicing archery.

WILD LOCKS

The animators of *Brave* (2012) wanted to give Merida a look that communicated her exuberance and energy—enter her wild, fiery red hair. Hours of computer design time were spent on Merida's locks. Her hair has its own way of reacting to Merida's emotions, and it moves with such a flamboyance that it is practically a character itself. Finding the delicate balance in Merida's personality—between her teenage rebellion and her yearning for her mother to listen to and understand her—was a challenge. But as mother and daughter struggle to break Queen Elinor's enchantment, they weave a deeper bond that frees Merida to at last find her own destiny.

▶ Pencil sketch depicting Merida's dramatic red hair by Matt Nolte

TV Toons

Disney animation became even more fun, adapted for the small screen and broadcast right into the audience's living room.

▲ Mickey Mouse and his pals welcomed TV audiences, as well as a host of Disney animated stars, to the fun at *House of Mouse*.

With the rise of cable television and the increase of TV channels in the 1980s, Michael Eisner and Frank Wells were determined to bring quality Disney animation to television on a regularly scheduled basis. Eisner had once overseen ABC's Saturday morning animation programming and wanted at least one new series on TV by the end of 1985—and right on schedule, *The Wuzzles* and *Disney's Adventures of the Gummi Bears* appeared as part of the 1985–1986 schedule. Not long after, *The New Adventures of Winnie the Pooh* premiered in 1987 and became the first of any Disney series to win the Emmy® Award for Best Animated Program, Daytime, in both 1989 and 1990.

QUALITY ANIMATION

These shows were produced on a bigger budget than other TV animations at the time so they could live up to the Disney name. One product of this first wave of creativity was *DuckTales*, featuring the syndicated escapades of ultra-wealthy Scrooge McDuck and the gang from Duckburg. This five-days-a-week series was so successful, as was its spin-off, *Darkwing Duck*, that Disney created *The Disney Afternoon* in 1990, with *DuckTales* as the linchpin of a two-hour animation block. Other popular shows were *Chip 'n' Dale Rescue Rangers*, *TaleSpin*, and *Gargoyles*. Mickey Mouse himself made a return to the small screen in two Saturday morning animated series', *Mickey Mouse Works* and the variety show *House of Mouse*.

EDUCATIONAL ENTERTAINMENT

Preschool audiences and their parents are offered an abundance of animated and interactive adventures in a variety of artistic styles on Disney Junior channel. In the award-winning series *Jake and the Never Land Pirates*, Jake and his mates interact with audiences through jaunty songs while trying to outsmart Captain Hook in their search for doubloons. The musical series *Sofia the First* is the tale of a young princess in training, and explores what makes a real princess— the inner qualities of kindness, generosity, loyalty, honesty, and grace. The series includes appearances by Fauna, Flora, and Merryweather, the three good fairies from Walt Disney's *Sleeping Beauty* (1959), as well as special

◄ *DuckTales* brought the exploits of Scrooge McDuck and the rest of the Duck clan from the Carl Barks comic-book series to animation.

◀ Jake is ready for a swashbuckling adventure in *Jake and the Never Land Pirates*.

▲ Doc from *Doc McStuffins* follows the example of her doctor mother and, with the aid of her crew of helpers, "heals" or fixes stuffed animals.

"All these shows have really good, strong, and inspirational messages and I think that's why they are connecting with kids."

NANCY KANTER (EXECUTIVE VICE PRESIDENT, ORIGINAL PROGRAMMING AND GENERAL MANAGER, DISNEY JUNIOR WORLDWIDE)

◀ In *Sofia the First*, Sofia discovers what it means to be a princess living in a castle, learning life lessons along the way.

visits from Cinderella and other Disney Princesses. *Doc McStuffins* introduced more complex storytelling and characters to pre-school television, with Doc helping kids to understand what's happening at the doctor's office as she treats broken toys in her neighborhood. The Disney Junior channel's shows are fun and entertaining and continue to educate children in living rooms the world over.

▲ Traditional watercolor background
of Lilo's Hawaiian home by Peter Moehrle

Watercolor to Anime

Mischievous alien Stitch zaps through animation styles, from the classic watercolor look of Walt's films to cutting edge anime.

Writer/director Chris Sanders first sketched a monstrous character who lived in an isolated forest 17 years before *Lilo & Stitch* (2002) was released. Those sketches went on to inspire the offbeat animated film about a pugnacious planet-hopping alien known as Experiment 626 and the lonely Hawaiian girl who befriends the creature and names him Stitch. As Sanders' idea evolved, rather than the usual storyboards animators tend to employ, he created a 15-page book with watercolor illustrations. Seeing this storybook-like presentation, fellow writer/director Dean DeBlois was especially taken with Lilo's quirky but loving personality and the way she and Stitch unexpectedly affect each other's lives.

▲ An early visual development sketch of Stitch

REVIVING TRADITIONS

Originally Sanders had thought of sparsely populated Kansas for Stitch's touchdown point, but while planning a trip to Hawaii, he realized that the islands, isolated by thousands of miles of water, would be the perfect setting. Production designer Paul Felix and art director Ric Sluiter believed that Chris' loose, translucent watercolors were the perfect medium for capturing

▼ Concept sketch of Stitch guzzling food

▶ Advice by native dancers ensured that Lilo's hula steps were authentic. Background painting by Ron DeFelice.

▲ ▼ Concept art of naughty Stitch in action

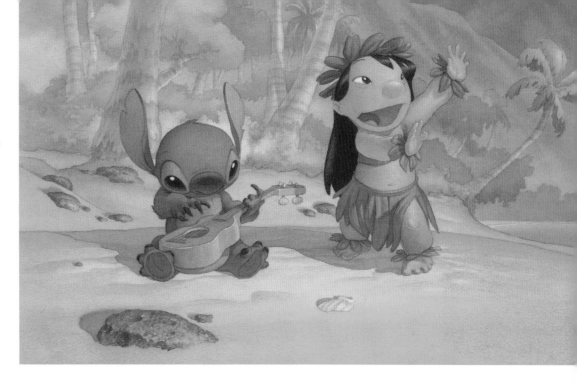

"*Ohana was just waiting for us to discover and incorporate.*" CHRIS SANDERS (WRITER/DIRECTOR)

▲ Stitch and Yuna with friends and foes, clockwise from top left: Hamsterviel, Delia, Takumi, Reika, Toyoda-San, Jumba, Pleakley, BooGoo

the island's lush landscape and luminous light. Watercolor had not been used for animated backgrounds at Disney since *Bambi*, six decades before, so background supervisor Bob Stanton and his team of 15 painters studied original watercolor backgrounds at the Animation Research Library and trained for six months to learn how to revive the art form for a Disney animated feature.

A MOVIE WITH HEART

Lilo & Stitch echoes *Dumbo*, too, in an important way— the simplicity and warmth of the story. Early on, Sanders and DeBlois decided to focus on developing the characters and their relationships. As Sanders learned more about the rich Hawaiian culture, including the important native concept of 'ohana, (family), it became the heart of the film. It is Lilo's strong attachment to 'ohana that redeems Stitch from his previous destructive programming and gives him the one thing he wasn't designed to have—a family.

ANIME ANTICS

The mischievous blue alien and his adopted Earth family were so loved that *Lilo & Stitch* inspired a television series, *Lilo & Stitch: The Series*, in 2003 and three direct-to-video sequels. Stitch's monstrous popularity in Japan inspired a TV series designed in anime style, *Stitch! (Sutitichi!)*, taking Experiment 626 to a fictional island off the coast of Okinawa where he shares wild adventures with Yuna, a karate-kicking 10-year-old tomboy. *Stitch! (Sutitichi!)* aired in Japan from 2008 to 2012, and has since taken the world by storm, Stitch-style.

Melting Hearts

Frozen enchanted audiences everywhere with an endearing snowman, two unconventional heroines, and one of the most spectacular gowns ever. One special song took the world by storm …

◀ Development sketch of Olaf by Hyun-Min Lee

Inspired by *The Snow Queen* by Hans Christian Andersen, musical animated feature *Frozen* (2013) tells the snowy story of optimistic Anna and her epic journey to find her sister Elsa, whose icy powers have trapped the kingdom of Arendelle in an unending winter. *The Snow Queen* had tantalized Disney artists—including Walt Disney himself—several times over the decades. But it wasn't until 2008, when director Chris Buck suggested a musical version to executive producer John Lasseter, who had long been interested in the Andersen fairy tale, that the creatively iced up project started to thaw. Writer/Director Jennifer Lee—the first female director in Walt Disney Animation Studios feature film history —was inspired by the source material, particularly its theme of "love vs. fear" and she and the team created an original story from there. Once the filmmakers hit upon the idea that the heroine and the villain were sisters with a shared past, they realized the full potential of the story. Normal fairy-tale tropes were turned on their heads as the movie focused on the sisters' love for each other.

NORDIC ART DIRECTION

Art director Mike Giaimo drew on diverse Disney inspirations to create *Frozen*'s distinctive style. The design of Anna's traveling capes reflects patterns seen in costumes worn by Annette Funicello in *Babes in Toyland*, while the strong vertical and horizontal planes and bold use of color throughout the film evoke the stylized *Sleeping Beauty*. Giaimo traveled with his team to Norway to visit fortresses, castles, museums, cathedrals, fjords, and glaciers. The production design team found the unexplored environment, the architecture, and the folk costume aesthetics perfectly suited to a Disney film they envisioned in the classic style.

SCORES OF ACCOLADES

Composer Christophe Beck skillfully infused Norwegian musical influences into the score, which was recorded by a full 80-piece orchestra featuring 32 vocalists, including native Norwegian Christine Hals, who provided authentic "kulning," or herding calls. The songwriters—Kristen Anderson-Lopez and Robert Lopez— were deeply involved in the creation of the story. While building the plot, the filmmakers met with the duo every day.

"We decided we didn't a traditional Disney

They focused not just on the songs but also on the characters. The runaway hit "Let It Go" gives voice to Elsa's profound transformation. During the "Let It Go" number, Elsa transitions from buttoned up perfectionist

◀ Digital art exploring lighting, shapes, and character placement by assistant art director Lisa Keene

▼ Elsa in her dazzling Snow Queen dress

to a person who gives herself permission to be who she is. Everything changes, including her hair, which becomes wilder, and her gown takes on a magical dimension. Elsa is finally free—even if she is alone.

want this to be princess song."

ROBERT LOPEZ

"Let It Go" won an Academy Award® for Best Song, while *Frozen* won the Oscar® for Best Animated Feature.

*F*rozen was the movie that took the world by storm, and as a result of its success, Walt Disney Animation Studios decided to make a short sequel in 2015—*Frozen Fever*. Created by the feature directing team of Chris Buck and Jennifer Lee, the short includes the original voice talent and a brand new song written by Kristen Anderson-Lopez and Robert Lopez. This warm-hearted story packs a lot of fun into just seven minutes. Viewers can watch the people of Arendelle celebrate Anna's birthday, with party-planning mayhem from Kristoff, Sven, and Olaf, and many other magical snowmen.

Brains, 'Bots, and Non-Stop Action

▲ Baymax, the cutting-edge nurse robot, is transformed into a warrior with super-strength and the power of flight.

Dynamically combining anime-influenced design with cutting edge computer animation, *Big Hero 6* is a Disney adventure unlike any before.

Based on a little-known Marvel comic-book series, *Big Hero 6* (2014) centers on brilliant robotics prodigy Hiro Hamada, who finds himself in the grip of a sinister plot that threatens to destroy the city of San Fransokyo. With the help of a caring healthcare robot named Baymax, Hiro transforms a group of reluctant but supportive applied science students into a band of high-tech heroes.

BUILDING BAYMAX

The filmmakers decided early on that the heart of the film was the relationship between Hiro and the medical-care 'bot, invented by the boy's brother. Hiro's love of technology was inspired in part by Japanese researchers, who were all influenced by the robots seen in animation. In Japanese pop culture, robots are portrayed as the key to a hopeful future. Director Don Hall sought to present a robot never before seen on screen. Part of the process of creating compassionate Baymax involved researching the robotics world during field trips to MIT, Harvard, and Carnegie Mellon University in the U.S. and to Tokyo University in Japan. At Carnegie Mellon University they witnessed research into soft robotics, that included an inflatable vinyl arm. The minute the filmmakers saw the non-threatening arm, they knew they had their huggable robot. According to head of animation Zach Parrish, many references were sought for Baymax's movements, including real and movie robots, cuddly babies, and koala bears. With their long torsos and short legs—similar body proportions to Baymax—baby penguins were a particular source of inspirational moves and gaits. Fellow Director Chris Williams admits to loving "newborn" characters like Baymax who allow audiences to see the world anew through their eyes.

WAY OF THE WARRIOR

The "warrior" version of Baymax, upgraded by Hiro with a rocket fist, super-strength, and rocket thrusters,, was given karate abilities by the *Big Hero 6* artists to broaden his skillset.

◄ The masked menace Yokai is a powerful and ruthless adversary.

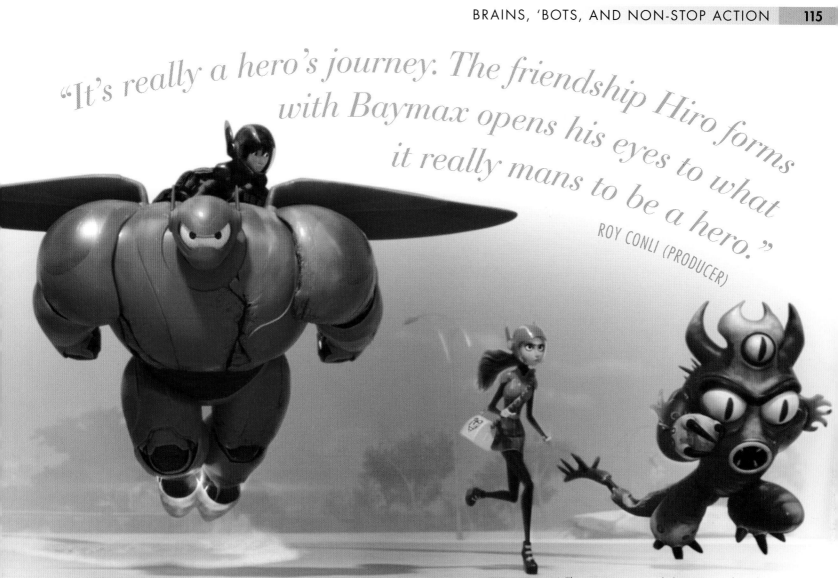

"It's really a hero's journey. The friendship Hiro forms with Baymax opens his eyes to what it really mans to be a hero."

ROY CONLI (PRODUCER)

▲ The team's powers include super-speed maglev wheels, plasma blade weaponry, flight, balls filled with potent chemical agents, and steel-melting flames.

A few members of the team visited a nearby martial arts studio, where professional karate practitioners were asked to make some of the moves while on their knees to simulate Baymax's signature proportions. In order to choreograph and execute the sequences of Baymax and Hiro soaring above the San Fransokyo skyline, filmmakers consulted with flight specialist Jason McKinley, who worked in the same role for Disney's *Planes*. As a result of the filmmakers' efforts, the movie won an Oscar® in 2015 for Best Animated Feature Film.

▶ An exotic mash-up of San Francisco's geography and Tokyo's energy, San Fransokyo makes an ideal location for this action-packed film.

Surprises and Salutes

Have you ever noticed the Mickey Mouse watch at the Rescue Aid Society's headquarters in *The Rescuers*? Did you spot Belle from *Beauty and the Beast* wandering through the square in *The Hunchback of Notre Dame*? Many Disney animated features have visual surprises hidden within the action to honor other characters and films. Disney artists include these salutes to amuse themselves as well as sharp-eyed Disney aficionados, and finding them has become a popular sport of sorts. Here are a few of these blink-and-you'll-miss-it filmic treats.

ONE HUNDRED AND ONE DALMATIANS (1961)
Peg and Bull from *Lady and the Tramp* (1955) put in a cameo appearance in the London pet store window during the "Twilight Bark" scene.

THE LITTLE MERMAID (1989)
Keen eyes can spot Goofy and Donald Duck in the audience at the recital of King Triton's daughters.

ALADDIN (1992)
A figure of the Beast from *Beauty and the Beast* (1991) can be seen among the toys and trinkets that the Sultan plays with in his throne room.

HERCULES (1997)
The film's co-directors, John Musker and Ron Clements, appear in charicature form as two builders that Hercules accidentally knocks off an awning. (Look out for a cameo of John and Ron in *Aladdin*, too!)

TARZAN (1999)
During the "Trashin' the Camp" number, Terk plays a tune on a teapot and matching teacups strangely reminiscent of Mrs. Potts and her brewing brood from *Beauty and the Beast* (1991).

LILO & STITCH (2002)
Nani, Lilo's older sister, has a *Mulan* (1998) poster on her bedroom wall. The co-directors of *Lilo & Stitch*, Dean DeBlois and Chris Sanders, both worked on *Mulan*.

THE PRINCESS AND THE FROG (2009)
Co-directors John Musker and Ron Clements pay homage to their earlier classic, *The Little Mermaid* (1989), by including a King Triton float in the Mardi Gras parade.

TANGLED (2010)
Flynn and Rapunzel are surrounded by library books, three of which are classic Disney titles—*Beauty and the Beast* (on the floor), *The Little Mermaid* (far right), and *Sleeping Beauty* (under the window).

WRECK-IT RALPH (2012)
The score of the Niceland video game refers to Walt Disney's date of birth: December 5, 1901. In *Big Hero 6* (2014), footage of Niceland plays on a San Fransokyo's skyline big screen.

FROZEN (2013)
Rapunzel and Flynn from *Tangled* (2010) attend Elsa's coronation in *Frozen*. Rapunzel is wearing the same costume she wore at the conclusion of *Tangled*.

Infinite Possibilities

▶ *Disney Infinity* features Sorcerer's Apprentice Mickey from *Fantasia* (1940), complete with the Sorcerer's hat.

Disney Infinity combines many Disney properties in one interactive world where you can create your very own story.

Disney Interactive Studios took video games to a whole new level with the launch of *Disney Infinity* in 2013. The popular action-adventure video game immerses Disney fans and gamers into a storytelling world where Disney characters from different movies co-exist— Mr. Incredible can ride Cinderella's coach or Merida from *Brave* can board Captain Jack Sparrow's ship. The game uses collectible character figures and releases have included characters like Anna and Elsa from *Frozen*, Rapunzel from *Tangled*, Woody and Buzz Lightyear from the *Toy Story* movies, and Sorcerer's Apprentice Mickey from *Fantasia*. Marvel Super Heroes made their debut in the game with the release of *Disney Infinity (2.0 Edition)* in 2014 and *Star Wars* characters were introduced in 2015. The characters are recognizable; Jack Sparrow speaks in his signature pirate voice and Sulley roars. Familiar elements of Disney architecture throughout the game add to the storytelling fascination, such as Sleeping Beauty Castle and the Matterhorn from Disneyland Park.

A BOTTOMLESS TOY BOX

In Play Set mode, the gameplay is themed to a single story. Different Play Sets are available, such as the Pirates of the Caribbean Play Set and Inside Out Play Set. Toy Box mode is more like a modern, digital form of a kid's toy box. According to Art Director Jeff Bunker, *Toy Story 3*, in which all sorts of different toys interact, was the genesis of the Toy Box for the game's developers and designers at Disney Interactive Studios and Avalanche Software. In Toy Box mode, players can create their own

◀ Super-charged robot Baymax from *Big Hero 6* packs plenty of power.

◀ Missions are more fun with the roguish and loveable Stitch from *Lilo & Stitch* (2002).

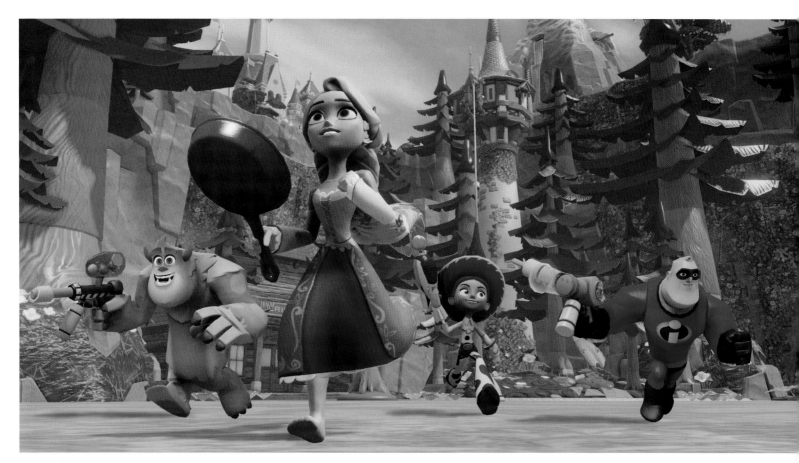

▲ In this scene directly from the game, Rapunzel leads the adventure with Sulley, Jessie, and Mr. Incredible—all ready for action.

▼ Playful Wreck-It Ralph is naturally at home in a video game world

journey and tell unique stories in their own way using lots of amazing Disney characters and without any rules. As John Lasseter has said, "If you can think about it, you can create it." The possibilities are endless, both for players and for the game's developers as new releases inevitably reach exciting new heights.

DESIGNING DISNEY INFINITY FIGURES

When discussing the look of the characters, John Lasseter told the Disney Infinity team that the figures would have to be "wicked awesome." The quest for "wicked awesome" began, and a lot of work went into the creation and look of the figures. The designers were inspired by Urban Vinyl collector's figures with their hard, smooth, chiselled edges and matte finish. The hope was always that the figures would be displayed on bedroom shelves rather than stored away in a box.

"We've come up with a fantastic tool chest for creativity." JOHN LASSETER

▲ Courageous Anna from *Frozen* (2013) isn't afraid to use a climbing hook or shovel swing to take down monster snowmen.

"I do not make films primarily for children.
I make them for the child in all of us,
whether we be six or sixty." WALT DISNEY

Disney in Action

▲ Bobby Driscoll in London during his 1950 *Treasure Island* publicity tour.

A Live-Action Treasure

The adventure movie that launched a thousand movies, *Treasure Island* got Walt's all-live-action career off to a swashbuckling start.

Though he had originally considered *Treasure Island* (1950) as an animated feature in the late 1930s, the prolific producer soon changed his mind, planning the pirate property as an animation/live-action combination similar to *Song of the South* (1946), with Long John Silver spinning animated animal yarns for young Jim Hawkins. But the Disney Studio had frozen funds in England: box office receipts earned by Disney films in the UK could not be exported due to postwar currency regulations. Walt decided to spend the funds in England, sailing into uncharted waters by producing *Treasure Island* as his first all-live-action feature film.

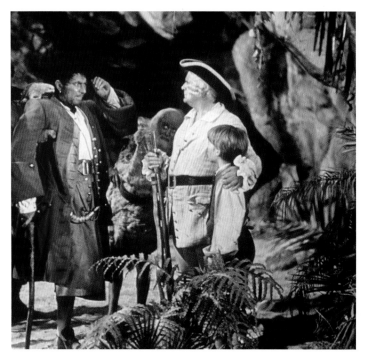

◄ The exotic-looking beach was actually in a studio in London, England.

FILMING IN ENGLAND
Exteriors were shot at Denham Studio near London while the sea scenes were filmed at Falmouth in Cornwall. For the seagoing scenes, an 1887 three-master schooner was rebuilt and outfitted with two concealed diesel engines. Walt also enlisted master British matte painter Peter Ellenshaw. The artist added ship masts and other visual elements through paintings on glass panes placed in front of the camera during filming. Later, at Walt's invitation, Peter joined the Disney Studio in California, contributing to such classics as *Mary Poppins* (1964).

CLASSIC PERFORMANCES
Walt long had his young contract player Bobby Driscoll in mind to play Stevenson's stouthearted hero, Jim Hawkins, just as soon as Bobby reached the right age to play the cabin boy. The recipient of an Academy Award® for Outstanding Juvenile Performance in 1949, Bobby was the only American (and the only child) in a cast otherwise filled with British performers, chief among them the brilliant stage and film actor Robert Newton. Having already won acclaim working with such esteemed filmmakers as Alfred Hitchcock, Laurence Olivier, and David Lean, Newton turned in an indelible performance as the rascally one-legged Long John Silver. The role not only defined his career but also cemented the popular stereotype of a pirate.

▼ Disney star Bobby Driscoll as heroic cabin boy Jim Hawkins and Robert Newton in his signature role as Long John Silver

► Map detailing the location of pirate Captain Flint's lost treasure

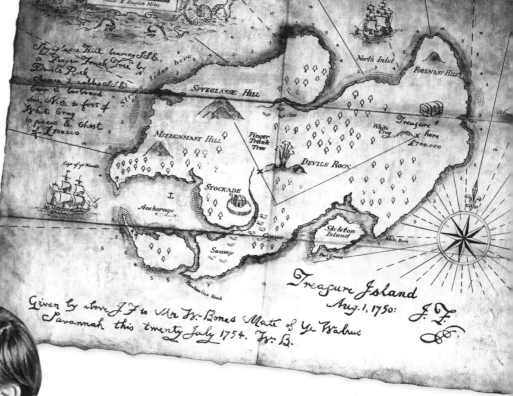

"Buried treasure, pirates, excitement, and adventure— all these combine to make Robert Louis Stevenson's Treasure Island *one of the best known—and best loved—adventure stories of all time."* WALT DISNEY

JUST THE BEGINNING

After its world premiere in London on June 22, 1950, *Treasure Island* was released on July 19, 1950. The film was a hit—so much so that Disney set sail with three more swashbucklers filmed in England, including *The Story of Robin Hood and His Merrie Men* (1952). Though he would of course continue with his animated features and shorts, Walt Disney was now undisputedly a live-action filmmaker.

Oceans of Adventure

From two great fabulists—Walt Disney and Jules Verne—surged *20,000 Leagues Under the Sea*, one of Hollywood's most acclaimed science-fantasy epics.

▲ The crew films underwater with specially augmented cameras.

▲ Disney-designed hand signals chart for underwater filming

The inspiration for one of Walt's greatest live-action classics actually began with his award-winning True-Life Adventure nature documentaries. Visualizing an undersea True-Life Adventure storyboard, production artist Harper Goff created a sequence drawn from *Twenty Thousand Leagues Under the Sea* by Jules Verne. Fascinated, Walt decided to produce *20,000 Leagues Under the Sea* (1954) as his first made-in-Hollywood blockbuster live-action feature.

WALT'S INNOVATION

20,000 Leagues was only the second movie to be produced in CinemaScope® and a custom waterproof case for the cameras and the CinemaScope® viewfinder was devised. To encompass the mammoth production, Walt had constructed a huge new sound stage on his studio lot, Stage 3, which included a massive indoor tank.

THE STAR OF THE MOVIE

Walt cast the film from among Hollywood's best. Top box-office star Kirk Douglas was signed as bold harpoonist Ned Land, and James Mason delivered a powerful

Dorsal fin

Rivets pattern

Shark-like tail

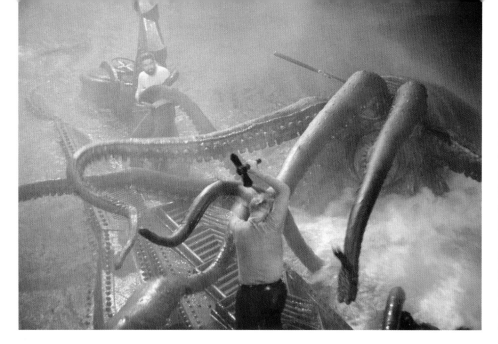

◄ James Mason as Captain Nemo in the amazing squid battle scene

as was a full-size *Nautilus*, which was 200ft (61 m) long and 26 ft (8 m) wide at its broadest point. The mechanical two-ton (2,000 kg) squid that battled the mighty *Nautilus* had eight 40 ft (12 m) long tentacles and required a team of 28 to operate.

UNDERWATER MOVIEMAKING

Filming began January 11, 1954, with the underwater footage filmed on location in the crystal clear waters of Nassau in the Bahamas. For eight weeks, a 54-member crew shot more underwater footage than had ever been seen in a film up to that period, with the crew limited to 55 minutes at a time underwater due to the amount of oxygen in their air tanks. Disney's diving and design experts invented unique but practical costume diving suits: hand-tooled outfits weighing a staggering 225 lb (102 kg).

performance as tormented undersea genius Captain Nemo. To Harper Goff, however, the star of the film is Nemo's atomic-powered submarine, the *Nautilus*. The artist's starting point in envisioning this Victorian-styled vessel was its supposed appearance as a sea monster. Its streamlined body, dorsal fin, and prominent tail simulated features of a shark. The heavy rivet patterns on the surface plates represented the rough skin of an alligator, while the forward viewports and top searchlights represented its menacing eyes. Six scale models of the sub were used in the filming,

"When we decided to make a picture out of this classic story, we soon discovered that the imagining was much easier to do than the doing." WALT DISNEY

Viewports

▼ Captain Nemo's undersea ship, the iconic *Nautilus*

Anchor

Favorite Classics

Over the years, Walt produced a myriad of live-action motion pictures, many of which are true Disney classics that have stood the test of time.

▼ A lavish song-and-dance spectacle in the grand Hollywood tradition, *Babes in Toyland* was Walt's first all live-action musical.

"... we have never lost our faith in family entertainment stories that make people laugh, stories about warm and human things ..." WALT DISNEY

The kaleidoscope of classic live-action films created by Walt through the years is part of the enduring Disney legacy. The wide variety of subjects includes the leprachauns in the fantasy *Darby O'Gill and the Little People* (1959), which originated from the great showman's fascination with the Darby O'Gill stories by H. T. Kavanagh. In the 1940s, Walt visualized the film as a combination of animated leprechauns and live actors, but by the 1950s, he saw it as a spectacle of live-action effects.

MAGICAL EFFECTS

Walt challenged his filmmaking wizards to make the tiny leprechauns completely believable, a task that called for painstaking planning. By placing Darby (played by Albert Sharpe) in the foreground and the actors playing leprechauns much farther back and lower, the camera perspective convincingly made it look as though the wily old storyteller was interacting with the Little People. The intense special effects used for *Darby O'Gill and the Little People* called for an extremely well-lit set, and so much electricity that one particularly complex shot caused a citywide power failure in Burbank.

ENDURING CLASSIC

Classic Mother Goose characters and an entrancing vision of a Toyland where wooden soldiers come to life have made *Babes in Toyland* (1961) a holiday perennial. Disney composer George Bruns enlivened Walt's vision by adapting the beloved melodies from Victor Herbert's original stage hit into an Academy Award®-nominated movie score. Annette Funicello is the film's leading lady. Disney's "girl next door" from TV's *Mickey Mouse Club*, she was then at the peak of her success as a recording star. For the comically villainous Barnaby, Walt cast Ray Bolger, the Scarecrow in MGM's *The Wizard of Oz* (1939).

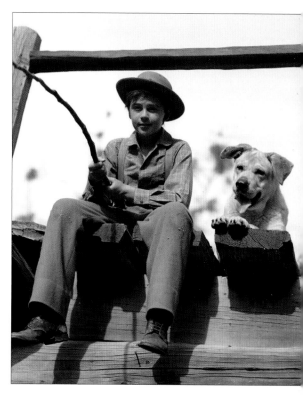

▲ One of Disney Studio's biggest stars of the 1950s and 1960s, Tommy Kirk shone in *Old Yeller*, a coming-of-age story about a boy and his dog.

CRUCIAL CASTING

Walt cultivated his own stable of stars that in addition to Annette, included Tommy Kirk, who turned in a deeply affecting performance in *Old Yeller* (1957) and Hayley Mills, who made her Disney debut in *Pollyanna* (1960), an adaptation of Eleanor H. Porter's novel. The casting of Pollyanna was crucial, and more than 300 girls were auditioned. Walt finally found his perfect Pollyanna in the daughter of British stage legend John Mills. With her expressive face, natural emoting, and innate flair for comedy, Miss Mills more than held her own with the all-star cast.

Zany Comedies

Disney comedies earned a place in cinema history with a distinctive blend of slapstick, fantasy, and innovative special effects.

▶ The Shaggy Dog (1959) put a teen-turned-pooch in the driver's seat, fueling a whole series of special-effects comedies.

Walt reveled in creating cartoon-like antics in live-action films. The result was a series of zany comedies combining slapstick, special effects, and a soupçon of social satire. Walt had originally planned *The Shaggy Dog* (1959) as a TV show, but when the network wasn't interested, he produced it as a theatrical feature instead. Starring Disney favorite Tommy Kirk as the teenager-turned-canine, this wacky live-action funfest also featured Fred MacMurray in his first Disney film. The sight of a big,

◀ Fred MacMurray mastered the science of slapstick in *The Absent-Minded Professor* (1961).

furry dog driving a car, brushing his teeth, and performing other human activities was a crowd-pleaser and *The Shaggy Dog* became one of the biggest box-office hits of the year.

SHOWSTOPPING EFFECTS

MacMurray returned in *The Absent-Minded Professor* (1961), the story of Medfield College's Professor Ned Brainard, who discovers an anti-gravity material—flying rubber—that he dubs "Flubber." The airborne-automobile effects in the film utilized a number of filmmaking techniques, including the matte process (where actors and background footage are combined), miniatures, and wire-supported mock-ups. The basketball game scene, featuring the Medfield basketball team bouncing high over the heads of their rivals, took two months to shoot. As well as trick shots mixed together, the scene used an all-new approach to create the illusion of flight by suspending actors on wires.

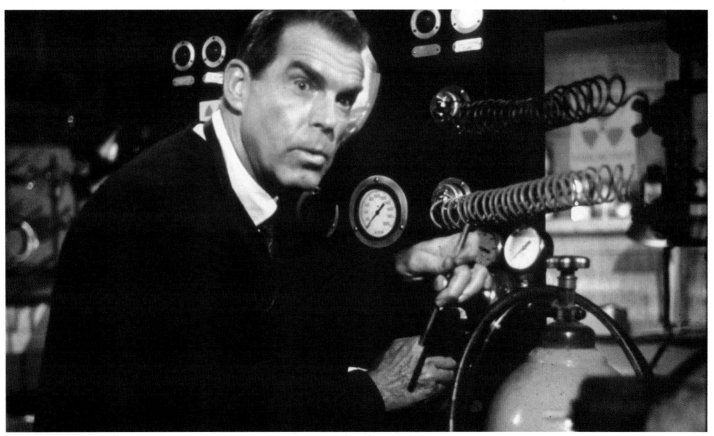

"A family picture is one the kids can take their parents to see and not be embarrassed."

WALT DISNEY

COMEDY CAR

Planned by Walt as a worthy addition to his comedy canon, though not released until three years after his passing in 1966, *The Love Bug* (1969) featured a most unusual movie star: Herbie, a 1963 sunroof-model 1200 Volkswagen, complete with signature red, white, and blue racing stripes. Herbie's astounding speed was achieved with a powerful bus engine in some sequences, and a Porsche engine with a top speed of 115 mph (185 kph), in others. The car with a mind—and heart—of his own captured the imaginations of moviegoers, and the film was the number one hit of 1969. Herbie drove on to star in a fleet of sequels, including *Herbie: Fully Loaded* in 2005.

The Absent-Minded Professor was such a hit that Walt produced a popular sequel, *Son of Flubber* (1963), that used equally hilarious trick shots. The flubberized soccer game scene had to be shot on a specially constructed set—built on one of the Studio's largest soundstages—where the trick shots could be carefully controlled.

▼ MacMurray returned as Prof. Brainard in *Son of Flubber* (1963).

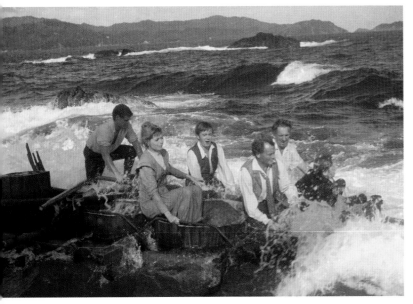

Escapade in Paradise

Disney adventure on an epic scale, *Swiss Family Robinson* features pirates, wild animals, and the world's most famous treehouse.

▲ The sequence in which the shipwrecked Robinsons floated themselves and the ship's livestock ashore was one of the most challenging to film.

▼ Standing at the center of all the action-adventure: the iconic Swiss Family Robinson treehouse, topped by a Swiss flag

► The action-packed pirate attack was carefully planned out on storyboards before on-location filming.

One of Walt Disney's most popular live-action escapades, *Swiss Family Robinson* (1960) unfurls the tale of castaways on an uninhabited South Seas island, who resourcefully utilize wreckage from their ship to build a new life in paradise. Walt viewed the orginal 1812 book by Johann Wyss as a great adventure that was an ideal subject for a Disney production. Though he originally considered the project for television, the prolific producer soon envisioned a widescreen epic. Walt challenged his filmmakers to expand the book's excitement by imagining every kind of fun a family living on an island could have.

BRINGING THE VISION TO LIFE

Walt realized that a studio sound stage could not contain all the adventure he had envisaged, so director Ken Annakin and co-producer Bill Anderson scouted the globe until they found the Caribbean island of Tobago. Though inhabited and civilized, many of Tobago's natural wonders remained untouched, with pristine beaches, coral-rimmed coves, and lush jungles. But the main attraction of the Swiss Family location was built by Disney artistry and ingenuity: the unforgettable triple-deck treehouse. Inspired by concept art from veteran Disney artist John Hench, the iconic treehouse was constructed in an immense, 200-ft (61-m) tall Samoan rain tree spotted by art director John Howell through a gap in a cricket-field fence just outside the town of Goldsborough. This ingenious, dream treetop abode was built just as it appears on screen, complete with such amenities as a giant waterwheel, bamboo skylight, and a working pipe organ. For the cast, Walt signed up distinguished British actor John Mills and Hollywood veteran Dorothy McGuire as Mr. and Mrs. Robinson, with Disney favorites James MacArthur, Tommy Kirk, and Kevin "Moochie"

Corcoran as their sons. Filmed in Panavision® over a span of 22 weeks, the elaborate production demanded three separate camera units, making it the most expensive live-action movie Walt Disney ever produced. *Swiss Family Robinson* was released on December 21, 1960, to the excitement of thrill-seeking audiences.

TREETOP ATTRACTION

Disneyland® Park guests could experience the treehouse in all its glory from November 1962, when Walt Disney dedicated the Swiss Family Treehouse attraction. The original at Disneyland Park is called a "Disneyodendron semperflorens grandis" (translated as "large ever-blooming Disney tree"). In August 1999, the attraction was transformed into Tarzan's™ Treehouse, but Swiss Family Treehouse itself continues to allow guests to climb to adventure in several Disney theme parks around the world.

"Since our stage was a tropical island we knew we would be faced with many problems. But like the Swiss Family Robinson we improvised, invented, and had a wonderful time doing it." WALT DISNEY

Practically Perfect

Walt Disney combined unforgettable performances, lilting songs, and wondrous movie effects into one of Hollywood's biggest hits, *Mary Poppins*.

With astounding special effects overflowing from a bottomless carpetbag of movie magic, *Mary Poppins* (1964) is an extravagant musical fantasy about the proper British nanny who can do anything. She can slide up a banister and sing a duet with her own mirror reflection or pop into a chalk pavement picture for tea and cakes. Walt knew this unique fantasy was an ideal subject for Disney special effects to bring to life in a movie musical. He first became intrigued by this extraordinary character in the early 1940s when he found his daughter Diane laughing as she read the first of the *Mary Poppins* books by P. L. Travers. He finally obtained the screen rights in the early 1960s, and assigned songwriting siblings Richard and Robert Sherman to weave the stories into song. One of the first and most significant songs, "Feed the Birds" was inspired by a story Mary Poppins tells the children in her care about the old Bird Woman who sells bread crumbs at St. Paul's Cathedral. The Shermans saw the story as deeply spiritual; a gentle plea for charity and love.

▲ The magical nanny floats over the rooftops of London, the world of the chimney sweeps.

"We decided to try something that would employ about every trick we had learned in the making of films ... in an enormous fantasy— Mary Poppins." WALT DISNEY

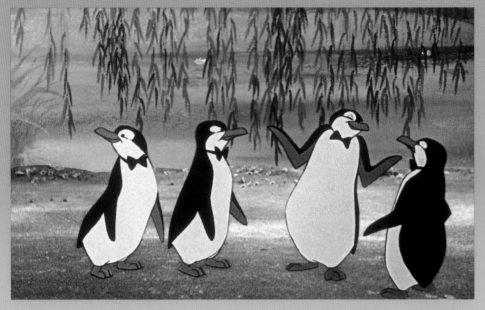

▲ It was Walt Disney's own idea that the "Jolly Holiday" waiters should be penguins.

CASTING A NANNY AND A CHIMNEY SWEEP

In 1961, Walt saw Julie Andrews in her Broadway hit, *Camelot*. He visited the star backstage and launched into an all-out rendition of the *Mary Poppins* story. Later, Julie agreed to make her motion-picture debut as the enigmatic enchantress.

It was Walt's idea to combine several different characters from the original books into Bert, a jack-of-all-trades who is a one-man band and a chimney sweep, among other occupations. The great showman ultimately cast Dick Van Dyke, the versatile star of the stage and film musical *Bye Bye Birdie* and the classic television series, The *Dick Van Dyke Show*, in the role of the happy-go-lucky friend of Mary Poppins.

WALT'S GREATEST ACHIEVEMENT

By combining all the eye-popping movie magic at his command—from live-action, animation, and music to comedy, sentiment, and *Audio-Animatronics*® technology—Walt brought *Mary Poppins* to cinematic life in a most delightful way. When it debuted on August 27, 1964, the movie was a huge hit. It was nominated for 13 Academy Awards® and won five Oscars®, including Best Actress for Julie Andrews. A true classic, it's no wonder that *Mary Poppins* was known as "Walt Disney's Greatest Film Achievement."

▲ The letter blocks from the children's nursery are now housed in the Walt Disney Archives.

A Special Storyboard

A Disney-developed practice for visualizing the action of a film, the first complete storyboards were drawn up for the Silly Symphony animated short *Three Little Pigs* (1933). Walt Disney credited artist Webb Smith for inventing the concept of drawing scenes on separate sheets of paper and pinning them up on a bulletin board to develop a story in sequence. But storyboards are not just for animation; Disney has long utilized the technique for live-action movies. Storyboards were created for the entire *Mary Poppins* film including the "A Spoonful of Sugar" sequence. Stop-motion specialists Bill Justice and X Atencio planned the eye-popping "Spoonful of Sugar" special effects through the storyboard process, too.

ORIGINAL STORYBOARD
Credited with "Nursery Sequence Design" in the film's opening titles, veteran Disney artists Bill Justice and X Atencio storyboarded *Mary Poppins'* magic as she tided up the nursery to the tune of "A Spoonful of Sugar."

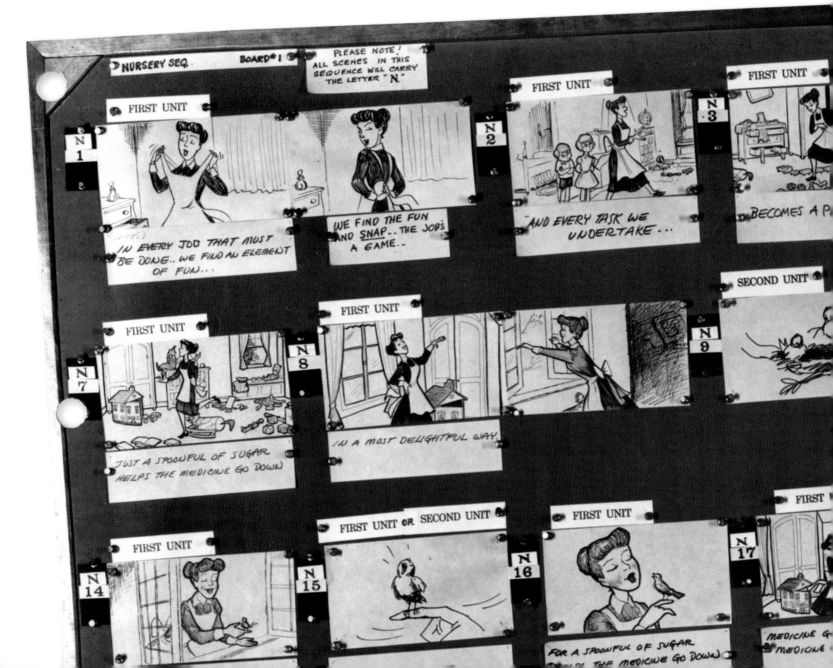

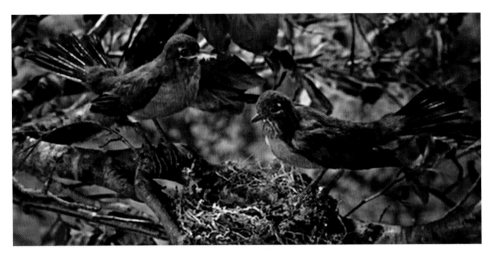

AUDIO-ANIMATRONICS® BIRDS
The robins who whistle the merry song along with Julie Andrews were created by *Audio-Animatronics®*, Disney's own technology of three-dimensional figural animation. This innovative process was then in its early stages and was creating a sensation at the 1964–65 New York World's Fair the same year *Mary Poppins* was released.

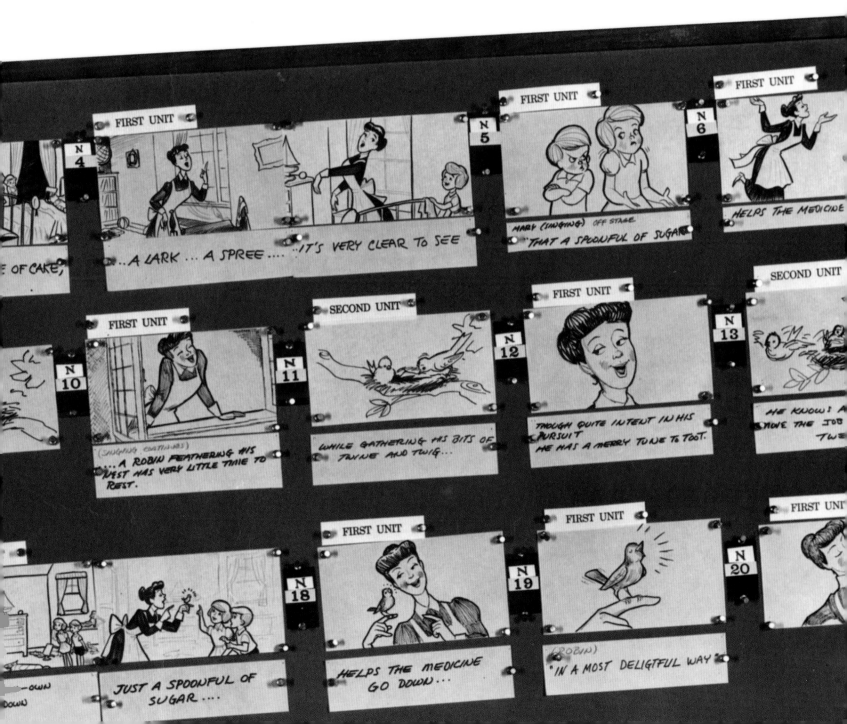

"The Isle of Naboombu" prop storybook is preserved in the Walt Disney Archives.

A Creative Encore

Bedknobs and Broomsticks reunited the creators of *Mary Poppins* to conjure up show-stopping musical numbers, live-action and animated antics, and the magical misadventures of an amateur witch.

Angela Lansbury stars in this musical extravaganza as prim and proper Miss Eglantine Price, who just happens to be taking a correspondence course in witchcraft. Miss Price reluctantly teams up with three young Cockney orphans and a conman—played by Disney favorite David Tomlinson—to find an ancient spell to help save England from invasion in World War II. Amazingly, the origins of this Oscar-winning film actually predate *Mary Poppins*, as Walt Disney obtained screen rights to *The Magic Bed-knob* and *Bonfires and Broomsticks* by English author Mary Norton in the 1940s. However, it was not until the 1960s, during a dormant period in the development of *Mary Poppins*, that Walt, songwriters Richard and Robert Sherman, writer/producer Bill Walsh, and co-writer Don DaGradi began crafting a screen musical. These moviemaking magicians took the basic idea of a spinster sorceress and combined it with an idea from a 1940 newspaper story that Walsh remembered, which speculated about British witches staving off Nazi invasion. "The Old Home Guard" was the first tune the songwriting Shermans composed for *Bedknobs and Broomsticks* (1971) because they felt strongly that the film was really about the spirit of England. Most of the *Bedknobs* songs and

▲ Filming the Oscar®-winning special effects using the Disney-perfected sodium vapor process, or "yellowscreen," which is similar to the famous bluescreen process.

story material were created in conjunction with Walt during this early period. When work resumed on *Mary Poppins*, Walt temporarily set *Bedknobs* aside.

BRINGING IT ALL TOGETHER

Flash forward to 1969, three years after Walt's death, when Bill Walsh revived the project. Setting out to fulfill Walt's original vision, he reunited the *Mary Poppins* team, including director Robert Stevenson, and cast Angela

◄ Publicity art showcasing the hybrid of cartoon critters and real life action.

Lansbury, fresh from her Broadway triumph in *Mame*. The film was shot at the Disney Studio on lavish sets including a three-block recreation of London's famed Portobello Road. The animated soccer match was directed by one of Walt's legendary Nine Old Men, Ward Kimball, and feature 130 gags at a breakneck pace. *Bedknobs and Broomsticks* premiered in London on October 7, 1971, at the famed Odeon Theatere in Leicester Square.

The sorcery-filled super-spectacular was nominated for five Academy Awards® (including Best Song for "The Age of Not Believing"), and its eye-popping onscreen magic won the Oscar® for Best Special Effects.

"There's kind of a nice, homey, folksy quality about an English witch"
BILL WALSH (PRODUCER/CO-WRITER)

▼ Miss Price's magic bedknob (aided by Disney's Oscar®-winning special effects) takes the spell-seekers to the bottom of an animated ocean.

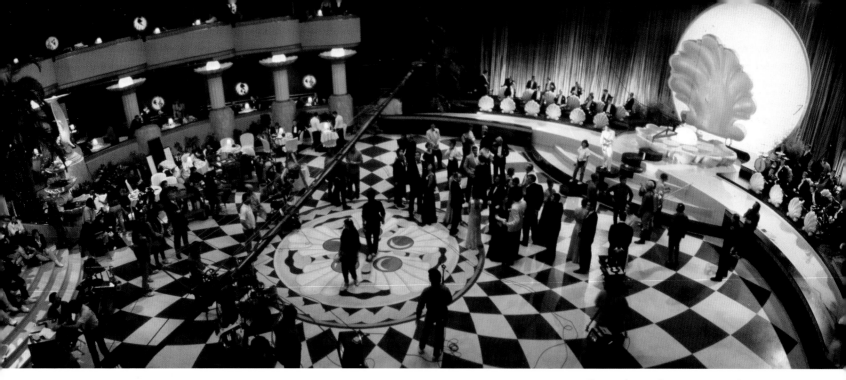

Rocketing into Adventure

A thrilling adventure in the air, *The Rocketeer* zoomed into the hearts of sci-fi and comic book fans to become a high-flying cult classic.

Comic-book action, pulp magazine adventure, and movie serial suspense combine to create high-octane adventure in *The Rocketeer* (1991). Young test pilot Cliff Secord is hurled into a daring adventure of mystery and intrigue in 1938 Los Angeles when he discovers a top secret rocket pack that allows him to navigate the skies as the mysterious helmeted hero the Rocketeer. Reminiscent of 1930s TV adventure serials, the film is based on a comic-book series introduced in 1981 by writer-artist Dave Stevens (who has a cameo in the movie as the German test pilot in the black-and-white Nazi film).

DYNAMIC DESIGN

A fan of the original comic book, director Joe Johnston strove for lots of action in the movie, but also authenticity in recreating the look of the period. The design of the film required hundreds of technicians to recreate a 1938 Los Angeles. In addition to building period

▶ Artist and sculptor Edward Eyth designed sets, props, storyboard sequences, and the iconic rocket jetpack.

A functioning engine was included in the prop jetpack.

The Rocketeer's jetpack emitted real fire trails from its thrusters.

A leg guard was added to the pack for the safety of the stunt performers.

The jetpack could be easily dismantled to make adjustments to the engine.

sets—including the pup-shaped Bulldog Café, based on an actual Los Angeles restaurant—designing the all-important Rocketeer costume was a challenge. The designers reimagined the rocket pack from its original comic-book design, giving it a more aerodynamic, functional look. The Rocketeer's helmet had to appear practical as well as dynamic in design, and dozens of variations were drawn up. Finally, just a week before filming was due to begin, Stevens worked with sculptor Kent Melton to create the sleek, streamlined headgear that is seen in the movie.

STARRING ROLE

In casting for the role of Cliff Secord, hundreds of actors were considered (even Dave Stevens himself was invited to audition). But it was Billy Campbell, the physical embodiment of the youthful test pilot as seen in the comic, who was finally selected to play the Rocketeer.

"I was intrigued by the comic-book character, the period in which it is set, and what I knew would be a great adventure story."

JOE JOHNSTON (DIRECTOR)

HIGH-FLYING EFFECTS

The special effects wizardry in the film had to be effective enough to convince an audience that a rocket-powered man could fly, and required much preparation. To create the illusion of flight and to make it look as realistic as possible, Johnston had the Rocketeer stunt performers suspended by cables under a helicopter that flew at speeds of up to 90 mph (145 kmp). The effects technicians rigged the jetpack to emit real fire trails and the Rocketeer costume had to be insulated against the open flames. These alterations to the costume and jetpack weighed an additional 50 lbs (23 kg), making the flying scenes that much more demanding for the performers. Costume designer Marilyn Vance-Straker created 40 versions of the Rocketeer jacket, and each one had a different function. One version had a panel with a parachute inside that was needed for a scene where the stunt performer does a 100 ft (30 m) freefall.

▶ Stunt performers were suspended from invisible wires to create the illusion of flight.

Illuminating the Digital Frontier

A futuristic sci-fi adventure set in a video-game universe, *Tron* is a revolutionary experiment in computer-generated images.

▲ A storyboard drawing for the Master Control Program, one of the first characters in cinematic history realized through computer generated imagery.

*T*ron (1982) foresaw the digital revolution film and gained a cult following fostered by the growing popularity of video games. In the film's sci-fi story, video game designer Kevin Flynn finds himself trapped inside a computer where he is forced to compete in life-or-death video games by the evil Master Control Program (MCP). In a daring plan, Flynn teams up with Tron, a rebel program, to challenge MCP for control of the computer world, his only hope of returning to the real world.

TALENTED TEAM
The genesis of this electronic epic began in 1975, when writer/director Steven Lisberger saw his first video game. Lisberger found himself intrigued by the uncanny, lifelike quality of computer graphics. Armed with his inspiration, Lisberger assembled a top-flight creative design team including comic book artist Jean "Moebius" Giraud, visual futurist Syd Mead, and special effects wizards Richard Taylor and Harrison Ellenshaw (*Star Wars* matte painter and son of Disney special effects wizard Peter Ellenshaw). Together they developed the look of the futuristic vehicles, costumes, and scenery as they would appear in the digital world of *Tron*.

BACKLIT TECHNIQUE
During pre-production, Lisberger decided to use video compositing

◄ Tron's costume, as designed by Elois Jenssen and Rosanna Norton.

> *"I realized that I could use computers to tell a story about video games. The games were the basis for the fantasy; the computer imagery was the means to create it."*

STEPHEN LISBERGER (WRITER/DIRECTOR)

▶ To achieve the glowing effects on the characters (1) the actors were photographed in black and white (2) Special matte cutouts were made of each frame, and (3) the circuit glow along with painted backdrops were added in post-production through backlit animation.

to create the illusion of real actors (who performed against plain black backgrounds) in a world made of electricity. By photographing in black and white, then reprocessing the film using colored filters and backlit animation (a process whereby colored light is shone through cutouts in animation cells), live characters took on a glowing design that effectively linked them with their surroundings in the electronic world. Jeff Bridges, who portrayed Flynn, played video games both at home and on set with his fellow actors to research his character, and to help him imagine the digital sets.

SPECIAL EFFECTS SPECTACULAR

The intensive postproduction process of combining computer-generated imagery with the live-action footage took ten months to complete. *Tron* required 1,100 special effects shots with 200 of those incorporating live-action— the most ever used up until that time in a non-animated feature. 48 million bits of information were needed to complete a single frame, each frame requiring up to six hours to render.

THE SEQUEL

Seven years in the making, *Tron* was released on July 9, 1982, to critical acclaim for its groundbreaking visual effects. The enduring popularity of the film among its passionate fans inspired the sequel *Tron: Legacy* (2010) also starring Jeff Bridges.

▼ The Lightcycle scene required both computer-generated graphics and traditional animation to create the illusion of programs racing inside a computer.

Like its predecessor, *Tron: Legacy* was a triumph of special effects, and pushed the boundaries of new technology. The virtual reality of the Grid aimed for a more advanced version of the cyberspace visited by Flynn in *Tron*, and director Joseph Kosinski was determined to make the audience feel like filming actually occurred in the fictional universe. This meant building several physical sets, as well as using a variety of special-effects techniques. Cameras were also specifically designed to shoot the Grid sequences entirely in 3D.

▲ Walt changed the name of his anthology series to *Walt Disney's Wonderful World of Color* in 1961, and sales of color televisions soared.

The Wonderful World of Television

Disney entertainment is welcomed on the small screen for the first time in living rooms all over the world.

Walt Disney was the first major Hollywood producer to enter the world of television with his *One Hour in Wonderland* special in 1950. In 1954, he launched a one-hour weekly anthology series on ABC, entitled *Disneyland*. The show was an instant hit, especially with its "Davy Crockett" episodes about the real-life frontiersman, which started a U.S.-wide "Crockett" craze. Under various titles, the prime time series—best known as *The Wonderful World of Disney*—was broadcast for twenty-nine consecutive seasons, airing on all of the three major networks at the time. In 1955, Walt debuted the groundbreaking *Mickey Mouse Club*, one of the most famous children's shows in television history. The unique daily variety show featured a talented group of young Disney discoveries called the Mouseketeers. A later version began on Disney Channel in 1989 and introduced future stars Britney Spears, Christina Aguilera, Ryan Gosling, and Justin Timberlake.

TEEN SPIRIT

In the 2000s, Disney Channel became the go-to destination for hit comedy series that reflected children's everyday lives. Premiering in 2001, *Lizzie McGuire* (title character played by actress Hilary Duff) portrayed a teen trying to fit in at school, with animated sequences illustrating her inner thoughts. When it debuted in 2006, *Hannah Montana* became a worldwide phenomenon. Playing an average teen by day and a superstar by night, Miley Cyrus had originally auditioned for a supporting role. The producers, however, thought she was the perfect Hannah, and she skyrocketed to stardom.

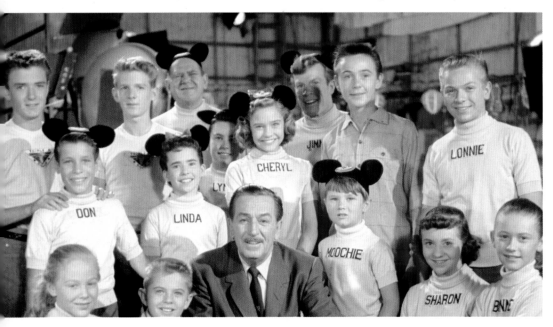

◀ Walt Disney surrounded by some of the *Mickey Mouse Club* cast

"... the ideas, the knowledge, and the emotions that come through the television screen in our living rooms will most certainly shape the course of the future for ourselves and our children." WALT DISNEY

CLASS ACT

Also debuting in 2006 and creating a global sensation was *High School Musical,* a Disney Channel Original Movie, or DCOM. A combination of teen romance and musical theater, the show, starring Zac Efron and Vanessa Hudgens, was renowned for its elaborate dance routines. More than 600 teens were auditioned for the role of musically-inclined basketball player Troy Bolton before Efron was chosen for the part. The basketball games in the movie were as choreographed as any of the production numbers, and in addition to two weeks of intense dance rehearsals, Efron had three hours of basketball practice a day. *High School Musical* launched two sequels. *High School Musical 2* made its debut on Disney Channel in 2007 and it is the most watched single piece of programming in Disney Channel and cable history. *High School Musical 3: Senior Year* was released in theaters in 2008.

STAR ATTRACTION

Today, Disney Channel and Disney XD programs such as *Austin & Ally, Dog With a Blog, Kickin' It,* and *Liv & Maddie,* as well as DCOMs like *Camp Rock* and *Teen Beach Movie* continue to attract wide audiences. They have also helped launch the music careers of stars such as Demi Lovato and the Jonas Brothers.

▼ Go Wildcats! Left to right: Corbin Bleu, Ashley Tisdale, Zac Efron, Vanessa Hudgens, Lucas Grabeel, and Monique Coleman from *High School Musical.*

◄ Miley Cyrus rocks out as Hannah Montana, the lead in Disney Channel's much-loved series (2006–2011).

▼ Johnny Depp wields Captain Jack Sparrow's sword, an antique from the 18th century.

Jack Sparrow on the High Seas

▲ Coin props from the movies

Inspired by the classic Disneyland Park attraction, *Pirates of the Caribbean: The Curse of the Black Pearl* launched a mighty series of swashbuckling adventure films.

When producer Jerry Bruckheimer asked Gore Verbinski to direct *Pirates of the Caribbean: The Curse of the Black Pearl* (2003) Gore said he felt as excited as a nine-year old boy. That enthusiasm was infectious, with actor Johnny Depp also hearkening back to his childhood dreams to play a pirate. The now-iconic costume of offbeat pirate Captain Jack Sparrow helped Depp bring the character to life. Working with costume designer Penny Rose, Depp was outfitted with an array of period costuming, including hats, boots, belts, and a pistol (a 1760 antique from a London gun maker). Depp spent only 45 minutes at the mirror before finding Jack Sparrow's perfect look. He selected the trinkets to wear in his hair and the signature pirate hat was an instinctive choice—he was presented with seven hats and immediately chose the leather tricorn.

► Jack's magical compass doesn't point north, but to the thing he wants most. A magnet was added to the compass so that it would behave accordingly.

REALISTIC MAKEUP

Shooting for the movie took place on the Caribbean Sea in St. Vincent, the Grenadines, and Dominica. It was a massive undertaking for the cast and crew who were on barges four miles out from port. Among the crew were upward of 50 makeup artists applying believable grime and gore with a careful layering of special pigments to the extras in the teams of pirates, skeletons, and cannibals.

MOVIE SEQUELS

The task of reconvening exactly the same creative and technical teams for a sequel was a big concern, and the decision was made to shoot the next two installments, *Dead Man's Chest* (2006) and *At World's End* (2007) simultaneously. The new, full-scale version of the Black Pearl pirate ship sailed from Alabama to Grand Bahama Island where the new base camp for production was established. To make *At World's End* distinct from *Dead Man's Chest*, production designer Rick Heinrichs creatively interpreted designs of 18th century Singapore on a Universal studio backlot, creating a city on stilts over a water tank. Fresh locales were also chosen, with second unit shooting in

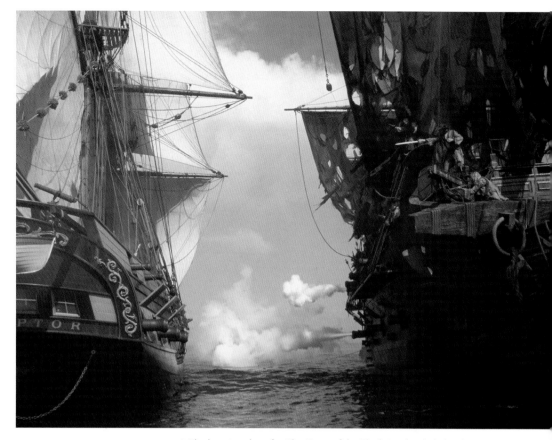

▲ The location shoot for *The Curse of the Black Pearl* included at least 20 different islands, 3 large pirate ships, and 900 pieces of clothing.

Greenland, Hawaii, and Niagara Falls. *Pirates of the Caribbean: On Stranger Tides* (2011) was filmed in 3D to give audiences a greater sense of immersion. The fifth installment, due in July 2017, is *Pirates of the Caribbean: Dead Men Tell No Tales*, in which Jack Sparrow must find the Trident of Poseidon, known for giving its owner mystical power over the sea.

"I think we take the swashbuckler genre to a new level." JERRY BRUCKHEIMER (PRODUCER)

▶ St. Vincent and nearby tiny islands in the Caribbean were chosen by scouts as shooting locations for *The Curse of the Black Pearl.*

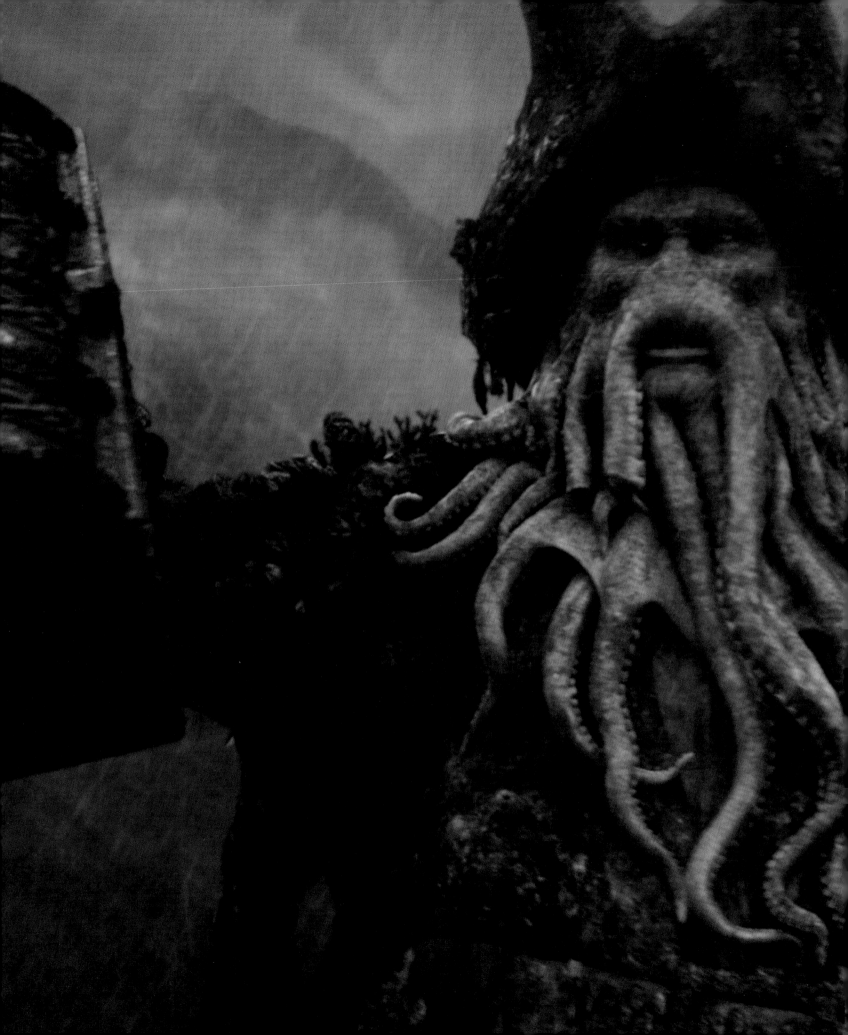

The fearsome and immortal pirate Davy Jones (played by British actor Bill Nighy) is the ruler of the Seven Seas and former captain of the *Flying Dutchman*. The most distinctive part of his appearance is his octopus-like tentacles.

Hidden deeply within these tentacles at all times is the key to the infamous Davy Jones' Locker. The inspiration for the brown, stippled effect on the tentacled skin of his face came from the color and texture of a coffee-stained Styrofoam cup.

Dead Man's Chest

In *Pirates of the Caribbean: Dead Man's Chest* (2006), Captain Jack Sparrow finds himself once again in a life-or-death scenario, with the ruler of the ocean depths, Davy Jones in the mix. Jack visits voodoo practitioner Tia Dalma, who tells Jack he must find the fabled Dead Man's Chest that contains Davy Jones' heart in order to save his own life. Many others are ruthlessly seeking this

piratical object of desire as well, and it takes quite a beating throughout the film. Johnny Depp had to act as though he were carrying a heavy iron chest, although the stunt version of the iconic prop was in fact made of rubber. Prop master Kris Peck noted that the goal was to make the mystical chest appear unbreakable, like a cast-iron skillet, while featuring detailing of the film's themes.

LIFE SAVER
Johnny Depp as Captain Jack Sparrow, standing before the mythical chest that may save his life

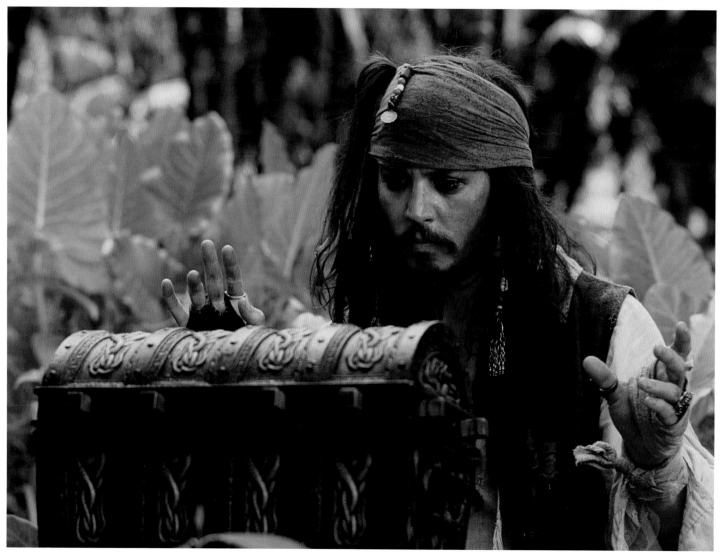

THEMES
Writers, illustrators, sculptors, and molders worked with the production designer Rick Heinrichs to create the "story" of the chest. A heavy, metal chest was built for the films as well as the lighter stunt version shown here.

An antique, hardware finish makes the chest look like it is from the long-ago world of the film.

The stunt prop chest was made to look heavy, as if made of cast-iron, but is actually flexible and light so that it could withstand the repeated manhandling during filming.

Lock can be opened by a special double-pronged key.

Director Gore Verbinski wanted a heart design for the lock because the chest contains Davy Jones' heart.

Lock design resembles a heart when closed and a crab when open.

Marine life motifs resemble the Kraken and tentacles on Davy Jones' face.

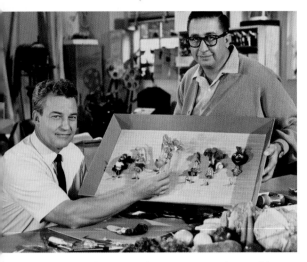

▲ Bill Justice and X Atencio created vegetable characters for the Academy Award®-nominated *A Symposium on Popular Songs* (1962).

Spectacular Stop-Motion

Often a painstaking and time-consuming process, the stop-motion technique has been used to produce some of the most iconic Disney films to be seen on the big screen.

Walt Disney's first animated films in the 1920s were made with articulated paper figures brought to life through stop-motion animation. This painstaking process requires the animators to move each character incrementally, shoot one frame of film, and then move the characters again. In the late 1950s, animation director Bill Justice was experimenting with stop-motion, achieving a never-before-seen fluidity. As a result, Walt produced a fully stop-motion animated featurette, *Noah's Ark* (1959). The 150 characters in this Academy Award® -nominated film were constructed by Justice and fellow Disney artist X Atencio from everyday objects such as corks, erasers, and golf tees. Walt asked Justice and Atencio to utilize the stop-motion technique for other films such as *Babes in Toyland* (1961). The toy soldiers in the "March of the Wooden Soldiers" sequence were about 12 in (30 cm) high with bodies cast out of hollow fiberglass, and each one was made with interchangeable sets of arms and legs. There were 40 soldiers in some scenes and each had 12 sets of legs. At every new frame, the legs on each soldier had to be placed at different angles to make one complete step.

STOP-MOTION SPECTACULAR

Director Tim Burton has always had a fascination with stop-motion animation. While involved in the time-consuming process of creating the Disney short, *Vincent* (1982), he also planned a holiday stop-motion spectacular about a skeletal Pumpkin King who becomes obsessed with Christmas. Tim Burton's *The Nightmare Before Christmas* (1993) was originally a poem with concept sketches that set the visual and thematic tone for a feature film.

◀ Bill Justice works on the stop-motion sequence of *Babes in Toyland* (1961). The iconic toy soldiers returned in the "A Spoonful of Sugar" number in *Mary Poppins* (1964).

B41 B42 [B42] ∅

B43 B44 B45 ∅

B46 B47 B48 B51 [B46]

B52 B53 B54 B55 ∅

B56 B57 B58 B61 B62

▶ Counting the duplicates that were made for backup, Jack Skellington from *Tim Burton's The Nightmare Before Christmas* (1993) had almost 800 different heads.

▼ A *Frankenweenie* (2012) sculptor works on the puppet of Mr. Rzykruski, who was designed as a homage to legendary horror actor Vincent Price.

Director Henry Selick used a 40,000 square feet (430,560 square meters) vacant warehouse to accommodate the 230 sets and more than 227 animated characters. Most of the puppets stood about a foot (30 cm) tall, with a metal armature inside a foam body. All of the figures had multiple heads—the ragdoll Sally puppet had 120—with slightly different expressions or mouth positions. The film turned out to be the most extensive stop-motion production ever made.

HORROR ANIMATION

The story of a boy who uses Frankenstein-like methods to bring his dog back to life, *Frankenweenie* (2012) was originally directed by Burton as a live-action short back in 1984. But the filmmaker had always envisioned it as a full-length, stop-motion animated film. Burton modeled the characters in the style of classic horror films from the 1930s, and it took over a year to make with 33 animators using more than 200 puppets to create some of the most complicated puppets and scenes ever to be seen in a stop-moton animation.

"By using the magic of stop-motion photography we find that it's possible to give life to anything."

WALT DISNEY

▶ Tim Burton "directs" the puppet of young Victor Frankenstein on one of the miniature sets of *Frankenweenie* (2012)

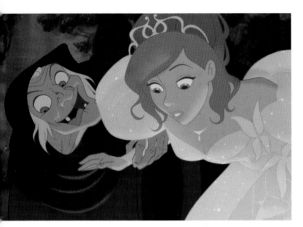

▲ In the animated segment of *Enchanted* (2007), Queen Narissa disguises herself as an old hag and throws Giselle into a well and into reality.

Welcome to the Real World

The rich legacy of Disney's animated classics inspires new live-action epics that transport animated characters into the realm of reality.

"We tried to let the script speak back to all the traditional Disney movies." KEVIN LIMA (DIRECTOR, ENCHANTED)

Disney likes to weave new live-action films from the fairy-tale magic of Walt's animated features. *Enchanted* (2007) blends classic-style animation and modern live-action to create a wholly unique adventure. Would-be princess Giselle (played by Amy Adams) is tricked by the evil Queen Narissa and banished from her fairy-tale kingdom to modern-day New York City. An animation veteran, director Kevin Lima knew that this Disney homage was the perfect project for him. The filmmakers had always planned *Enchanted* as a musical in the Disney tradition, and Amy Adams and James Marsden (who plays Prince Edward) were aided in Disney-style vocalizations by voice coach John Deaver. The dancing in the ballroom scene was choreographed by John "Cha-Cha" O'Connell, who referenced waltzes performed in the ballroom sequences of Disney animated movies such as *Cinderella* (1950) and *Beauty and the Beast* (1991).

DOWN THE RABBIT HOLE

Tim Burton's *Alice in Wonderland* (2010) tumbles back down the rabbit hole to a world Alice first entered as a child, where she embarks on a journey to discover her true identity. The wildly imaginative characters of Lewis Carroll's 1865 book and Walt Disney's 1951 animated adaptation naturally attracted the quirkily creative director. Burton believes Wonderland has remained viable because it taps into the things that people aren't aware of on a conscious level. The mixture of visual effects with CGI characters showcases Burton's vision in a richly detailed manner that is well-suited to the surreal Wonderland environment.

▶ Giselle finds herself uprooted from the animated kingdom of Andalasia to the real-life streets of Manhattan in *Enchanted*.

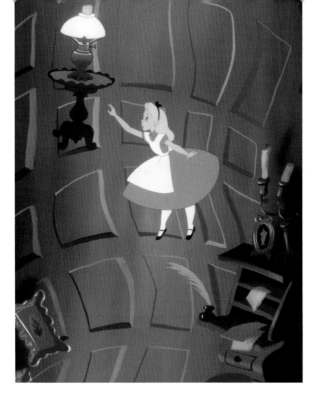

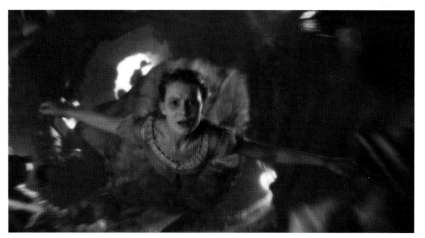

◀ In Disney's 1951 animated feature, Alice finds the experience intriguing as she slowly floats down the rabbit hole toward Wonderland.

▲ In contrast to the animated version, the Alice of Tim Burton's 2010 adaptation is terrified as she falls down the rabbit hole.

VILE VILLAINS

Another fresh take on a fairy tale explores the untold story of Disney's most iconic villain from *Sleeping Beauty* (1959). The saga of *Maleficent* (2014) uncovers the betrayal that led to her pure heart turning to stone. The filmmakers wanted the evil fairy to have an element of fantasy and an unreal quality about her, but also to be grounded in reality. Maleficent's uniquely wicked style involved the talents of Oscar®-winning actress Angelina Jolie, as well as a team of artists and designers. Costume designer Anna B. Sheppard drew upon the work of Maleficent's original animator, Marc Davis, to create the flowing cape, high collar, and iconic horns of her dramatic costume. Producer and animation veteran Don Hahn believes that as storytellers, the filmmakers are called to reinvent these ancient stories, which is exactly what Walt did in his animated features and Disney continues to do in its live-action films.

▶ Angelina Jolie is a vision of vileness as Maleficent, aided by her extravagant costume.

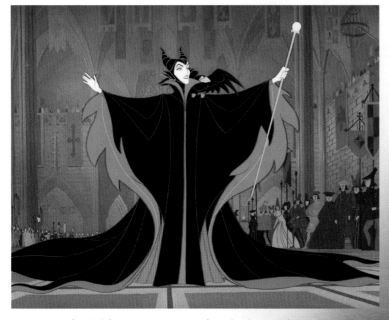

▲ Inspiration for Maleficent's costume came from the designs of legendary animator Marc Davis in Walt Disney's *Sleeping Beauty*.

Cinderella *Couture*

To create this retelling of the timeless fairy tale, the filmmakers found their own unique vision of the settings and costumes from a magical time and place.

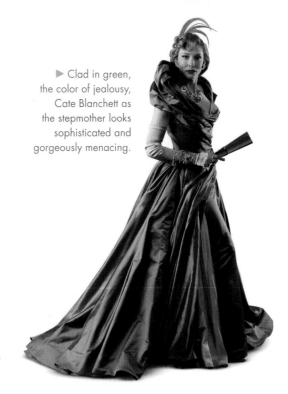

▶ Clad in green, the color of jealousy, Cate Blanchett as the stepmother looks sophisticated and gorgeously menacing.

In one of most cherished moments in Walt Disney's animated classic *Cinderella* (1950), the Fairy Godmother transforms a hopeful serving girl's rags into a shimmering ball gown and puts sparkling glass slippers on her dainty feet. When it came to the 2015 live-action adaptation, three-time Academy Award®-winning costume designer Sandy Powell would play Fairy Godmother in real life by creating a ball gown so beautiful, that it would seem almost to have been made by magic.

HISTORY MEETS FAIRY TALE

Powell started working on concepts for the characters' gowns two years before principal photography began. She wanted to evoke a fairy-tale sensibility conveying the characters' personalities, and create gowns that were simple yet breathtaking. Powell was influenced by the Disney animated classic, but drew much of her inspiration from both the 19th century and the 1940s, when women's clothes were lavishly draped and ornamented. Because the story is a fairy tale, the costumes did not have to adhere to a specific period, but rather help to create an atmosphere of enchantment. To evoke the feeling of an illustrated book come to life, Powell used an explosion of vivid colors.

THE MOST BEAUTIFUL GIRL AT THE BALL

At the center of Powell's lavish spectacle of fabric and color are Cinderella's ball gown and wedding gown. Powell wanted the ball gown to be extravagant, and yet make Cinderella look as if she is floating when she dances across the ballroom. Over 270 yds (247 m) of silk, polyester, and iridescent nylon in shades of blue and turquoise went into the multi-layered skirt, which is adorned with 10,000 glittering Swarovski crystals. For the famous footwear, eight pairs of Swarovski crystal slippers were crafted, inspired by an 1890s shoe that Powell had seen in a museum in Northampton, England.

A FAIRY-TALE WEDDING

For the wedding scene, Powell opted for a completely different look that would emphasize Cinderella's simplicity, modesty, and purity of heart. Powell designed a gown with

◀ The ugly stepsisters' vulgar characters are reflected in the colors and brash styles of their outfits.

"I had never considered directing a fairy tale, but I was captivated by the power of the story and thought I was in sync with the visual artistry." KENNETH BRANAGH (DIRECTOR)

◄ Cinderella's twelve-layer ballgown took 16 people more than 550 hours to create. Nine copies were used during production.

▲ Cinderella's kindness, modesty, and goodness are evoked in the simple elegance of her wedding gown.

a long, slender line in silk organza. An entire team of seamstresses worked for nearly a month to stitch the delicate fabric and once it was completed, another team of artists hand-painted elegant flowers on it. The *Cinderella* couture is such fantastical fashion that it caught the eye of the high-fashion world. Harrods in London celebrated the costumes in a series of windows, while the movie wardrobe and its creators were showcased in the pages of *Vogue* and *Vanity Fair*.

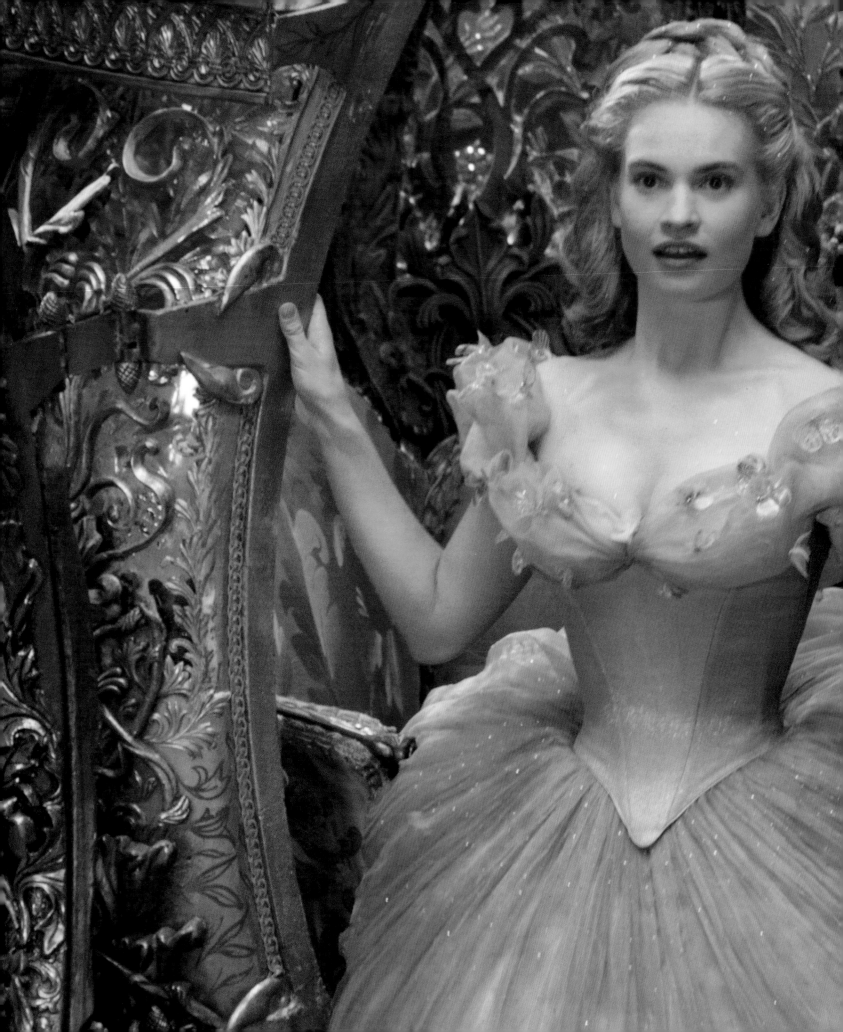

One of the most spellbinding scenes in *Cinderella* (2015) is when the Fairy Godmother uses her magic to make sure that Ella shall go to the ball! With a flick of her wand, a pumpkin is transformed into a magnificent golden carriage. The carriage prop was decorated with gold leaf and weighs two tons (1,814 kg). Four mice are turned into horses, a goose becomes the coachman, and two lizards turn into footmen! The magic may only last until midnight, but Ella's happy memories of the ball will last forever.

"I think what I want Disneyland to be most of all is a happy place—a place where adults and children can experience together some of the wonders of life, of adventure, and feel better because of it." WALT DISNEY

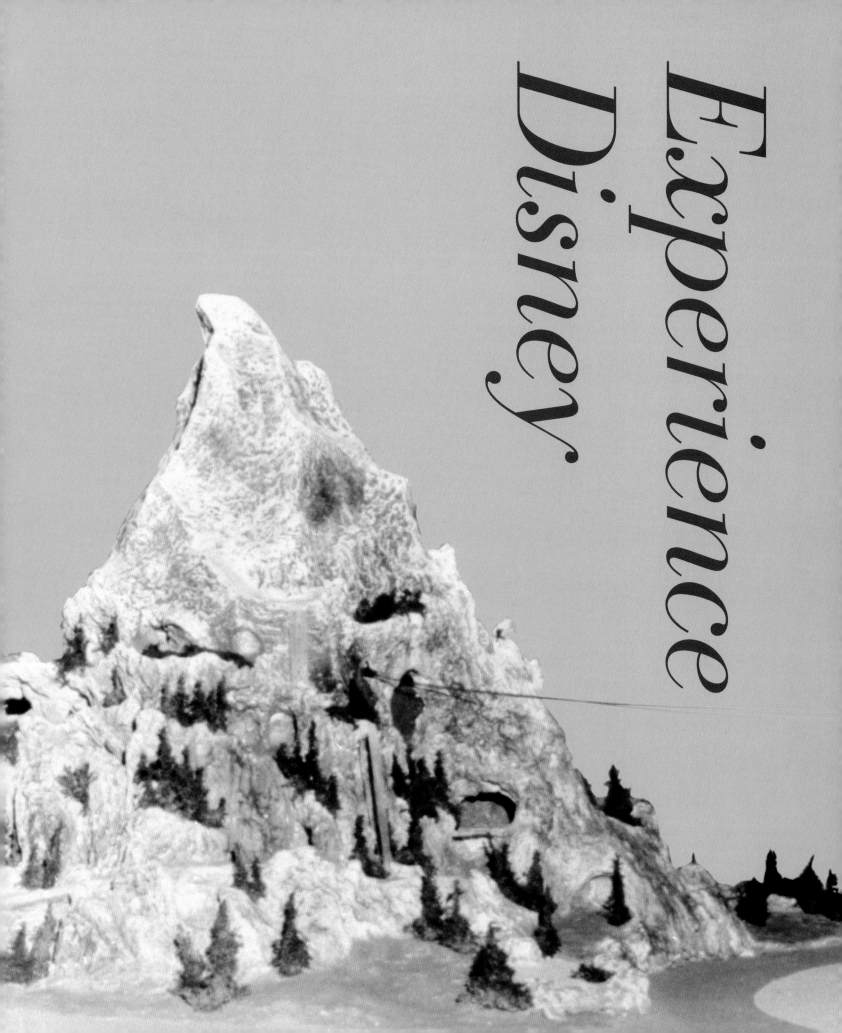

Experience Disney

Attraction Posters

From Alice in Wonderland to Splash Mountain, the attractions of the Disney Theme Parks worldwide have inspired a dazzling variety of posters. As veteran Imagineer Marty Sklar said, "The posters are enticing pieces of theatre that give the audience previews of what's to come." Often placed at the main entrance—like in a cinema lobby—these beautifully designed placards tantalize with stylized graphics and lively slogans. Every day, tens of thousands of guests pass the Disney Theme Park posters, which provide an artful experience in visual adventure.

MONORAIL, DISNEYLAND (1959)
Artist Paul Hartley used imagery of the first "E Ticket" attractions—Matterhorn Mountain and the Monorail—into this classic Disneyland Park poster.

LE CHATEAU DE LA BELLE AU BOIS DORMANT, DISNEYLAND PARIS (1992)
Designed by Disney artists Tracy Trinast and Tom Morris, this poster sets the tone for Disneyland Paris, with the iconic image of one of the most fanciful of the Disney castles.

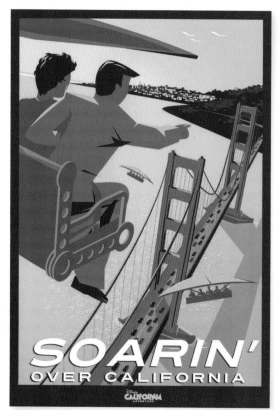

SOARIN' OVER CALIFORNIA, DISNEY CALIFORNIA ADVENTURE (2001)
This poster, developed by Greg Maletic, gives guests a taste of an exciting attraction—a simulated glider ride over California's scenic vistas.

MICKEY'S PHILHARMAGIC, HONG KONG DISNEYLAND (2005)
George Scribner, the director of the Mickey's PhilharMagic attraction, actually designed the poster himself.

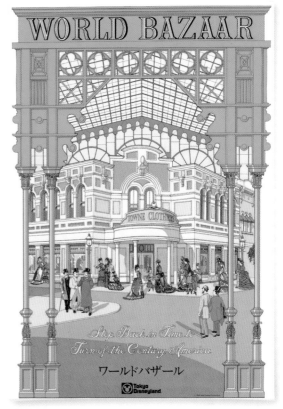

BIG THUNDER MOUNTAIN RAILROAD, DISNEYLAND (1977)
This poster concept for the Frontierland classic by Jim Michaelson graphically captures the wildness of the runaway train coaster-like attraction.

20,000 LEAGUES UNDER THE SEA EXHIBIT, DISNEYLAND (1955)
Artist Bjorn Aronson employed powerful graphics for his poster for this exhibit—a display of the original sets and menacing giant squid used in *20,000 Leagues Under the Sea* (1954).

WORLD BAZAAR, TOKYO DISNEYLAND (2002)
Will Eyerman's poster, adapted from the original 1983 poster by Rudy Lord and Greg Paul, translates the idealized vision of Victorian Americana for an international audience.

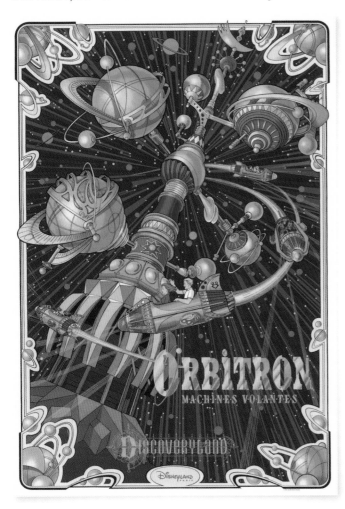

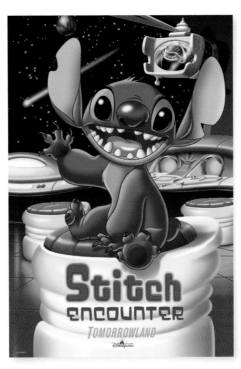

STITCH ENCOUNTER, HONG KONG DISNEYLAND (2006)
Artist Anne Tryba emphasized the leading role of Stitch and his crazy alien antics for this attraction.

ORBITRON—MACHINES VOLANTES, DISNEYLAND PARIS (1992)
Tim Delaney and Jim Michaelson capture the pulp-science fiction tone of the works of H. G. Wells and Jules Verne, with their larger-than-life illustrations.

The Art of Imagineering

Walt Disney and his team were always exploring and experimenting. He called it Imagineering—a combination of imagination and engineering. Walt Disney Imagineering (WDI) comprises Imagineers, who design and build Disney parks and other entertainment venues. It was founded on December 16, 1952, under the name WED (Walter Elias Disney) Enterprises. From writers and architects, to artists and beyond, the Imagineers employ a variety of skills in the Disney tradition of artistry and technical innovation.

ONE LITTLE SPARK
Herb Ryman, one of the first Imagineers, working on concept art for Disneyland Paris. Ryman worked with Walt one historic weekend in 1953 to create the first visualization of Disneyland Park.

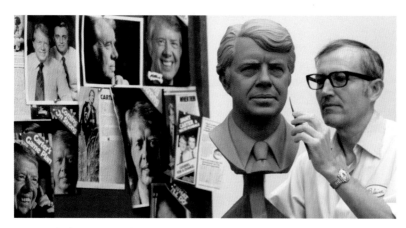

PRESIDENTIAL SCULPTOR
Blaine Gibson, one of Imagineering's master sculptors, sculpts Jimmy Carter in 1976 for the Hall of Presidents at Magic Kingdom Park in Walt Disney World Resort. Since Walt Disney World opened in 1971, each newly elected U.S. President has allowed an *Audio-Animatronics*® figure to be made of their likeness.

YO HO, YO HO!
X Atencio, writer and lyricist for the Pirates of the Caribbean attraction, works on the "barker bird" that once welcomed guests to the attraction at Walt Disney World Resort.

LITTLE LEOTA
Leota Toombs at work on one of the many *Audio-Animatronics*® figures for "it's a small world" at Disneyland Park. Toombs was later immortalized at Haunted Mansion as Madame Leota, the face in the crystal ball.

DOING THE IMPOSSIBLE
Bill Justice studies reference actors for programming the Pirates of the Caribbean *Audio-Animatronics*® figures.

FANTASY COMES TO LIFE
Harriet Burns at work in 1971 on the Mickey
Mouse Revue, Magic Kingdom, Walt Disney World.
One of Walt's biggest dreams when creating
Disneyland was to build a place where his
animated characters could interact with their fans.

TACTILE DREAMING
Walt Disney Imagineering comprises a variety of disciplines to
create authentic environments. Lynne Itamura, Ellen Guevara, and
Kyle Barnes work in the Interiors Department, and are responsible
for decorating parks with wallpaper, carpet, and other materials.

FINE ART AND ARTISANS
Great attention to detail is needed to realize Disney attractions. It requires
skilled artists, such as the painters seen here creating the ceiling mural
in Magellan's restaurant at Mediterranean Harbor, Tokyo DisneySea.

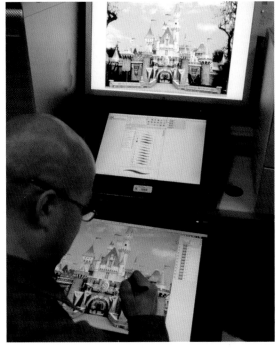

ADORNING THE CASTLE
Imagineers play a vital role in planning the
celebrations held at Disney Parks. Here, Owen Yoshino
designs commemorative decorations for the 50th
anniversary of Disneyland Park in 2005.

MINIATURE WORLD
When designing new attractions, shops, and eateries, Imagineers construct scale models.
This is Claude Coats with the model of the Village Inn Reastaurant (later Village Haus
Restaurant), New Fantasyland, Disneyland in 1983.

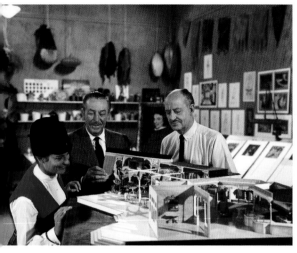

▲ 1965 First Disneyland Ambassador Julie Reihm, Walt, and Imagineer John Hench review a model for the new Plaza Inn during the park's "Tencennial" celebration.

Walt Disney's Magic Kingdom

A revolutionary family entertainment never seen before, Walt Disney's Disneyland Park opened up the whole Disney experience to guests from all over the world.

The original Disney Park created by Walt Disney, Disneyland Park, is such a big part of the world's collective culture that it is easy to forget that this concept in family entertainment was revolutionary. Walt felt that visitors to the Studio should have something to see besides artists sitting at desks in small rooms. It was on "Daddy's Day"—the Saturdays when he took his two daughters to small local amusement parks—that inspiration struck. Walt was often left sitting on the bench eating peanuts while his daughters rode the merry-go-round and had all the fun—and he took this time to dream. But Walt dreamed of something more than just another amusement park and his idea was something entirely new—an all-encompassing environment that would be designed around themes. It would be clean, orderly, and welcoming, and a three-dimensional experience of Disney characters, stories, concepts, and fun. This "magical little park," as Walt referred to his brainchild, would be a *theme park*.

A NEW ENTERTAINMENT

As soon as Walt began shaping the early visions for Disneyland Park, he invited several of his most versatile animators and art directors to apply the principles of filmmaking to the three-dimensional world he was creating. But it was Walt himself who innovated the idea. Unlike other amusement parks, fairs, or museums

▲ Walt reviews the addition of several new animal figures to one of the original—and most beloved—Disneyland Park attractions, the Jungle Cruise.

◄ Two iconic symbols of Disneyland Park: Sleeping Beauty Castle and the Mouse who started it all

► New Disney-pioneered *Audio-Animatronics*® technology was unveiled in 1963 with Walt Disney's Enchanted Tiki Room.

▲ 1959 saw the introduction of three innovative attractions: Matterhorn Bobsleds, Submarine Voyage, and the Monorail.

of a single entrance, his would channel guests down Main Street, U.S.A., into various Disney "realms" of fantasy, including America's rich past, and the optimistic promise of the future, all radiating from a central hub.

WALT'S LEGACY

Disneyland Park opened on July 17, 1955, presenting 18 major attractions on its opening day, including the now-classic Jungle Cruise, Autopia, and Mark Twain Riverboat. Just seven weeks after opening, the park welcomed its one-millionth guest, and by the end of the first year total attendance had reached 3.6 million. Today, 750 million guests have experienced the nearly 100 attractions and entertainment offerings at the Resort. The Imagineers who uphold Walt's creative legacy have continued to pioneer extraordinary attractions (never "rides") that can only be experienced by "guests" (never "customers") at Disneyland and other Disney Parks—because, as Walt pledged, "Disneyland will never be completed, it will ... grow as long as there is imagination left in the world."

"We believed in our idea— a family park where parents and children could have fun together." WALT DISNEY

▶ In 2001, Disney California Adventure Park opened as part of the Disneyland Resort.

▲ The 105-ft-long (32 m) Mark Twain Riverboat was the first paddle wheeler constructed in the U.S. in 50 years.

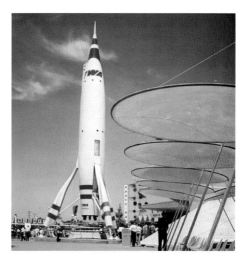

▲ Since 1955, Tomorrowland has offered futuristic adventures, such as this iconic early attraction, Rocket to the Moon (1955–1961).

▲ A host of Disney characters—headed by Mickey Mouse and his pals—may be seen greeting guests throughout Disneyland Park.

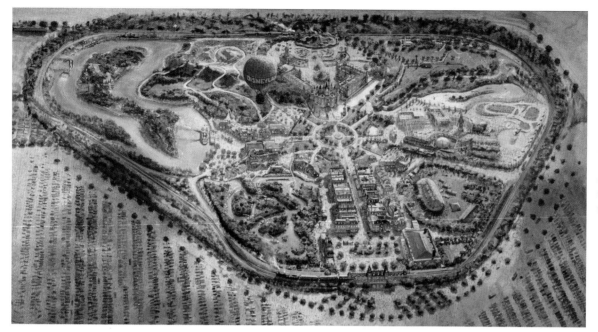

PITCHING THE PARK
Peter Ellenshaw created
this full color aerial view
of Walt's burgeoning
Magic Kingdom in 1954.
The legendary Disney artist
painted his expansive
rendering on a 4 x 8 ft
(1.2 x 2.4 m) storyboard—
overpainted with
phosphorescent paint for
a nighttime effect—for Walt
to present on his *Disneyland*
television series.

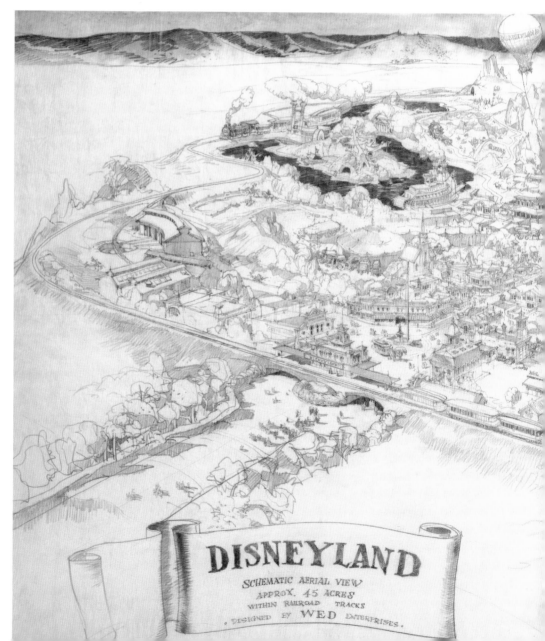

DISNEYLAND
SCHEMATIC AERIAL VIEW
APPROX. 45 ACRES
WITHIN RAILROAD TRACKS
DESIGNED BY WED ENTERPRISES.

Mapping a Magic Kingdom

There had never been anything like the "magical little park" Walt had been dreaming up since at least the late 1930s. As with his filmed productions, Walt knew that visualization was the optimal way to both develop and share concepts, especially one as revolutionary as the park Walt would come to call "Disneyland" (a name first used for the project in 1952). Beyond even castles, riverboats, and rocket ships, Walt's groundbreaking layout encompassed four themed "lands" radiating out from a central hub. The great showman knew his vision had to be mapped out in detail to gain the financial support needed to make his dream a reality.

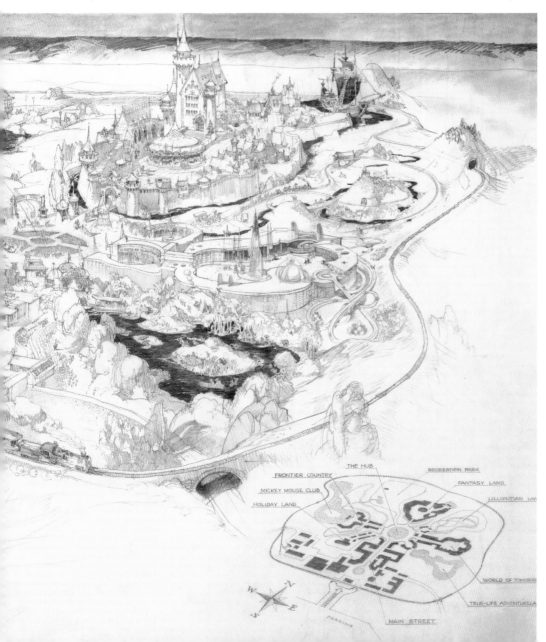

THE FIRST LOOK
Created under the direct supervision of Walt Disney over the weekend of September 23, 1953, this pencil concept sketch by artist Herb Ryman is the first true visualization of what is now recognized as Disneyland Park.

Disneyland Collectibles

When the gates of Disneyland Park first opened in 1955, Walt Disney wanted to ensure guests were able to take home a piece of magic so they could relive their experience. From traditional mementoes such as hats to more novel keepsakes including dolls and charms,

Disneyland souvenirs were all designed with that distinctive Disney touch. Early memorabilia that has been lovingly preserved is particularly coveted by Disney collectors. Here from the Walt Disney Archives is a treasure trove of perfectly preserved artefacts from Disneyland Park.

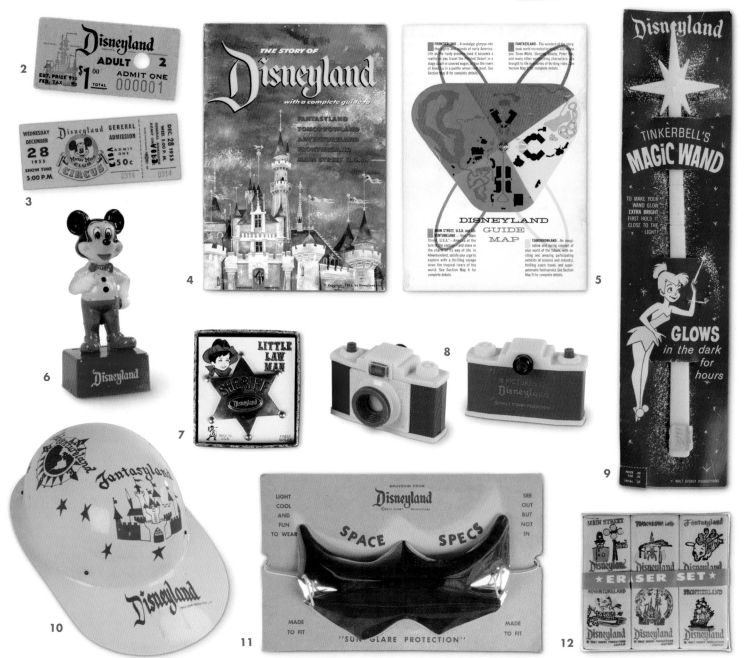

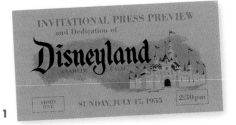

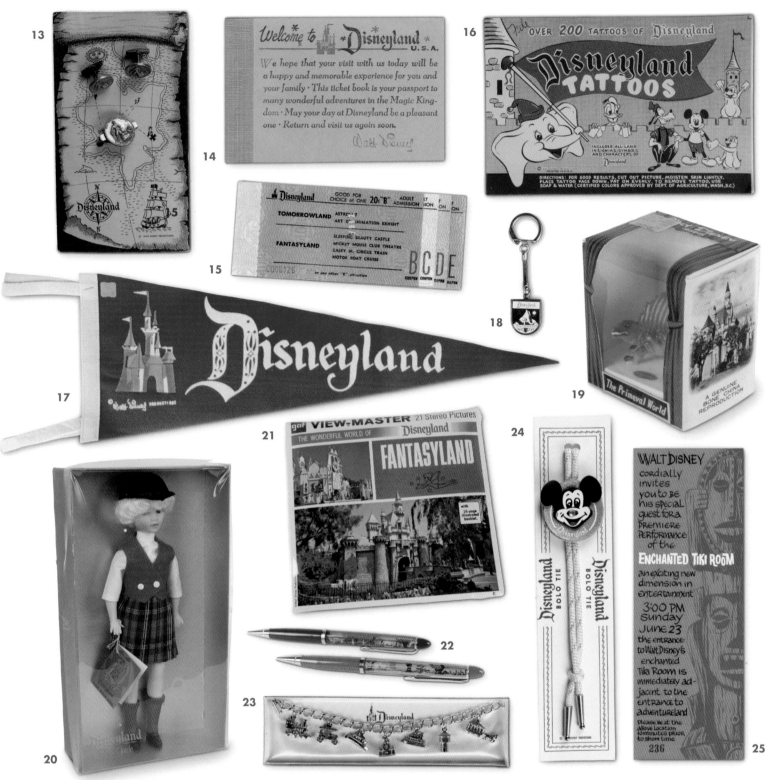

1 Press preview day ticket (July 17, 1955) **2** Opening Day Ticket No.1, purchased by Roy O. Disney (July 18, 1955)
3 "Mickey Mouse Club Circus" admission ticket (1955) **4** *The Story of Disneyland* guidebook [front cover] (1955)
5 *The Story of Disneyland* guidebook [back cover] (1955) **6** Mickey Mouse pencil sharpener (1955) **7** "Little Law Man" sheriff badge
8 Miniature camera viewer (1950s) **9** Tinker Bell's Magic Wand, Glow in the Dark (1950s) **10** Keppy Kap (1950s)
11 Space Specs "Sun Glare Protection" **12** Eraser Set (1960s) **13** Pirates of the Caribbean cuff links & tie clip (1960s)
14 Ticket Book [Front Cover] (1950s/1960s) **15** Ticket Book [B, C ,D ,E tickets] (1950s/1960s) **16** Disneyland tattoos (1950s) **17** Felt pennant
18 Matterhorn bobsleds key chain (1960s) **19** The Primeval World, "Dimetrodon" figurine (1964) **20** Tour Guide doll (1960s)
21 Fantasyland View-Master® stereo pictures (1960s) **22** "Floaty" Fountain Pens: Monorail (top, green) and Submarine Voyage (bottom, red)
23 Charm Bracelet (1950s) **24** "Mickey Mouse" Disneyland bolo tie. **25** Walt Disney's Enchanted Tiki Room premiere performance ticket (1963)

The Happiest Cruise

One of the best-loved Disney attractions, "it's a small world" allows guests to travel around the world in boats on a gentle cruise. Walt asked songwriters Richard M. Sherman and Robert B. Sherman to come up with a simple song that could be repeated over and over, in different languages. The result: one of the most well-known Disney songs of all time. Many regions of the world are represented in the attraction, and there are more than 300 amazing *Audio-Animatronics®* doll-like figures.

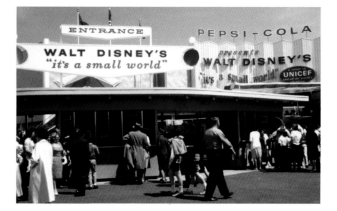

SMALL WORLD, BIG DEBUT
Opening on April 22, 1964, "it's a small world" was one of four attractions Walt created for the 1964–65 New York World's Fair, and it quickly became one of the most popular. More than 10 million visitors experienced the musical cruise at the fair.

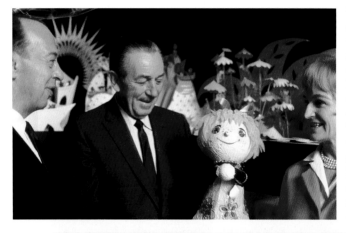

THE FLAIR OF MARY BLAIR
One of Walt's favorite artists, Mary Blair (right with Walt and left, Imagineer Marc Davis) worked extensively on "it's a small world." The small blonde doll wearing black boots and a poncho seen here is a tribute to Mary and can be spotted halfway up the Eiffel Tower.

ALL AROUND THE WORLD
One of the goals for "it's a small world" was to celebrate life in all parts of the world, including Eskimo life at the North Pole, seen here in this concept sketch by Mary Blair.

BEAUTIFUL COLLAGE
Walt handpicked artist Mary Blair to develop the style and color scheme for the attraction, as seen in this concept art collage depicting whimsical interpretations of such European landmarks as the Eiffel Tower, Leaning Tower of Pisa, and a Dutch windmill.

DISNEYLAND DEDICATION
When Walt moved it's a small world to Disneyland Park in 1966, he dedicated it, accompanied by children dressed to represent many nations, by pouring water that had been gathered from the oceans of the world into the Seven Seaways canal.

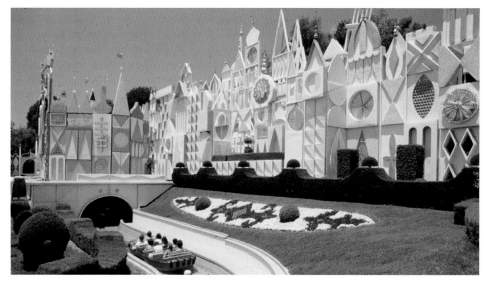

THE WORLD OVER
Mary Blair designed the kinetic attraction facade for Disneyland Park. It features an "International Gateway" with stylized spires and whirling, moving finials covered in 22-karat-gold leafing.

JUNGLE FUN
This charming African jungle scene features a variation of the "It's a Small World" song based around African drums.

A TIMELESS CLASSIC
Disney artists Will Eyerman and Greg Maletic artistically emulated Mary Blair's classic style for this 2008 Hong Kong Disneyland poster.

DANCING DELIGHT
Each scene of the attraction pays homage to the styles and cultures of the native peoples of the region, including traditional dress and dancing. This sketch is by Mary Blair for the New York World's Fair.

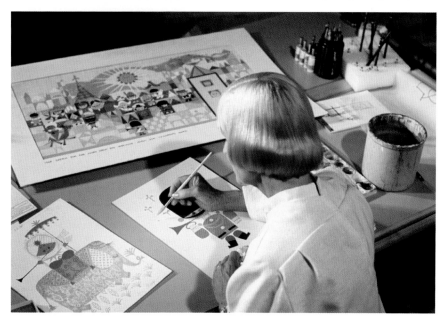

ARTIST AT WORK
Here, Mary Blair is painting some artwork for a mural in 1966. The mural was displayed at the Jules Stein Eye Institute in California.

A New Kind of World

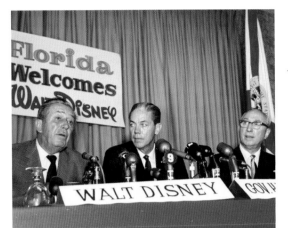

▲ With then-Governor of Florida, W. Haydon Burns, Walt and Roy Disney announce the project that would become Walt Disney World Resort.

In Walt Disney World Resort, Walt had found a space big enough to encapsulate his dreams, ideas, and imagination.

After the success of Disneyland Park in California, Walt Disney began to consider a new Disney project. As early as 1959 he was looking at options for a new "destination development" in locations east of the Mississippi River, including Florida. Many factors were considered, such as land cost, population density, and accessibility. The warm climate in Florida seemed the best for year-round operation, and by 1964, Disney agents began to secure what would become a land parcel near Orlando of 27,400 acres (11,088 ha) in total—twice the size of Manhattan Island. Walt declared that the "Florida Project" would be a whole Disney world of ideas and entertainment—a new, different kind of world.

"There's enough land here to hold all the ideas and plans we can possibly imagine." WALT DISNEY

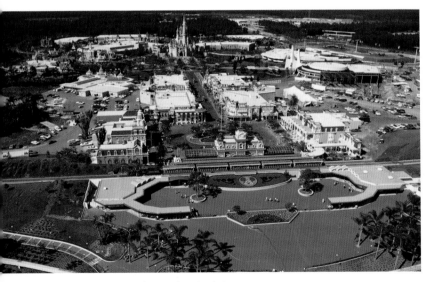

▲ Magic Kingdom Park is divided into six themed lands: Main Street, U.S.A., Adventureland, Tomorrowland, Fantasyland, Frontierland, and, unique to Florida, Liberty Square, home to the Hall of Presidents attraction.

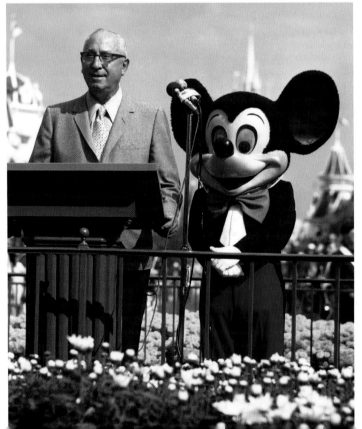

▶ Roy O. Disney dedicates Walt Disney World Resort to the memory of his brother, Walt. Just two months later, on December 20, 1971, Roy passed away.

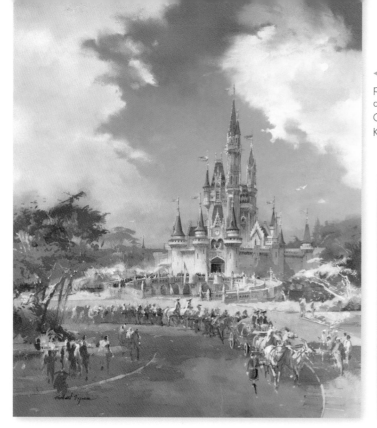

◀ Imagineer Herb Ryman's 1969 acrylic painting conveys the towering majesty and fanciful feel of the 189 ft (58 m) tall Cinderella Castle, the center of Magic Kingdom Park

▼ Concept art by Nina Rae Vaughn of Mickey's PhilharMagic, a 3D film featuring Disney characters, at Fantasyland

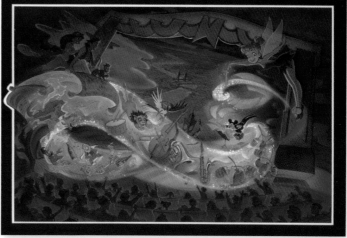

PLANNING BEGINS

Walt and Roy announced their Florida plans publicly on November 15, 1965, but Walt Disney died suddenly, a year later, in December 1966. Roy, who was 73 years old, was ready to retire, but was determined to stay on the job long enough to see Walt's final project to its fruition. Led by Roy, the team that Walt had formed continued to dream, imagine, and plan. Construction began in 1969, and more than 8,000 construction workers labored around the clock so that Magic Kingdom Park could open in 1971. Sparkling lagoons and man-made beaches emerged where there had once been only murky swamps and scrub pine forests. A state-of-the-art Monorail system was constructed, with the sleek Monorail trains even gliding directly through the A-frame of Disney's Contemporary Resort hotel.

A DREAM COME TRUE

At the peak of construction in 1970, Walt Disney World Resort was the largest private construction project in the world; it would take $400 million to get to opening day, also making it the largest privately funded project anywhere in the world. Right on schedule—for in 1966 Walt Disney had told the press the new resort would open in five years—Magic Kingdom Park, the first of four theme parks, opened October 1, 1971. When he presided at the grand opening, Roy dedicated Walt Disney World Resort as a tribute to the philosophy and life of Walter Elias Disney. He insisted that the new resort be called Walt Disney World so that everyone would always know the dreamer behind the dream come true.

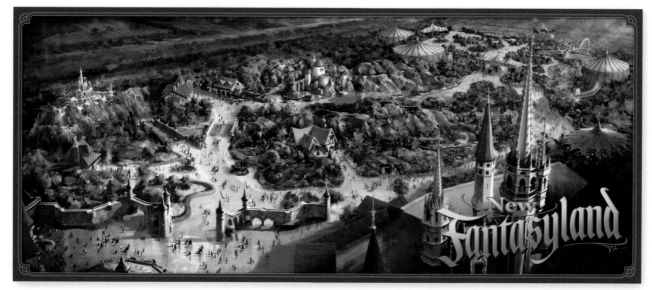

◀ Concept art of New Fantasyland by Greg Pro. The expansion was the largest in the history of Magic Kingdom Park, nearly doubling Fantasyland in size when it was completed in 2014.

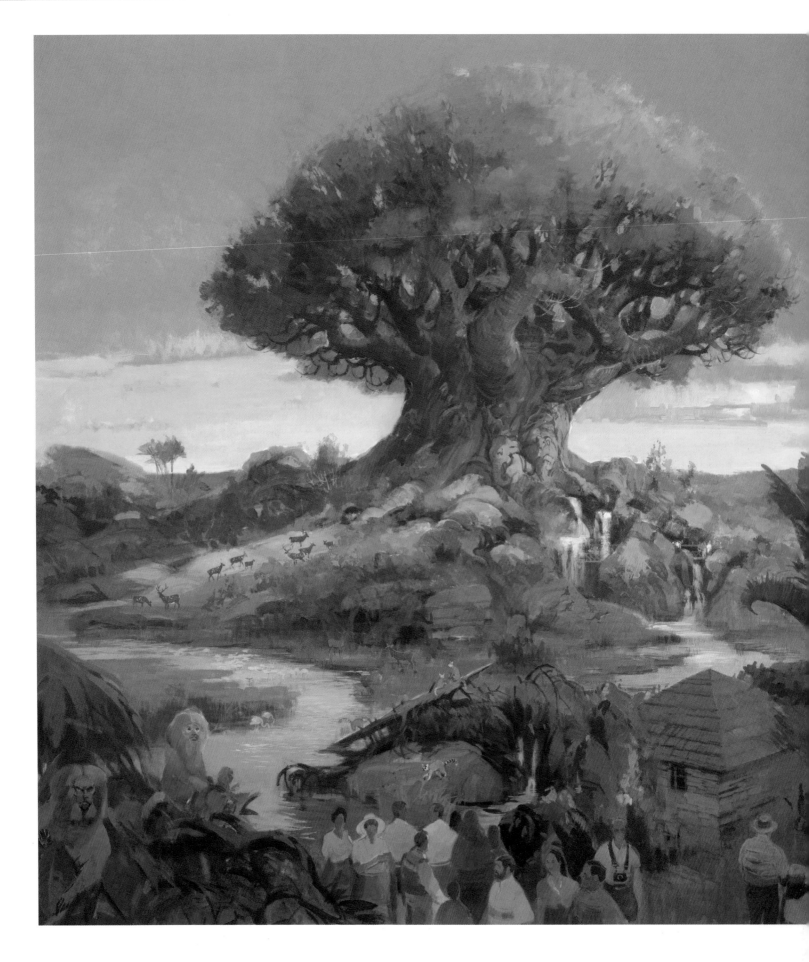

Disney's Animal Kingdom

In creating Disney's Animal Kingdom Theme Park for Walt Disney World Resort in 1998, the Imagineers were confronted with a unique challenge. They had to devise a castle-like centerpiece in a realm where architecture is downplayed in favor of lush landscaping, blooming plants, and amazing animals (there are around 1,000 animals, representing 200 species) living in natural settings. The solution was an immense tree named the "Tree of Life" that would not only represent this one-of-a-kind kingdom, but also encompass all of nature and life itself. This extraordinary icon rises from a dense island of foliage in the middle of such lands as Africa, Asia, and DinoLand U.S.A.—the very essence of animal attraction.

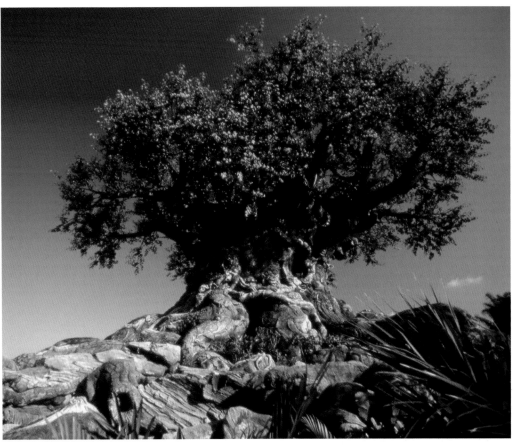

TREE OF LIFE CONCEPT ART
In this magnificent concept art painting by Tom Gilleon, the artist imagined the Tree of Life— a vision of how powerfully the attraction expresses the intricate balance of nature.

THE TREE CASTLE
Guests can take the Discovery Island Trails that wind around the intricately sculpted tree for a close-up view of the whirling tapestry of animal forms. The tree towers 14 floors above Discovery Island at the hub of Disney's Animal Kingdom and is 50 ft (15.2 m) wide and spreads to 170 ft (52 m) in diameter at its base.

Disney's Discovery Park

A celebration of human achievement from nations around the world, Epcot realizes Walt Disney's innovative vision.

Celebrating the human spirit, imagination, and ingenuity, the 340-acre (137-ha) Epcot at Walt Disney World Resort is divided into two distinct realms. Future World is a showcase of new ideas and technology, plus an exploration of planet Earth, from land and sea to air and space. World Showcase is a living celebration of nations, featuring architecturally authentic buildings and backdrops that celebrate their cultural heritage, arts, and entertainment. World Showcase ambassadors travel from across the world to represent their homelands at one of the 11 pavilions, which are situated along a 1.3-mile (2-km) promenade encircling the 40-acre (16-ha) World Showcase Lagoon.

▲ At a 1966 meeting, Walt presented this hand-drawn sketch of the Florida property. This drawing remained the basic model for Walt Disney World Resort, which eventually included Epcot Park.

▼ Project X concept art painted by Herb Ryman of the transport center beneath the park. Project X was the original working name for Epcot.

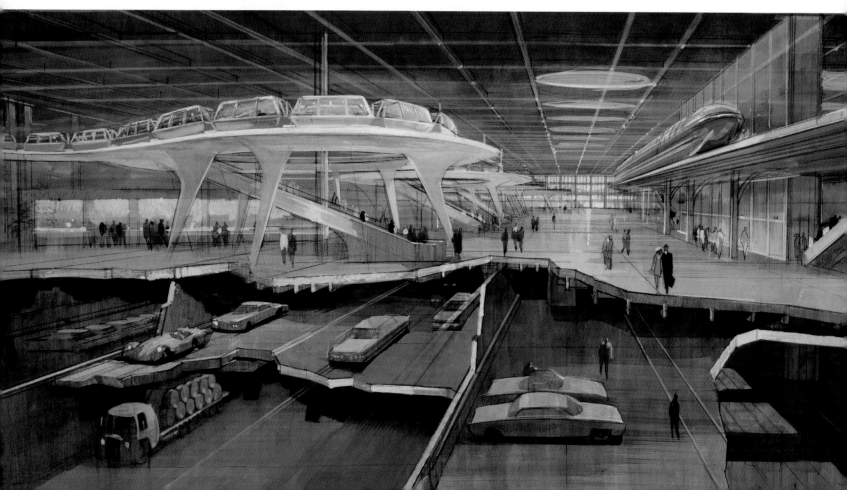

A NEW WAY OF LIVING

When dreaming of the place that was to be called Epcot (Experimental Prototype Community of Tomorrow), Walt Disney envisioned a showcase for innovation, where cutting-edge technology could help develop solutions for optimal living. Toward the end of his life, he became interested in the challenges presented by modern cities, such as crime and disorganization. Walt had pored over books on city planning, and with his experience in developing Disneyland Park and transportation systems such as the Monorail, he believed that he and his Imagineers could come up with solutions. Uninterested in simply creating "another" Disneyland Park, Walt made a film in October 1966, which explained some of his ideas for a planned community. He wanted to build a place where people could live in an environment like no other. With the huge number of acres that Walt was accumulating in Florida, an ideal place for the park was available within the Disney World project.

INNOVATIVE VISION

Walt Disney died in 1966, long before he and his artists could fully explore the preliminary concepts he had in mind. But the Imagineers carried on, inspired by their leader's vision. On October 1, 1978, Card Walker—then president of Walt Disney Productions—revealed plans for Epcot, a theme park inspired by Walt's philosophies. A groundbreaking ceremony was held one year later and EPCOT Center opened on October 1, 1982. As Card expressed in the dedication, Epcot is a place of joy, hope, and friendship and was inspired by Walt Disney's creative vision. It is a place where human achievements are celebrated through imagination, wonders of enterprise, and concepts of a future that promises new and exciting benefits for all.

▲ Imagineers Terry Palmer and Berj Behesnilian work on the master model of EPCOT Center in 1980, adding finishing details to the plywood, paper, and cardboard model of Germany.

▲ The symbol for all of Epcot, the freestanding 18-floor geosphere Spaceship Earth stands 180 ft (55 m) high and is 165 ft (50 m) in diameter.

"EPCOT is … an experimental prototype community that will always be in a state of becoming. It will never cease to be a living blueprint of the future." WALT DISNEY

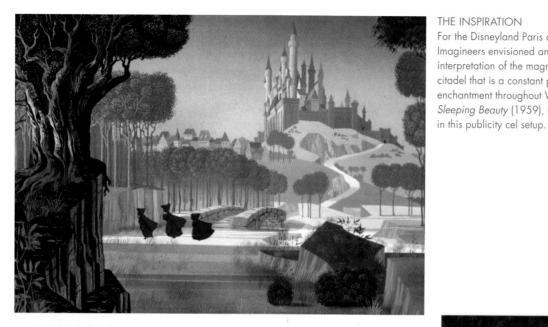

THE INSPIRATION
For the Disneyland Paris castle, Imagineers envisioned an imaginative interpretation of the magnificent citadel that is a constant presence of enchantment throughout Walt Disney's *Sleeping Beauty* (1959), as shown in this publicity cel setup.

LE CHÂTEAU DE LA BELLE AU BOIS DORMANT AT DISNEYLAND PARIS
The heavenward-spiraling architecture of Mont St. Michel, the famous French landmark, was a defining influence on Le Château de la Belle au Bois Dormant, which soars 148 ft (45 m) into the sky. The square trees of the movie and the concept art are evident.

STUNNING CONCEPT ART
In this dream-like concept painting, artist Frank Armitage—who had worked side by side with production designer Eyvind Earle in hand-painting the backgrounds for the original film —reimagined the fairy-tale castle. He incorporated some stylized *Sleeping Beauty* details including Earle's signature square trees in the surrounding landscape.

Castle of Dreams

One of the most distinctive of the Disney theme park castles, Le Château de la Belle au Bois Dormant is also the most fanciful. For this enchanting structure at Disneyland Park in Disneyland Paris, Imagineers sought to build a castle different from any of the many actual fortresses that can be seen in Europe— one that would have more of a fantastical appearance. Through an artful melding of architecture, nature, and fantasy, the designers created a fabulous, dreamlike fort that defies reality. As with all Imagineering projects, it started with a piece of beautiful and inspirational concept art.

Collectible Pins

Disney collectors have sought out Disney pins since the 1930s, but it was in 1999 that Disney Pin Trading became a phenomenon, as Disney parks began a new tradition of official pin trading with the kickoff of the Millennium Celebration at Walt Disney World Resort. Designed by Disney artists, each individual cloisonné, semi-cloisonné, and hard-enamel metal pin undergoes a painstaking processes of hand assembly, molding, painting, polishing, and firing to create a shining emblem of Disneyana. Pin traders, also called "pin pals," can collect over 60,000 individual designs commemorating characters, attractions, films, television, and special events.

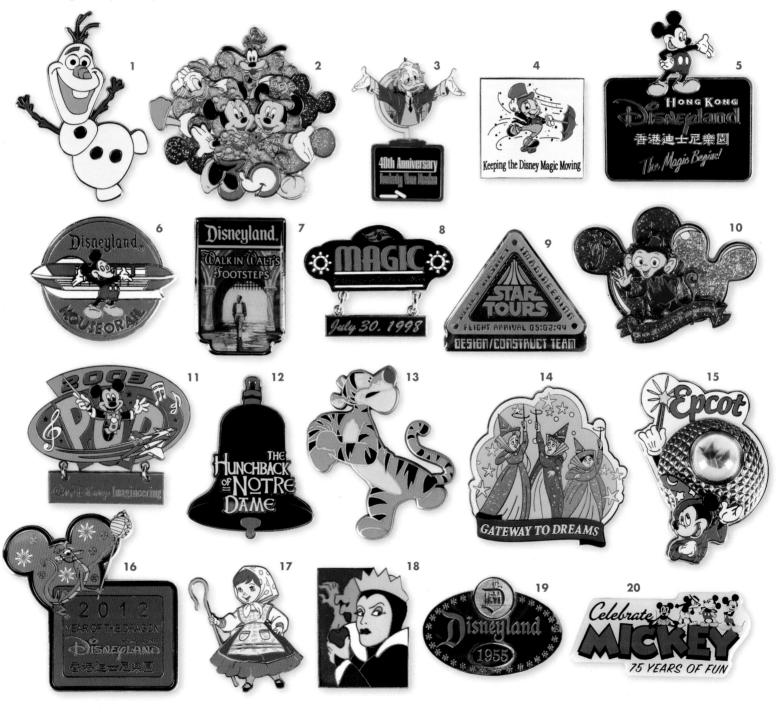

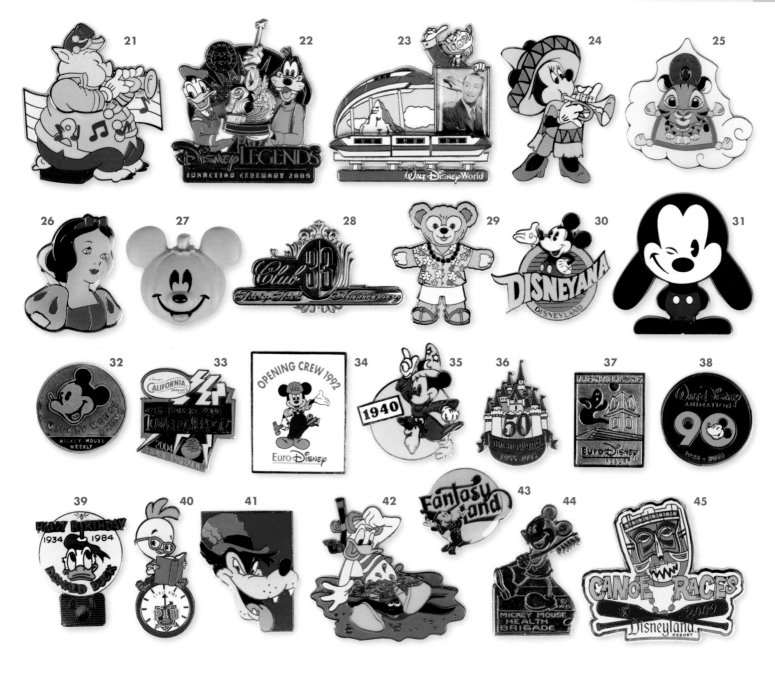

1 Olaf: Disney Parks, 2014 2 Tokyo Disney Resort 30th Anniversary 3 Ludwig Von Drake 40th Anniversary: Walt Disney World Resort, 2001

4 Commuter Assistance: The Walt Disney Studios, 1998 5 Hong Kong Disneyland: The Disney Store Hong Kong, 2012

6 Disneyland Mouseorail: Disney Decade Pin: Disneyland Resort, 1990 7 Walk in Walt's Footsteps Tour: Disneyland Resort, 1990

8 Disney Cruise Line: 2nd anniversary of ship launch, 2002 9 Star Tours Design/Construction Team,1994 10 Albert: Hong Kong Disneyland 9th Anniversary, 2014

11 Pop Century Resort: *Mickey's PhilharMagic Mission: Space* opening, 2003 12 *The Hunchback of Notre Dame*: Limited edition, 2014 13 Tigger: Disney Parks, 2014

14 Gateway to Dreams: Disneyland Resort, 2005 15 Epcot: Spaceship Earth: Walt Disney World Resort, 2005

16 Mushu: Zodiac Pin Collection: Year of the Dragon: Hong Kong Disneyland, 2012 17 "it's a small world": Blast to the Past: A Celebration of Walt Disney Art Classics, 2004

18 Evil Queen: Villains pin series: Disneyland Resort, 1991 19 1955 Cast member replica badge: Disneyland Resort, 2004

20 Celebrate Mickey 75 Years of Fun: The Walt Disney Studios, 2003 21 Peter Pig: Surprise Pin Series: Disney Parks, 2014

22 Disney Legends induction ceremony, D23 Expo, 2009 23 Walt's Legacy Collection: Walt Disney Resort, 2005 24 Mariachi Minnie: Disneyland Resort, 2001

25 Chandu: Tokyo DisneySea, 2013 26 Snow White: Given out at Radio City Music Hall in New York, 1987 27 Mickey Mouse Jack O' Lantern,

28 Club 33: 33rd anniversary celebration, Disneyland Resort, 2000 29 Duffy the Disney Bear: Aulani (Disney resort & spa), 2014 30 Disneyana shop: Disneyland Resort, 1992

31 Oswald the Lucky Rabbit: Disney Parks, 2013 32 Mickey Mouse Weekly, England, Mickey Mouse Chums, 1936

33 Disney's California Adventure: The Twilight Zone Tower of Terror™: Rose Parade Limited Edition, 2004 34 Euro Disney opening crew: Cast member exclusive, 1992

35 Sorcerer Mickey: The Walt Disney Company Canadian release, 1989 36 The Walt Disney Company Annual Report, Disneyland 50th Anniversary Cast Member Gift, 2005

37 Euro Disney Opening Cast Member Pin: Frontierland, 1992 38 Walt Disney Animation Studios 90th Anniversary, 2013

39 Happy Birthday Donald Duck: Disney Channel: Giveaway at NTCA Trade Convention, Las Vegas, 1984 40 Chicken Little: Pin Trading University: Walt Disney Resort, 2008

41 Big Bad Wolf: Villains Pin Series: Disneyland Resort, 1991 42 Donald Duck: Stitch's High Sea Adventure, Scavenger Hunt: Disney Cruise Line, 2005

43 Fantasyland: Disneyland Resort Give Giver Extraordinaire, 1986 44 Mickey Mouse Health Brigade, c.1934

45 Canoe Races: Cast Member exclusive: Disneyland Resort, 2009

Welcome, Foolish Mortals

One of the most popular Disney theme park attractions ever, Haunted Mansion has stood on the edge of New Orleans Square in Disneyland Park since 1962–1963, even though the show inside didn't debut for another six years. Originally, it was to be a walk-through attraction, but with Disney's development of the Omnimover transportation system, "Doom Buggies" were invented for guests to ride. It has been home to 999 unearthly specters since opening in 1969—and there's always room for one more. The spooky sights and sounds within Haunted Mansion are presented with a tongue-in-cheek lightheartedness, for as the attraction's Ghost Host himself intones, the Mansion has hot and cold running chills and wall-to-wall creeps.

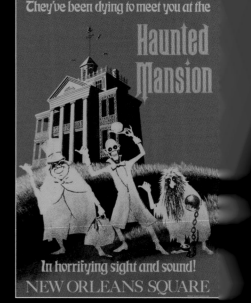

BEWARE
Featuring the Hitchhiking Ghosts, this original 1969 poster by Imagineers Ken Chapman and Marc Davis—one of the attraction's most significant creators—remains at Disneyland Park

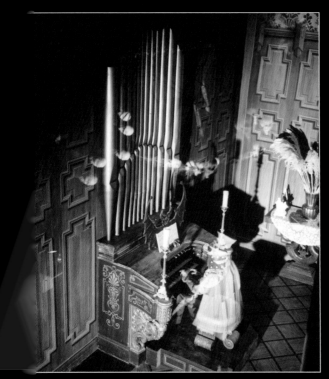

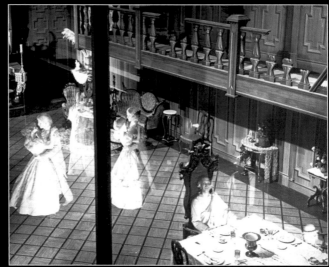

DYING FOR A DANCE
One of the most impressive effects in the attraction is the ballroom scene. It features waltzing ghosts that dance around, vanishing and reappearing before guests' eyes!

DEAD EFFECTS
Imagineer Yale Gracey with the notorious Hatbox Ghost. It was removed from the attraction soon after opening due to technical difficulties. With the help of newer technology, the Hatbox Ghost reappeared in May 2015.

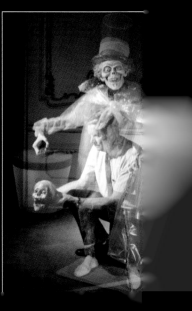

ORGAN DONOR
First played on screen by Captain Nemo in *20,000 Leagues Under the Sea* (1954), the oversized organ in the Disneyland Haunted Mansion spouts spectral banshees.

MACABRE MUSICIANS
In the Graveyard, spirited specters sing the haunting theme song "Grim Grinning Ghosts."

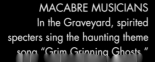

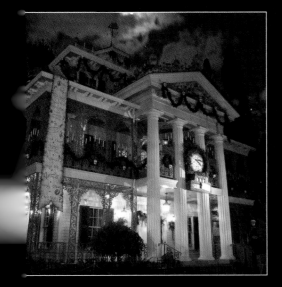

HOME HAUNTED HOME

Haunted Mansion (seen here with its Haunted Mansion Holiday overlay) is created in the elegant Southern style of its New Orleans Square home. Walt didn't want a traditional decrepit building in Disneyland, saying he'd keep up the outside and let the ghosts take care of the inside.

HOLIDAY SPOOKTACULAR

Introduced in 2001, Haunted Mansion Holiday redresses the classic Disneyland Park attraction over the Halloween and Christmas season with characters from *The Nightmare Before Christmas* (1993)

GHOST RIDERS

Haunted Mansion uses the Omnimover ride system. The oval-shaped attraction vehicles move continuously around the Mansion, swiveling to show each guest the sights and the spooks.

FRIGHTENINGLY FESTIVE

Jack Skellington, hero of *The Nightmare Before Christmas*, greets guests as they enter the ride queue for Haunted Mansion Holiday.

PHANTOM MANOR

Haunted Mansion is known as Phantom Manor at Disneyland Paris. This is Imagineer Bob Baranick with a model of the attraction.

Disneyland Goes Global

The turrets of Cinderella Castle tower above Tokyo Bay, where a Magic Kingdom stands in tribute to Walt Disney's timeless vision.

▲ Located in Urayasu, Tokyo Disney Resort is home to two theme parks, Tokyo Disneyland and Tokyo DisneySea.

"May Tokyo Disneyland be an eternal source of joy, laughter, inspiration, and imagination to the peoples of the world." TOKYO DISNEYLAND DEDICATION, APRIL 15, 1983

Known as the Kingdom of Magic and Dreams to its Japanese guests, Tokyo Disney Resort opened its gates on April 15, 1983, bringing the magic of Disney-themed entertainment to Japan and establishing the first Disney theme park outside the United States. Tokyo Disney Resort is not only Japan's most popular family destination—it's also one of the most visited theme parks in the world.

THEME PARK PLANS

The history of Tokyo Disney Resort goes back a lot farther than 1983, with the idea of a Disney theme park in Japan originating in 1974. At that time, there were two Disney destinations: Disneyland Park in California and Walt Disney World Resort in Florida. The latter was barely three years old and consisted of a single park, Magic Kingdom Park.

It was at this point that plans for a Disney park outside the continental U.S. began. In 1974, Keisei Electric Railway Co., Ltd., Mitsui & Co., Ltd., and Mitsui Fudosan Co., Ltd. sent an invitation under joint signature to Walt Disney Productions requesting that their executives visit Japan. In 1977, the name "Tokyo Disneyland" was officially announced, followed in 1980 by Japanese cast members

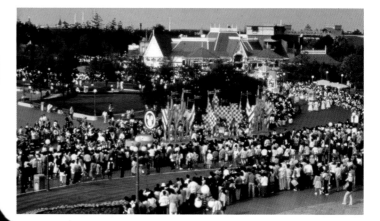

◄ Mickey and Minnie Mouse have been welcoming guests to Tokyo Disneyland since 1983.

▲ Festive parades, processions, and colorful festivals are a mainstay at the Magic Kingdom-style park.

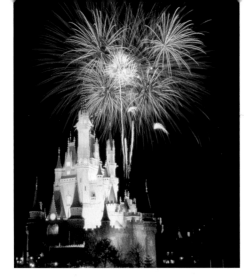

▲ Cinderella Castle is home to the Grand Hall, where guests can view artworks that tell the story of the scullery maid-turned-princess.

◀ Meet the World attraction at Tomorrowland in Tokyo Disneyland was a show that explored Japan's heritage in a rotating theater.

being sent to Disneyland for training. In December of that year, ground was broken with a site dedication and the 1983 grand opening was set as their goal.

TOKYO DISNEYLAND TODAY

The tremendous popularity of Disney films and memorabilia in Japan made it a perfect site for the first non-U.S. Disney Park. The Japanese had long admired what had been achieved in California and Florida, and wanted

many of the attractions from their Magic Kingdom-style parks recreated for Tokyo Disneyland. The park opened on schedule with more than 30 attractions in five themed lands, including World Bazaar (an adaptation of Main Street, U.S.A.) and Westernland. Today, the park's realms include Critter Country and Toontown. In 2001, Tokyo DisneySea, a 100-acre (40-ha) aquatic-themed park, opened next to Tokyo Disneyland. On entering and viewing

a unique AquaSphere, guests can visit seven distinct themed ports— Mediterranean Harbor, Mysterious Island, Mermaid Lagoon, Arabian Coast, Lost River Delta, Port Discovery, and American Waterfront.

▼ Concept art by Dan Goozee of Explorers' Landing in Mediterranean Harbor conveys the color and spectacle of Tokyo DisneySea and its amazing setting in front of the volcano on Mysterious Island.

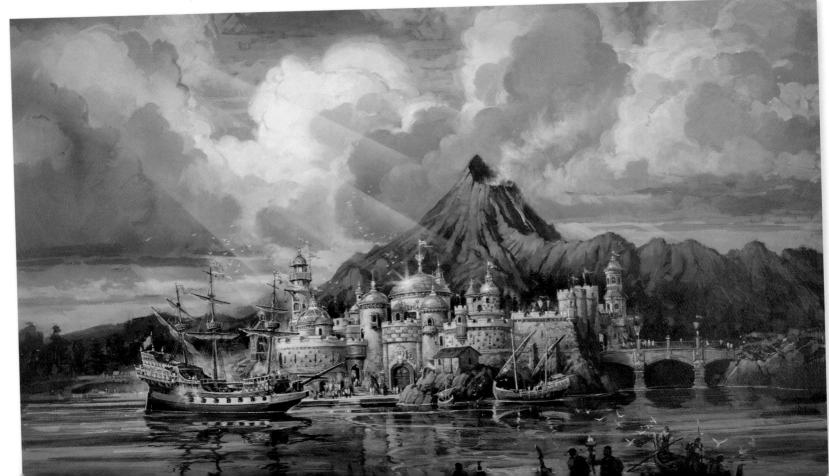

Some of the most unforgettable attractions at Disney Parks are the parades, which give visitors the chance to see spectacular floats carrying their favorite characters. The parades are always impressive, but the ones that take place during the Holiday season are particularly special. In the Christmas parade at the Tokyo Disney Resort, Mickey Mouse, Minnie Mouse, and Goofy are joined by Duffy the Disney Bear. Duffy was first created in 2002, and since then he has become incredibly popular with Japanese fans of Disney.

A Pirate's Life For Me

The Pirates of the Caribbean attraction was originally envisioned as a walk-through with wax figures, but it soon evolved into a showcase for *Audio-Animatronics*® storytelling. It was one of the most elaborate uses of *Audio-Animatronics*® figures ever attempted by Disney. Walt Disney worked extensively on the attraction, but passed away shortly before its debut in March 1967 at Disneyland. In 2006, it was enhanced with characters from the *Pirates of the Caribbean* films, including Captain Jack Sparrow, which were inspired by the classic attraction. More than 400 Imagineers worked for three years on the research, planning, and installation of these enhancements.

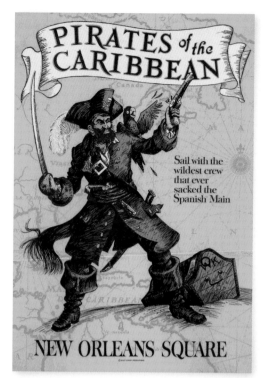

AVAST, MATEYS!
The pirate on this poster is a self-portrait of Disney artist and Imagineer Collin Campbell, who worked on the design of the original Pirates of the Caribbean attraction.

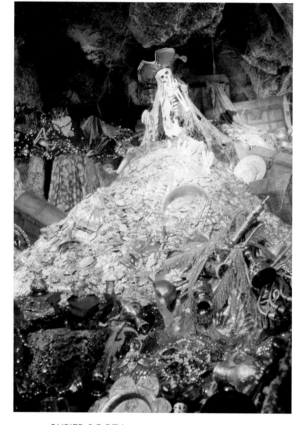

BURIED BOOTY
Guests travel in boats through scenes of pirate treasure, ghost ships, and a Caribbean town being plundered. More than 400,000 gold coins appear in this treasure scene.

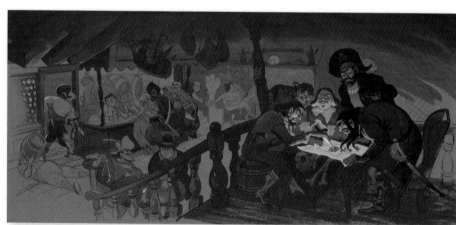

MAP TO TREASURE
This concept artwork by Marc Davis is from when the attraction was being developed as a walk-through, and depicts plotting pirates in an atmospheric tavern.

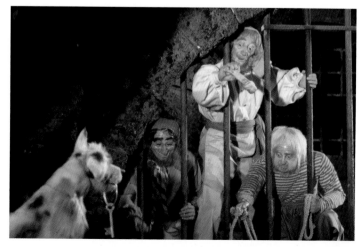

IMITATION OF LIFE
The attraction is populated with 53 *Audio-Animatronics*® animals and birds and 75 *Audio-Animatronics*® pirates and villagers utilizing advanced animatronics technology.

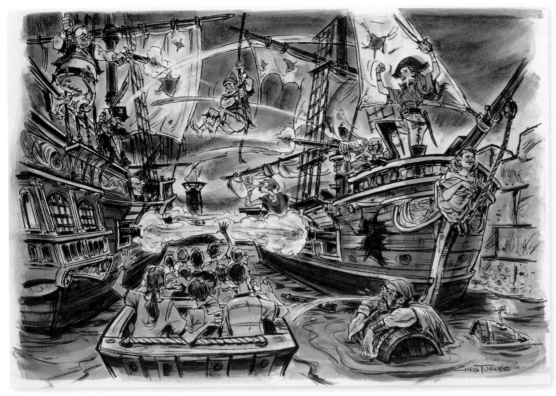

JOLLY ROGER
This concept artwork imagines the first time guests see pirates in action. They must navigate between the pirate ships and dodge cannonballs that land perilously close to their boats.

PIRATE RAID
This evocative study of the "chase scene" is by legendary Imagineer Claude Coats, who was largely responsible for the attraction's intricate settings.

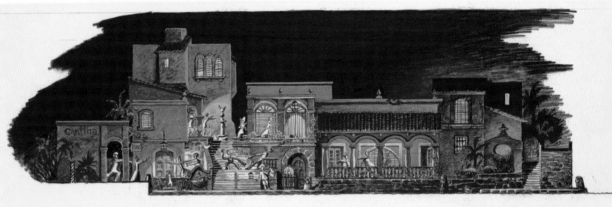

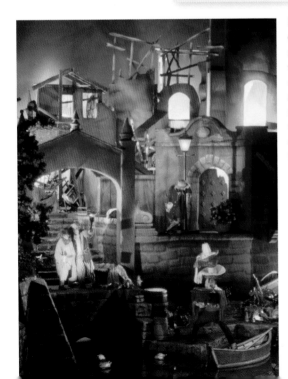

UP IN FLAMES
One of the most elaborate sequences in the attraction is when the pirate raid is foiled and the seaward village is set on fire. As real flames were not an option, the Imagineers developed effects using clever lighting and projection to simulate the blaze.

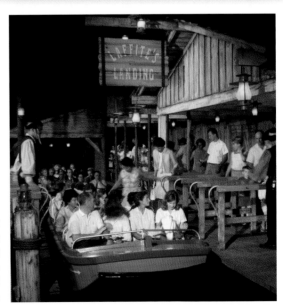

AHOY YE LANDLUBBER
Guests experience the attraction in free-floating "bateaux" that navigate the waters in a flume system, which uses 630,000 gallons (2.4 million litres) of water.

Blast Off!

Space Mountain takes voyagers on a thrilling galactic flight past meteorites, stars, and other outer space effects. The indoor roller coaster attraction made its debut in Magic Kingdom Park at Walt Disney World on January 15, 1975. Walt dreamed up the concept in the early 1960s, but it was 11 years before technology caught up with his vision. U.S. astronaut Gordon Cooper joined the creative team as an Imagineering consultant, using information gleaned from NASA's early space missions to make the experience feel like actual space flight.

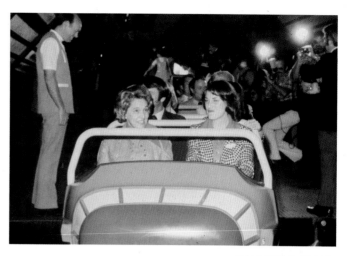

GALACTIC FRONTIER
Guests on the original Space Mountain at Magic Kingdom Park at Walt Disney World Resort rode in a doublewide rocket, before Imagineers replaced them with a single file vehicle.

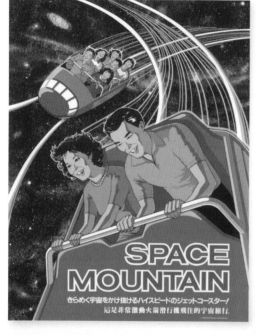

FUTURE ICON
This 1983 poster art emphasizes guests' experience of speed in outer space for the attraction at Tokyo Disneyland. This was the first Space Mountain to debut concurrent with the park's opening.

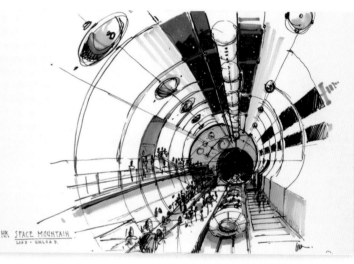

BREAKING NEW GROUND
This concept art of the Space Mountain attraction at Hong Kong Disneyland was drawn by Imagineering Executive Creative Director Greg Wilzbach.

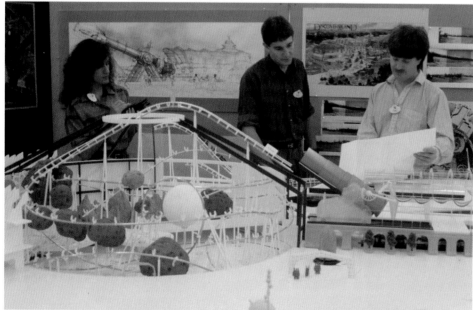

FROM THE EARTH TO THE MOON
Imagineers Victoria Aguilera, Pat Doyle, and Tim Stone helped re-imagine the attraction for its debut in Disneyland Paris on June 1, 1995, giving it a Jules Verne-inspired aesthetic.

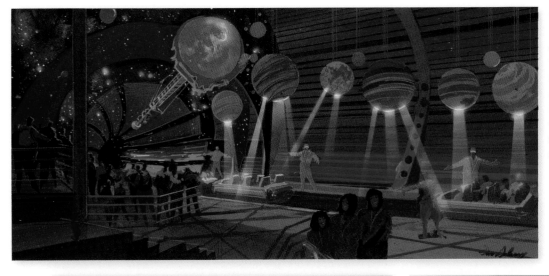

COSMIC ADVENTURE
This concept art by Tim Delaney for Hong Kong Disneyland depicts the load/unload area of the attraction, which gives visitors a hint of the galactic thrills to come.

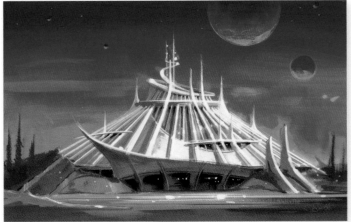

FUTURISTIC MOUNTAIN
Imagineers used concept art like this piece by Christopher Smith, to design the gleaming white, high-tech Tomorrowland "mountain" at Tokyo Disneyland.

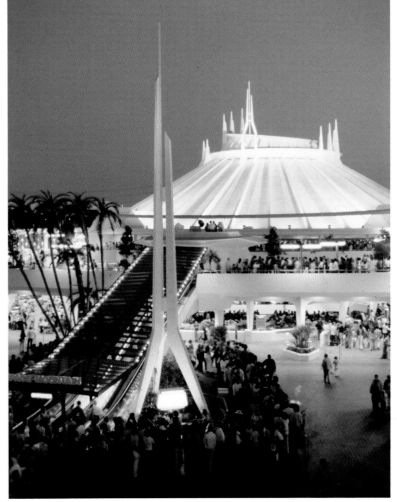

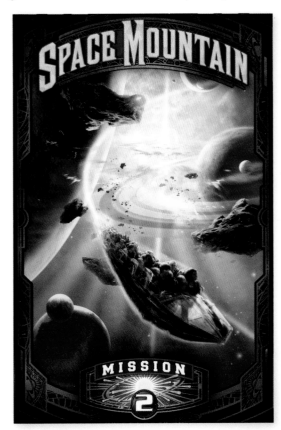

WELCOME TO THE FUTURE
At Disneyland Park, Space Mountain rises 118 ft (36 m) in the air. The attraction's exterior was changed in 1998 to bronze and gold, before returning to its classic gleaming white in 2004.

SPACE MOUNTAIN: MISSION 2
Space Mountain: de la Terre à la Lune in Disneyland Paris underwent a major refurbishment in the early 2000s, and became Space Mountain: Mission 2. Greg Pro and Owen Yoshino designed this poster in 2004 to celebrate the re-launched attraction.

A New Park

Scheduled to open its gates in 2016, Shanghai Disney Resort brings the tradition of Disney theme park magic to mainland China. Shanghai Disneyland park will be a Magic Kingdom-style theme park featuring classic Disney storytelling and characters, but with authentic cultural touches and themes tailored specifically for the people of China. Shanghai Disneyland park will include the first Pirates-themed land in a Disney park, to be named Treasure Cove. It will be unique to Shanghai Disneyland and include a major attraction, Pirates of the Caribbean: Battle for the Sunken Treasure—an all-new high-technology boat ride attraction. Located at the heart of the theme park, the iconic Enchanted Storybook Castle, a breathtaking attraction itself, will not only be the tallest and largest but also the most interactive Disney castle yet, complete with entertainment, dining, and performance spaces.

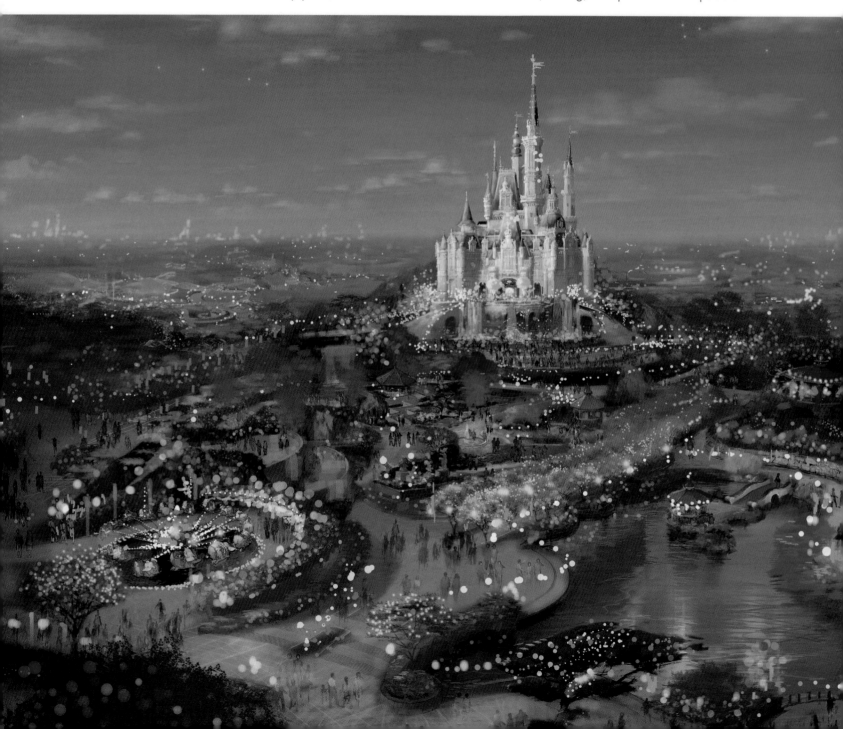

Shanghai Disneyland Resort Castle Entrance

SHANGHAI SPECTACULAR
This concept painting by Doug Rogers shows
the soon-to-be iconic Enchanted Storybook
Castle towering above Shanghai Disney Resort.
The resort will be home to the Shanghai Disneyland
theme park, two themed hotels, a large retail,
dining and entertainment venue, a Broadway-style
theater, and outdoor recreation areas.

WONDERFUL WELCOME
The magnificent entryway to enchantment is
depicted in this concept art by Doug Rogers.
Within the Enchanted Storybook Castle, guests
will find a boat ride attraction complete with a
secret underground chamber. Inside, fountains of
light will leap and dance in shimmering pools,
surrounding them with magic, music, and color.

Index

Credits

TIM BURTON'S "THE NIGHTMARE BEFORE CHRISTMAS" (1993)
The movie, Tim Burton's *The Nightmare Before Christmas*, story and characters by Tim Burton. Copyright © 1993 Disney Enterprises, Inc.

FRANKENWEENIE (2012)
Copyright © 2012 Disney Enterprises, Inc.

WINNIE THE POOH characters are based on the "Winnie the Pooh" works, by A. A. Milne and E. H. Shepard.

ONE HUNDRED AND ONE DALMATIONS
Based on the book The Hundred and One Dalmatians by Dodie Smith, published by The Viking Press.

THE ARISTOCATS is based on the book by Thomas Rowe.

THE RESCUERS AND THE RESCUERS DOWN UNDER feature characters from the Disney film suggested by the books by Margery Sharp, The Rescuers and Miss Bianca, published by Little, Brown and Company.

The movie THE PRINCESS AND THE FROG Copyright © 2009 Disney, story inspired in part by the book THE FROG PRINCESS by E.D. Baker Copyright © 2002, published by Bloomsbury Publishing, Inc.

THE LION KING (1994)
Song: "Hakuna Matata"
© 1994 Wonderland Music Company, Inc.

MARY POPPINS (1964)
The Disney movie, *Mary Poppins* is based on the Mary Poppins stories by P.L. Travers.

PIRATES OF THE CARIBBEAN
© Disney Enterprises, Inc.
Curse of the Black Pearl: (2003)
Based on the screenplay by Ted Elliot and Terry Rossio and Jay Wolpert
Produced by Jerry Bruckheimer
Directed by Gore Verbinski

DEAD MAN'S CHEST (2006)
Based on the screenplay by Ted Elliot & Terry Rossio
Based on the characters created by Ted Elliot & Terry Rossio and Stuart Beattie and Jay Wolpert
Based on Walt Disney's Pirates of the Caribbean
Produced by Jerry Bruckheimer
Directed by Gore Verbinski

AT WORLD'S END (2007)
Based on the screenplay by Ted Elliot & Terry Rossio
Based on the characters created by Ted Elliot & Terry Rossio and Stuart Beattie and Jay Wolpert
Based on Walt Disney's Pirates of the Caribbean
Produced by Jerry Bruckheimer
Directed by Gore Verbinski

ON STRANGER TIDES (2011)
Based on characters created by Ted Elliott & Terry Rossio and Stuart Beattie and Jay Wolpert
Based on Walt Disney's Pirates of the Caribbean
Suggested by the novel by Tim Powers
Screen Story and Screenplay by Ted Elliott & Terry Rossio

HANNAH MONTANA (TV SERIES)
Based on the series created by Michael Poryes and Rich Correll & Barry O'Brien

HIGH SCHOOL MUSICAL 1, 2
Based on the Disney Channel original movie "High School Musical," written by Peter Barsocchini

Walt Disney World® Resort
Disneyland® Resort
Disneyland® Park
Disney California Adventure® Park
Disneyland® Paris
Hong Kong Disneyland® Resort
Tokyo Disney Resort®
Tokyo Disneyland® Park
Tokyo DisneySea® Park
Magic Kingdom®
Main Street, U.S.A.®
Adventureland®
Frontierland®
Fantasyland®
Tomorrowland®
Epcot® Theme Park
Disney's Animal Kingdom® Theme Park

Photo Credits

All images © Disney

p.96 b Photo by Deborah Coleman / Pixar;
p.98 br Photo by Deborah Coleman / Pixar;
p.99 tr Photo by Deborah Coleman / Pixar;

All art images not specifically credited to a named artist are attributed to Disney Studio Artist.

Senior Editor Victoria Taylor
Senior Art Editor Lisa Robb
Editors Jo Casey, David Fentiman
Cover Design Lynne Moulding, Lisa Robb
Designers Mark Richards, Mik Gates, Sam Richiardi
Picture Researchers Sumedha Chopra, Myriam Megharbi
Senior Pre-production Producer Jennifer Murray
Senior Producer Alex Bell
Managing Editor Sadie Smith
Managing Art Editor Ron Stobbart
Publisher Julie Ferris
Art Director Lisa Lanzarini
Publishing Director Simon Beecroft

First American Edition, 2015
Published in the United States by DK Publishing
345 Hudson Street, New York, New York 10014. This edition, 2016.

Page design copyright © 2016 Dorling Kindersley Limited
A Penguin Random House Company

10 9 8 7 6
015–259436–Oct/2015

ISBN 978-1-4654-3787-7

Printed in China

DK books are available at special discounts when purchased in bulk for sales promotions, premiums,
fund-raising, or educational use. For details, contact: DK Publishing Special Markets,
345 Hudson Street, New York, New York 10014 SpecialSales@dk.com

ACKNOWLEDGMENTS

With special thanks to Jim Fanning for his incredible expertise
and dedication, and to Barbara Bazaldua for her writing assistance.

The publisher would like to thank Chelsea Alon, Justin Arthur, Amy Astley, Holly Brobst, Michael Buckhoff, Fox Carney,
Rebecca Cline, Debby Coleman, Kristie Crawford, Stephanie Everett, Christine Freeman, Ann Hansen,
Michael Jusko, Dale Kennedy, Kevin Kern, Wendy Lefkon, Betsy Mercer, Alissa Newton,
Obinna Ogbunamiri, Beatrice Osman, Edward Ovalle, Scott Piehl, Joanna Pratt, Frank Reifsnyder,
Alesha Reyes, Diane Scoglio, Rima Simonian, Dave Smith, Shiho Tilley, Jackie Vasquez and Mary Walsh at Disney.

Thanks also to Lauren Nesworthy, Julia March, and Beth Davies for editorial assistance;
Anne Sharples, Lynne Moulding, Anna Pond, Sol Kawage, and Amanda Ghobadi
for design assistance; and Anna Sander for administrative assistance.

A WORLD OF IDEAS
SEE ALL THERE IS TO KNOW
www.dk.com